Chinese Pottery and Porcelain

TRADITIONAL CHINESE ARTS AND CULTURE

Chinese Pottery and Porcelain

Li Zhiyan and Cheng Wen

FOREIGN LANGUAGES PRESS BEIJING

First edition 1984
Second printing 1989

Translated into English by
Ouyang Caiwei

English text edited by
Betty Chandler and Tang Bowen

ISBN 7-119-01167-7

ISBN 0-8351-1185-7

Copyright 1984 by Foreign Languages Press

Published by Foreign Languages Press
24 Baiwanzhuang Road, Beijing 100037, China

Printed by Wenlian Printing House

Distributed by China International Book Trading Corporation
21 Chegongzhuang Xilu, Beijing 100044, China
P.O. Box 399, Beijing, China

Printed in the People's Republic of China

Contents

Introduction

The Chinese civilization is one of the earliest in the world. The many great scientists and inventors in her long history with their wealth of creative work and innovations have left their mark on the political, economic and cultural development of Chinese society, and have influenced the history of world civilization as well.

Chinese pottery and porcelain have played their specific role in this impact, with China recognized as the "home of porcelain". One needs only to witness the name "china" as synonymous for porcelain. China is among the first countries in the world to use pottery, while her ancient invention, porcelain, has throughout the ages and the world been admired and valued for its use and beauty.

Pottery and porcelain refer to all products which are made of a mixture of clay, the main ingredient, feldspar and quartz, after shaping, drying and firing.

When did pottery first touch the life of mankind closely? Archaeological finds set the date in the Neolithic (New Stone) Age in Chinese primitive society (approximately 8000-2000 B.C.). Farm production which arose in the latter stage of primitive society, led to a fairly stable, settled life for our ancestors. Pottery was needed for convenience and improvement of their life, and they experimented with making vessels, gradually developing the art of firing pottery out of clay.

The existence of pottery was a hallmark of the New Stone Age in primitive society. The site of the Peiligang Culture in Xinzheng, Henan Province and the site of the Cishan Culture in Wuan, Hebei Province — both discovered in recent archaeological excavations — are the earliest Neolithic sites found in northern China, dating as far back as 7,900 years ago. The site of the Hemudu Culture in Yuyao County, Zhejiang Province, south of the Changjiang (Yangtze) River, is another early Neolithic site that flourished 7,000 years ago. Grey pottery, red pottery and even an occasional piece of painted pottery were found at all these ancient sites. The site of the Yangshao Culture at Banpo Village in Xian, Shaanxi Province, inhabited by people who lived in prosperity in a matriarchal clan society, is more than 6,000 years old. Large quantities of fine painted pottery were already made at that time.

The quality of pottery steadily improved with the progress of history. In the Shang and Zhou dynasties (16th century-211 B.C.) a clear-cut division of labour had appeared among potters. Elegant designs and pictures of flowers, birds and landscapes were being carved on pottery ware during the Warring States Period (475-221 B.C.). Potters later introduced lead glaze, which made the surface of pottery smooth and fine and added lustre to the vessels.

In the Western Han Dynasty (206 B.C.- A.D. 24) the art of glazing pottery became widespread. Multi-coloured glaze was also

introduced in the Han Dynasty (206 B.C.-A.D. 220). The renowned Tang Dynasty (A.D. 618-907) tri-colour pottery with lead glaze was the invention of potters who introduced white, yellow, blue, green, brown and purple glazes and skilfully applied them in combination. The appearance of Tang tri-colour glazed pottery marked the entry of pottery art into an era of greater variety and colour, which in fact began in the Sui Dynasty (A.D. 581-618).

Porcelain did not come easily. After several thousand years of hard work, the early potters accumulated rich experience in their craft. The earliest porcelain appeared in the Shang and Zhou dynasties of slave society. Porcelain as such was in its initial stage, rudimentary and known now as the proto-celadon from which porcelain developed independently. Porcelain is finer, harder and closer-knit in texture than pottery, which is porous, opaque and gives a dull sound when struck. Porcelain is non-porous, translucent and has a smooth surface. It gives a metallic sound when struck.

Since China's liberation in 1949 the Party and government have taken archaeological work seriously, resulting in a considerable number of Shang and Zhou proto-celadon vessels being unearthed in many provinces in the Huanghe (Yellow) River valley and the middle and lower reaches of the Yangtze. These were different from earlier pottery made from clay paste, the difference being mainly in two aspects. Proto-celadon used white china clay, or kaolin (an infusible white mineral earth produced in the area of Gaoling Village in Fuliang County, Jiangxi Province), a fine, pure material suitable for making good-quality porcelain. The second difference is that the firing temperature was at least 1,200°C — much higher than for firing pottery. The distinction between porcelain and pottery lay in the firing of the paste. These two changes — in the material used and in firing temperature — brought about porcelain. This Shang and Zhou proto-celadon, which basically resembled Song Dynasty (960-1279) celadon, is to our knowledge China's earliest porcelain, dating from the Shang Dynasty, 3,400 or 3,500 years ago.

Early in the Western Han Dynasty whole sets of celadon vessels were manufactured, specimens of Western Han vessels excavated in Peixian County, Jiangsu Province, having been displayed in the Pottery and Porcelain Hall of Beijing's Palace Museum. The ewers, steamers, vases, jars, tripods and boxes have a hard paste and are smooth and lustrous as compared with earlier ware. The frequent discovery of Han porcelain in archaeological digs indicates that large quantities of the ware were manufactured.

It was in the Sui and Tang dynasties that porcelain gained variety and colour, glaze ingredients containing different metal oxides being available to produce brilliant colours on firing. During the late Tang Dynasty, the Five Dynasties and early Song, Yue ware celadon (from the Yuezhou kilns around Shaoxing and Yuyao in Zhejiang Province), with a fine paste, had "the verdure of a thousand mountain peaks" and was "like dewy budding lotus flowers". The feudal ruling class monopolized this exquisite ware, known as "porcelain of secret colour" (the olive-green of fine Yue ware), as tribute to the imperial court.

In the Song Dynasty, porcelain kilns mushroomed in different places and porcelain schools representative of particular regions appeared. Before Song, porcelain was decorated by carving, incising and impressing designs. That is, before the paste was dried, designs were carved or incised with a knife on the unglazed body or impressed with stamps for mass production and then glazed for firing. In the Song Dynasty, decorative designs were painted over the glaze, black designs or red and green patterns on white porcelain for example, and this painting on

porcelain marked an entirely new stage in Chinese porcelain art. The Yuan Dynasty (1271-1368) saw continued new development in the art of porcelain-making which contributed to the types of famous wares.

Porcelain manufacture attained its acme in Chinese history in the Ming and Qing dynasties (1368-1911). This was shown in a tremendous variety of vessel shapes, lustrous colours and splendid designs made possible by the fine texture of the paste, adequate firing, abundance of pigments, improvement of craftsmanship and various social influences of the time. Apart from exquisite patterns, Ming porcelain decoration featured landscapes, portraits, flower-and-bird and other paintings. Most of the Qing paintings on porcelain were works of famous contemporary artists or imitations of their works.

Jingdezhen in Jiangxi Province was the centre of porcelain manufacture in China during Ming and Qing. Its kilns have contributed much to the perfection of porcelain and occupy a distinguished place in ceramic art.

China's various dynasties have seen a wealth of wares including the green Yue ware of Yuezhou, Xing white porcelain ware of Xingzhou, Ding ware in Hebei, Ru ware of Ruzhou, the celadon of Longquan in present-day Zhejiang Province, and Jingdezhen ware.

The distinctive style of each is admired in different parts of the world, for Chinese pottery and porcelain went abroad as early as in the Han Dynasty, and was exported in large quantities by the Tang Dynasty. From north China the wares went westward along the famous "Silk Road"; from the south they were shipped by sea to neighbouring Asian countries and thence to North Africa and the Mediterranean countries. Not until the 15th century did they reach Europe and so have the worldwide impact that provided their brilliant page in the history of world civilization.

Today, every Chinese province or autonomous region turns out ceramics with local features or in the style of the ethnic group of the area. China's working people have inherited and carried forward the fine national traditions of pottery and porcelain. On the principle of "letting a hundred flowers blossom and weeding through the old to bring forth the new", Chinese pottery and porcelain flourish in the socialist era.

This book, written with the lay reader in mind, deals with the beginnings and development of Chinese pottery and porcelain, bringing out their national style and artistic features. It also assesses the contributions made by Chinese pottery and porcelain to world culture. At the same time it outlines recent findings in ceramic research.

CHAPTER 1
Pottery Comes into People's Lives; Neolithic Pottery

SECTION 1
The Introduction of Pottery

Before the existence of pottery it was very difficult to cook food, the only method being to roast it over a bonfire. Some primitive tribespeople lined pits with rocks, skinned and dressed their game, filled the cavities with searing hot stones, put the game into the pits and covered all with hot ashes. The game was roasted and ready to eat after some time. People of some other tribes filled pits with water and placed food in the water. They then heated stones in a fire and threw them continuously into the water until the food was cooked. A variation of this method was putting fish or meat into a net which was immersed in hot springs till the food was done. Primitive people had a hard time getting a meal cooked!

How did people in remote times improve their food? This was possible in fact only after they had learned how to use fire and to fire pottery vessels, which served for cooking and for storing food and drinking water. Pottery-making is a useful craft which combines art and technique, and the introduction of pottery was a great event in improving the people's lives. Pottery manufacture was a primitive handicraft of mankind with very distinct features.

Many accounts of the introduction of pottery can be found in ancient Chinese books. For instance, *Yi Zhou Shu* (*Lost Books of the Zhou Dynasty*), a historical chronicle written between the Warring States Period and the Qin and Han dynasties, says: "Shen Nong [legendary emperor of ancient China] cultivated plants and made pottery." *Lü Shi Chun Qiu* (*Master Lü's Spring and Autumn Annals*), written in the 3rd century B.C., says: "Emperor Huangdi [legendary Yellow Emperor] placed an official named Kun Wu in charge of making pottery." *Shi Ji* (*Records of the Historian*) by Sima Qian in the Han Dynasty, says: "Emperor Huangdi appointed Ning Feng, an official, in charge of pottery-making." In addition, *Sou Shen Ji* (*Records of the Spirits*), a collection of mythological stories very popular among the Chinese people, also contains this fairly detailed description of pottery-making: "According to legends, Master Ning Feng, who flourished at the time of Emperor Huangdi, was the Emperor's pottery official. An immortal passed his place and helped him control the fire so that it gave off smoke of many colours, though he did not teach Ning Feng pottery-

making until long afterwards. Ning Feng built a kiln himself and went inside to watch the pottery baking, observing the rise and fall of the flames and smoke." Ning Feng did this so as to fire the pottery well. But one day he was burnt to death in the kiln. People cherished the memory of this person who gave his life for pottery-making, and they buried him on Ningbei Hill. Such legends bring to us fragments of remote history concerning the introduction of pottery, which occurred prior to the appearance of written records, setting it at nearly 10,000 years ago. Shen Nong, Ning Feng and Kun Wu in the legends may never have existed, yet the stories show that pottery resulted from centuries of people's collective labour.

Pottery seems extremely simple to make today, but at that time it was a monumental feat requiring certain social conditions. Judging by the data obtained from archaeological excavation and research, pottery appeared in the Neolithic Age of primitive society. And it was precisely this era that prepared the mature material conditions for the creation of pottery.

First of all, agriculture and stock breeding began to develop in the Neolithic Age, giving people control of food sources and enabling them gradually to enrich them. With an abundance of food, people had an increasing and urgent need for vessels for cooking and storing food, and for eating and drinking purposes. Various specific demands that arose in social life were a requisite factor in bringing pottery into existence. Rising living standards and growth in population provided conditions in society to set apart a portion of labour power for pottery-making, including conditions for the potters to display their creative artistic ability to shape and decorate their vessels.

Next, pottery had necessarily to await the first steps in settled life. Easily breakable, pottery vessels were not suited for nomadic life. A roaming people with no fixed dwell-

ings would have little use for much pottery and would therefore not perfect pottery-making methods. So long as the mode of life meant roasting food over a fire and made other cooking methods and the storing of food unnecessary or undesirable, pottery had no urgent place in daily life. The Oroqens, a nomadic nationality who live by hunting in China's Inner Mongolia and Heilongjiang Province, have no knowledge of pottery-making. The Iroquois tribe of American Indians, who lived a partially settled life in the United States, made a few pottery vessels of limited variety. The Wa nationality in China's Yunnan Province, though still in the stage of primitive clan community before 1949, made large amounts of pottery because they lived a settled life and engaged in farming. Since the development of production enables people to control sources of means of subsistence and become sufficiently well-to-do to have surplus grain to store, this is the key to opening up a stable, settled life, which in turn makes possible setting apart a number of people for pottery-making with its fairly complicated processes requiring an extended production time. Settled life was an important social prerequisite for the introduction of pottery into people's lives.

Frederick Engels deals scientifically with the introduction of pottery in his work *The Origin of the Family, Private Property and the State* when he says: "In many cases it can be proved, and in all it is probable, that the first pots originated from the habit of covering baskets or wooden vessels with clay to make them fireproof; in this way it was soon discovered that moulded clay answered the purpose without any inner vessel." [1]

Long experience in farm production ac-

[1] Frederick Engels, *The Origin of the Family, Private Property and the State*, Foreign Languages Press, Beijing, 1978, pp. 25-26.

quainted people gradually with the tenacious and plastic properties of clay. They knew that it could be mixed with water and used to coat their baskets, then that it could be moulded into vessels and containers of various shapes. Moreover, after long experience in using fire, people learned that it could change the properties of substances, and this hastened man's progress in battling nature. In the Neolithic Age, fire was mankind's aid in bringing pottery into human life.

SECTION 2
The Making of Pottery

Pottery has always been close to people's lives since its beginning in the Neolithic Age of primitive society. Pottery vessels have been turned out constantly to fill people's daily needs, and the processes of pottery-making have progressed continually from crude to refined. Pottery manufacture consists of three processes: first, selection and processing of raw materials; second, shaping and decoration of the vessels; third, firing by heat. Let us go into greater detail.

1. Selection and Processing of Raw Materials

The clay for pottery-making is a type of natural earth composed of a single inorganic substance or a mixture of several such substances. It is available almost everywhere. When mixed with water, it can be moulded into various shapes which it retains after drying and firing. This does not mean however that selection of clay is not necessary in pottery-making. Clay that contains too much sand is not suitable, for it will be loose, incohesive, and not take shape; the vessel will disintegrate after firing in the kiln. On the other hand, clay that contains too little or no sand is too sticky and close-knit. When mixed with water it is like starch paste, and when dried like a stone-hard crust that

breaks easily on heating. Potters must therefore first of all select pottery clay carefully and then try it out again and again so as to be working with suitable raw material.

What kind of clay went into the grey pottery and the red pottery of the Neolithic Age? Painted pottery shards unearthed at Yangshao Village in Mianchi County of Henan Province, the site of the famous Yangshao Culture, show the following chemical composition: aluminium oxide (Al_2O_3) 15.64%, silicon dioxide (SiO_2) 65.66%, magnesium oxide (MgO) 0.75%, and iron oxide (Fe_2O_3) 18.3%. Chemical analysis of unearthed shards from other Yangshao sites furnishes similar data. All were made of clay which differed from ordinary earth. First, the raw material for painted pottery or grey pottery had an iron content of at least 10 per cent. Iron is absent in ordinary loess. This high iron content may have accounted for the red or grey tint in painted pottery. Second, it was low in calcium and potassium, while ordinary earth is rich in calcium, potassium and sodium. Ordinary methods of washing cannot reduce the amounts of such mineral substances. Third, it contained fairly large amounts of magnesium, which is also absent in ordinary earth. Scientists' observations of cross-sections of the grey and the red potteries of the Neolithic Age show a much finer and close-knit structure than in ordinary bricks

and tiles. Air bubbles were also much fewer, indicating that these potteries were not made from farm or surface soil, which contains a fairly large amount of humus. Interestingly enough, local residents of famous ancient cultural sites are still manufacturing pottery. In Mianchi County of Henan Province and Rizhao County (site of the famous Longshan Culture) in Shandong, for example, grey pottery, red pottery and black pottery are still made by hand. Although ordinary loess is widespread in the Yellow River valley, it is not used, the local potters selecting instead red earth, black earth and sedimentary earth.

Yet, even carefully selected pottery clay cannot be used as found in nature, for the natural material is still not ideal and must be processed. Clay that is not sticky enough for easy moulding requires washing to reduce its sand content. Some clay is too tenacious, and the moisture and air inside the paste do not readily disappear during drying and firing, so that the vessel easily cracks and becomes distorted. Pottery clay must therefore be processed to produce vessels of desired shape and size. Less-sticky or non-sticky substances must be admixed with clay which is over sticky. These are called mixing substances and may include powdered quartz, feldspar and sandstone. Grass ash or powdered oyster shells or broken pottery are sometimes added to improve the shaping property of pottery clay. These substances also improve the heat-resistance of pottery ware and its ability to withstand sudden temperature change and so increase productivity of ware that can stand high temperatures and so serve as cooking utensils.

Raw materials must be pulverized after selection and preparation. This aims at reducing the density of granular material so that the various ingredients can spread evenly throughout the paste, a situation that directly affects the properties of pottery ware after drying and firing. Reducing the size of the grains facilitates various physical and chemical reactions of the raw materials during heating. It also enables the materials to be easily fired to form a close-knit texture, reduces air bubbles in the paste and increases its strength, hardness and specific gravity after firing.

Kneading and leavening are the final processes in preparing the raw materials. The grains and moisture in the clay mixed with water do not spread evenly, so kneading is necessary to increase clay density, reduce air bubbles and improve plasticity. In ancient times this kneading was done by treading the paste clay with the feet or pressing it with the hands, or using cattle to tread the clay or a stone roller to press it. Kneading causes the moisture in the clay paste to spread more evenly between its grains, but it still requires keeping in a moist state for a period of time to allow seepage into the finer parts of the grains and a more thoroughly even spread of moisture in the paste. The result is then a glutinous substance between the grains that increases the stickiness and plasticity of the paste. This process, called leavening, gives better results the longer it is carried out.

The painted pottery of the Yangshao Culture and the black pottery of the Longshan Culture of Neolithic times in primitive Chinese society were made of a fine paste that did not swell or break apart, indicating that the clay had been well leavened.

2. The Shaping and Decoration of Pottery Vessels

After the raw materials have been prepared and processed, semi-finished products, or clay shapes, are made. Examination of large numbers of pottery vessels unearthed from Neolithic cultural layers in China re-

veals two methods of making pottery at that time: hand-modelling and throwing on the potter's wheel.

Before pottery-making skills were developed, the only products were a few simple useful utensils moulded by hand. Later, basing on this experience, potters made large or more complicated pottery vessels with small mouths and big bellies.

Later, a new technique, known as the coiling technique gradually evolved (figs. 1 & 2). Coiling was the main method for making pottery vessels discovered in the various Neolithic cultures of China. The process involved kneading the clay into a long strip which was coiled upon itself spirally around a stone ball or pottery mould, the potter holding the clay strip with one hand and the mould with the other. This was done from the bottom right to the mouth rim, making the embryo of the pottery vessel. The Wa nationality in Yunnan Province still use this method to make pottery, first forming the bottom of the vessel and then coiling the clay strip circularly layer upon layer, allowing each layer of the paste to dry slightly before applying the next. The finished vessel is put in a shady place to dry thoroughly before firing. Traces of such coiling are often seen inside pottery vessels made by this method.

Throwing on the potter's wheel was a more complicated method developed after the acquisition of further experience in pottery-making. Potters now designed the simple device of a support propping up a wooden disc. The clay was put on the disc which one person pedalled by foot while another moulded the clay with both hands into a vessel, keeping pace with the rotating disc (fig. 3). This wheel method invented in the late Neolithic Age resulted in pottery vessels that were round and regular on the outside, with a series of circular stripes in clear symmetrical lines on the surface.

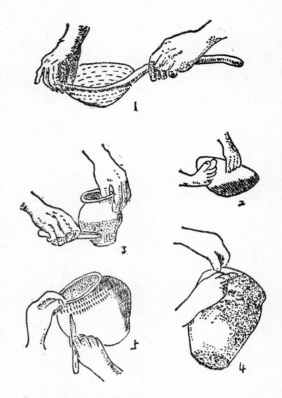

1. Shaping and decoration of pottery.

Moulding was another method, probably invented later. In this, a mould of the desired vessel was first made and the clay stuffed into it to be extruded. Vessels made with moulds were uniform in size and shape, though the shapes in the early stage were rather simple and variety was limited. Later, moulds were mainly used to make the components of vessels.

The next step — embellishing the body of the vessel already shaped — involved several processes.

The first was to smooth the moulded vessel with wet hands. Water had to be applied constantly to the clay shape to prevent its drying prematurely and cracking. This also smoothed the surface of the vessel. But this had to be done carefully by hand, as too much water softens the clay and makes it

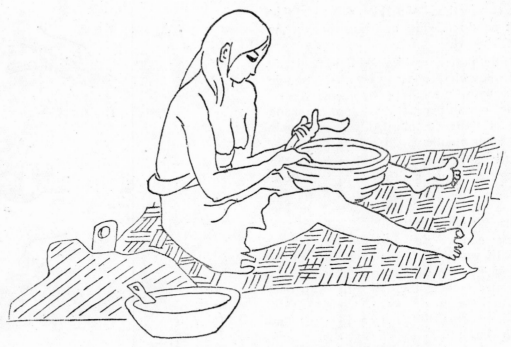

2. A woman in matriarchal clan society makes pottery
with the coiling method.

sag. The potter had also to smear water by hand to erase the joint seam and fill in the fissures.

Impressed decoration. After smoothing the vessel with the hands wet, its surface was even but had no lustre. Nor had the body as a whole a finished look, and decoration was achieved by impressing the body with designs on a stamp made from a wooden plank. This was engraved with various designs, or the stamp was wound with twine to produce a cord impression. Basket patterns, mat markings and checks were among the designs engraved on the stamps. Smoothing the clay shape and impressing the designs were done simultaneously during shaping. When the vessels became slightly dry, some were irregular in shape while others retained remnants of the clay strip, which required smoothing out. Some vessels were made in separate sections which were joined together during this process.

Rubbing. When the clay body was partially dry, ancient potters rubbed the piece with pebbles so as to fill up the fissures and smooth the rough surface. This process repositioned mica and other flake-like minerals in the clay so that they were parallel to the surface of the vessel, reducing the scattering and increasing the parallel reflection of light rays to produce a lustre.

Painting. Any painted patterns on the pottery were applied before firing. Ancient Chinese pottery vessels were beautifully shaped and painted. Decorative motives included animals, plants and weaving patterns, indicating the closeness of these themes to people's lives in primitive society. They also demonstrate that productive labour is the source of art. Spectrum analysis of the

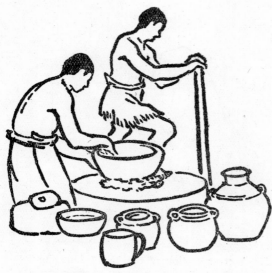

3. Making pottery on the potter's wheel (The Period of Longshan Culture).

black, brown and white pigments used shows that the main colouring agent was an iron-containing substance, possibly red ochre. The black colouring agents were iron and manganese; perhaps red earth with high iron content was used. Patterns painted with this pigment on the pottery became black after firing. The white colour may have been produced by mixing flux into clay.

3. Firing

The shaped and embellished vessels were still semi-finished articles in the process of pottery-making. Firing was required to evaporate some of the water in the texture and harden the clay into pottery vessels. The temperature for firing pottery in the Neolithic Age in China was 800°-900°C or slightly higher, though 1050°C was not exceeded. Most pottery vessels of that era in China were fired in pottery kilns. Good or poor quality depended on the potters' skill in controlling firing temperature, and the invention of pottery kilns more or less

guaranteed this, though successful experience required long practice. A more primitive method of firing pottery had, however, certainly preceded the invention of pottery kilns, the pottery probably being fired over an open blaze, though we have no archaeological finds to substantiate this. Yet the use of a related method to this day by certain minority people, e.g., the Wa in Yunnan Province, provides us with a clue. The Wa people pile aired clay vessels on a dry plot of ground outside their village, placing large vessels underneath and smaller ones above. Firewood was placed in the spaces between the vessels, which were burnt for three hours. The pottery makers then used sticks to pick out the fired pottery vessels one by one from the charcoal, coating the mouth rims or bodies of the vessels with glutinous brown pigment while the vessels were still hot. The firing site was then ploughed under and crops were planted, leaving no trace of the firing.

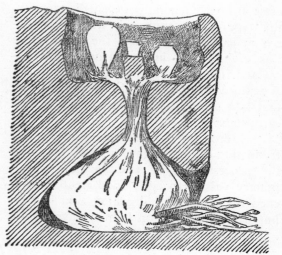

4. Vertical pottery kiln of Yang-shao Culture at Banpo, Xian.
Fire chamber: 2.24 metres long, 2.06 metres wide and 0.9 metre high.
Fire passage: Only two passages exist now.
Diameter: 20 cm. Length: about 30 cm.

Many kiln sites for firing pottery in China's Neolithic Age have been discovered. Typical of these are the pottery kiln sites of the Yangshao and Longshan cultures in Banpo Village of Xian and in Fengxian County in Shaanxi Province; Miaodigou in Shanxian County, Sanliqiao at Sanmen Gorge, Xugawang Village of Zhengzhou, Fanjiazhuang Village of Anyang, all in Henan Province; and Jiangou in Handan, Hebei Province. The pottery kilns were of two structures: vertical (fig. 4) and horizontal (fig. 5). Most were horizontal. This had a fire opening, a fire chamber, a fire passage, a kiln chamber and a fire grate. The kiln chamber was round with the grate at the bottom. The grate was perforated with numerous fire holes through which the flames from the fire chamber were led from the fire passage to the kiln chamber. The fire opening, fire chamber and fire passage were contoured right in the earth and then smeared with a layer of peat. The kiln grate and other parts were also made of peat, which hardened into red baked earth after firing. Generally of small capacity, this type of kiln took only five or six vessels at each firing, though the temperature was even. And, judging from pieces excavated, the colour was basically uniform. A distorted or cracked find was rare, showing that kiln firing was fairly advanced at that early date.

The foregoing is a summary of the introduction of pottery into people's lives and the processes of its manufacture. Using pottery vessels to cook food greatly shortened the process of digestion and had an important influence on human physical de-

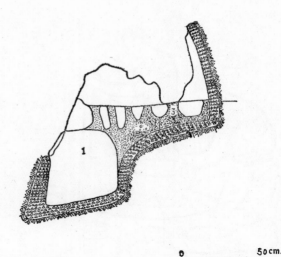

0 50 cm.

5. A cross section of the No. 1 kiln site of Longshan Culture at Miaodigou.
1. Fire chamber. 2. Fire passage.
3. Fire hole.

velopment. The use of pottery facilitated the consolidation of settled life and made possible the improvement of farm production. The introduction and long-term use of pottery provided favourable conditions for mankind to enter the era of metals. Pottery is refractory, the clay into which strongly calcining agent is added being especially resistant to high temperatures. Pottery vessels can therefore be used as crucibles to smelt metals. And when the technique of metallurgy appeared in the world the productive forces inevitably leapt ahead, promoting appropriate change in the relations of production. Human society advanced speedily and classes arose. In short, the use of pottery was a monumental hallmark of the Neolithic Age.

SECTION 3
Fine Pottery of Ancient China

The earliest pottery vessels so far found in China are those unearthed at the site of the Peiligang Culture in Xinzheng, Henan Province and the site of the Cishan Culture

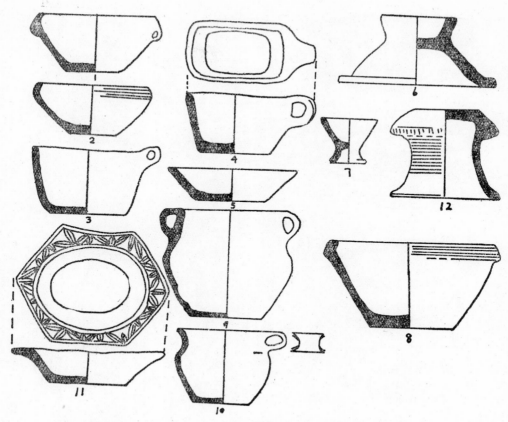

6. Pottery vessels of Hemudu Culture in Yuyao County, Zhejiang Province.

in Wuan, Hebei Province, both dating as far back as 7,900 years ago. The Hemudu site in Yuyao County, Zhejiang Province at seven millennia is one of the earliest in southern China. The pottery vessels found at the Hemudu site are featured by large quantities of organic matter such as grass and powdered leaves and seed hulls of plants of the grass family being admixed with the pottery clay. Firing reduced the organic matter to charcoal which made the pottery black. A cross-section of a shard shows clearly charcoal grain crystals, and this was known as charcoal-mixed black pottery. The vessels, entirely hand-made, were fired at a fairly low temperature and the walls of the body were rather thick. They were simple and irregular in shape, especially the jars,

which were often uneven in thickness and colour and not properly curved. Some were even distorted in shape, showing the art of pottery-making at that time to be very primitive, while variety was mainly limited to cauldrons, jars, basins, plates, bowls, lids and stands for the vessels. There was also a broad-mouthed *yu* jar and other vessels of special shapes (fig. 6).

Painted Pottery in Primitive Society

Among the various potteries produced in the Neolithic Age of China's primitive society, painted pottery has drawn most attention. Primitive cultures producing

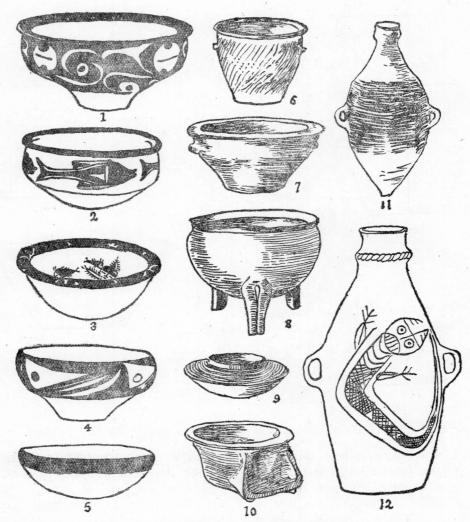

7. Pottery vessels of Yangshao Culture.

1.2.3.7. Basins. 4.5. Bowls. 6. Jar. 8. *Ding* tripod. 9. Cauldron.
10. Stove. 11. Jug with small mouth and pointed base.
12. Vase with small mouth and flat base.

painted pottery were wide throughout China, though the best known were the Yangshao Culture on the Central Plains in the Yellow River valley, the Qingliangang and Daxi cultures in the Yangtze River valley, and the Qujialing Culture in the region around the confluence of the Yangtze and Hanshui rivers. The painted pottery discovered at these sites has been of various types but uniformly beautiful.

Most of the designs were painted on red pottery. The vessels themselves show great variety (fig. 7), their shapes suggesting their uses. Bowls and basins were probably used for eating and drinking. Jugs with a pointed base and a larger volume had either a long

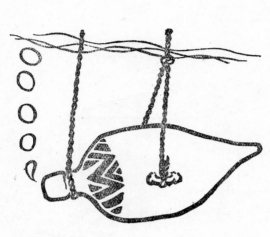

8. Picture showing how a jug of small mouth and pointed base of the Neolithic Age is filled with water.

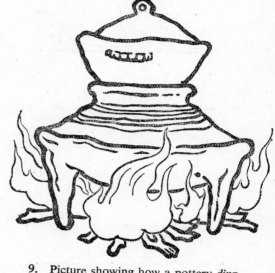

9. Picture showing how a pottery *ding* tripod or cauldron cooks food.

or short neck and two handles above the belly. These were likely used for dipping up, carrying and storing water (fig. 8). Other urns and jars were used for storing grain and water. The painted pottery sites also yielded cauldrons, tripods and ovens for cooking (fig. 9), also rings, beads and other small objects used as ornaments.

Long experience in gathering berries, fruits and plants and in tilling the soil brought people close to nature, and they expressed their love of living things through fine and varied designs and patterns, painting twigs, leaves, flower petals and seeds on the pottery. These designs were well arranged, graceful and decorative indeed. Fine specimens are the stylized chrysanthemums and roses (fig. 10) on the painted pottery found at the Yangshao sites in Banpo Village of Xian.

Primitive dwellers on the Central Plains and in the region of present-day Gansu and Qinghai provinces used parallel lines, circles, checks, zigzags, waves and herringbone patterns according to the shape of the vessel, the patterns providing varied and

colourful artistic decoration.

The painted depictions of humans, animals and birds were highly artistic. Pottery unearthed at Liuzizhen market town in Huaxian County, Shaanxi Province, is decorated with standing swans and flying wild birds; vessels found at the Yangshao digs of Banpo Village in Xian feature scampering wild deer and long-tailed aquatic birds with fish in their beaks, as well as swimming fish, insects and frogs (fig. 11). One pottery basin has painted on it the smiling face of a man wearing a fish-shaped headdress. He has fine, long, arched eyebrows and is grinning so broadly that his eyes are mere slits. His ample mouth is a symmetrical triangle, while around his ears are shoals of small fish. Is he not dreaming that the fish are swimming to him (fig. 12)? In any case, the paintings show clan members engaged in fishing and hunting, and of course they hoped for good catches and bags. Some vessels have paintings of groups of people dancing hand in hand, presumably after work (fig. 12), suggesting the timeless-

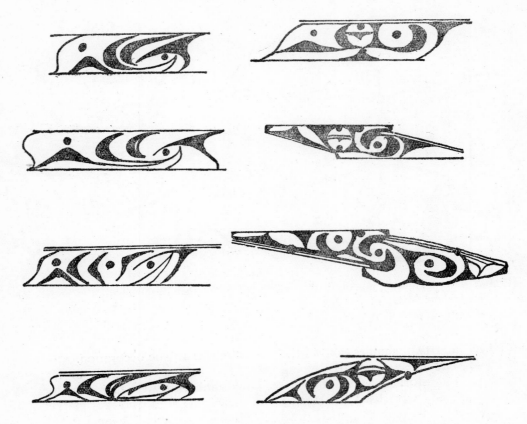

10. Decorative designs on painted pottery of the Miaodigou type.
Left: Chrysanthemum family (the composite family). *Right:* Rose family.

ness of the working people's zest for life. The painted pottery depictions are vigorous and bright, reflecting in art scenes of people carrying on their primitive economy. It is realized that engaging in productive labour and also carefully observing its processes for a long time is the basis for creating works of such beauty and realism.

Potters made ingenious use of the special shapes of parts of the vessels to mould artistic images, and these were the earliest coloured clay sculptures in China. A pottery potshard discovered at the Miaodigou site in Shanxian County, Henan Province, bears the image of a creeping house lizard. The lizard peers ahead and looks so vigilant that one may feel it is in danger of falling into

the jar of which it once formed the decoration if it stretches its neck any farther (fig. 13). Equally lifelike are the carved images of birds, including eagles.

Most fascinating perhaps is the image of a man's head on the lid of a vessel. The face is round and plump with the eyes gazing ahead, a smile curving the corners of the mouth. With ornaments on the head and a sparse beard under the chin, the image looks alive, kind and amiable. Diminutive carvings of the human face have moulded nose ridges, eyes and mouths, all exquisitely done.

Another culture known as the Longshan Culture which arose late in primitive society, i.e., in the stage of patriarchal clan society,

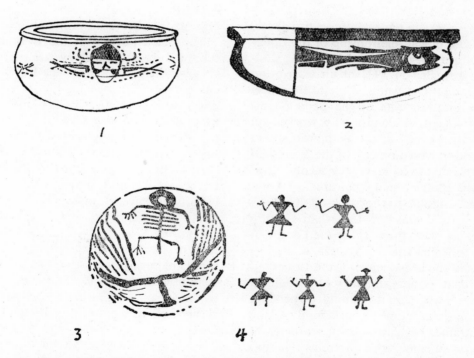

	Banpo Period	Miaodigou Period	Majiayao Period
Frog Designs			
Bird Designs			

11. THE DEVELOPMENT OF THE FROG AND BIRD DECORATIONS
ON THE POTTERY VESSELS OF THE YANGSHAO CULTURE

1

2

3

4

12. 1. Pottery with design of human face and fish of Yangshao Culture at Banpo, Xian.
2. Pottery with fish pattern of Yangshao Culture at Banpo, Xian.
3. Painted pottery with design of human figure of Yangshao Culture at Majiayao.
4. Design of dancing human figures on pottery of Yangshao Culture at Xindian.

13. Figure of a house lizard on a painted pottery of Yangshao Culture at Miaodigou.

was discovered in Longshan Town of Licheng County, Shandong Province in 1928. This culture is characterized by a lustrous black pottery ware simultaneous with stone and bone artifacts. It pervaded the middle and lower Yellow River valley, south of the Yangtze and China's southeastern coast, or what is today Shandong, Jiangsu, Zhejiang, Anhui, Hebei, Henan and Liaoning provinces. The stratigraphical relationship of the Longshan Culture overlaying the Yangshao Culture was revealed in 1931 at an excavation at Hougang in Anyang, Henan Province. Teachers and students of the Beijing University archaeology faculty who worked on the 1960 excavation at the Wangwan site in Luoyang discovered objects of the Yangshao Culture in the lowest layer, the second layer being the transitional cultural stratum from the Yangshao to the Longshan Culture, while the third was the Longshan Culture layer. This order proved that the Longshan Culture followed that of Yangshao.

It was in the social stage of the Longshan Culture that pottery manufacture changed from clan ownership to family ownership, and the craft developed considerably. The vessels attained regularity of shape, the paste was even, and some vessels were as thin and smooth as egg shell. This type was the eggshell black pottery well known in the history of Chinese pottery and porcelain. Its processing involved careful washing and adequate kneading of the pottery clay. Firing in a kiln was first done with an oxidizing flame, which causes metals in the clay and glaze to show their oxide colours. As the kiln firing was near completion, the pottery was smoked with reducing flame to return the oxides to their respective metal states. The black colour of this pottery was due to a relatively high charcoal content, the tiny holes in the paste being filled with charcoal grains.

Utensils and vessels made of black pottery included bowls, basins, plates, *dou* stemmed vessels, cups, jars, *yan* steamers, *zeng* steamers, *jia* wine goblets, *gui* (three-legged cooking vessel with handle) and *ding* tripod cooking vessels. The *gui* and *jia* and also *li* (the bottom part of a steamer) and the *zeng* steamer were new cooking vessels that did not exist in the Yangshao Culture, showing that the art of cooking had made substantial progress.

The black pottery of the Longshan Culture was distinguished by the shapes of its vessels. The outside surface featured clearcut curved and raised lines. Details were dexterously treated, the auxiliary lines for example. The mouth, foot and handle shapes of a vessel were emphasized by using raised lines. Another special feature of the Longshan Culture black pottery was concise and fresh contour and simple decoration. Ingenuity is implicit in the pleasing proportion of different parts of the vessels and the execution of detail — features that were rare in Neolithic pottery vessels. Animal motifs picturing goats, dogs, ducks and geese were used as decoration on the black pottery of the Longshan Culture, indicating that the raising of domestic animals and poultry was relatively well developed.

A post-Longshan Culture emerged in Guangdong, Taiwan, Fujian, Jiangsu, Zhejiang, Hunan and Hubei provinces in the late stage of primitive society. This prevailed through slave society in the Shang

and Zhou dynasties and Spring and Autumn Period, and on to early feudal society in the Warring States Period.

Sites of this culture yielded a type of pottery vessels decorated with patterns from a carved stamp, called impressed-design pottery. It was grey with either a brownish or bluish tint. The texture of some vessels was rather loose, its softness suggesting the name impressed-design soft pottery, or simply impressed-design pottery. Other vessels were of extraordinarily hard texture. These were fired at relatively high temperatures and were known as impressed-design hard pottery. Impressed-design pottery was for the most part wheel-made, usually in the shapes of *ding* tripods, jars, ewers, *dou* stemmed vessels, basins, cups, plates and *gui*. The decoration was stamped on, and pottery vessels showed traces of the stamping of pottery bats. Designs included checks, rhombi and wave patterns, stripes and cord impressions.

Pottery from the Shang and Zhou to the Qin and Han Dynasties

SECTION 1
Pottery of the Shang and Zhou Dynasties

In about 2100 B.C. the primitive Chinese society began gradually to disintegrate, while slave society started to consolidate from the beginning of the Xia Dynasty (approximately from the 21st to the 16th century B.C.) and continued into Shang after the 16th century B.C. Chinese recorded history dates from the Shang Dynasty, when inscriptions were made on oracle bones, tortoise shells and on bronzes. Discoveries at Shang tomb digs have revealed large numbers of slaves buried with their deceased masters.

Slave society furnished the first exploitative system in the ancient world. But, under the prevailing conditions of the primitive commune, even this replacement by the slave system marked notable advance, for slavery as a system provided the possibility of a rudimentary division of labour between agricultural and handicraft pursuits. The supersession by slavery of the primitive commune was accompanied in Chinese history by striking progress in economy, politics and handicraft art. Although China entered the Bronze Age as early as in the Shang and Zhou dynasties, bronze could not replace pottery in use, bronze vessels constituting but a limited range of utensils for upper ruling-class life, while pottery vessels filled the daily needs of the masses.

In the Shang Dynasty there were six handicraft trades: potters, smiths, stonemasons, carpenters, animal tenders and straw weavers. Potters, who made tiles as well as vessels, ranked first. One pottery artisan of the Zhou Dynasty is verified in *Zuo Zhuan* (*Zuo Qiuming's Chronicles*) as follows: "Yu Efu was a potter in the early Zhou Dynasty. King Wu relied on him to make good pottery vessels. After Yu became a wondrous craftsman, the king took him as son-in-law and enfeoffed him with the State of Chen." For a potter to win the king's daughter's hand and become the chief of a vassal state on the merits of his craft is some indication of the esteem in which pottery was held at that time.

Shang and Zhou dynasty pottery was mainly of the grey type, either grey clay pottery or grey sandy pottery. Archaeological excavation reveals the ware to be cooking utensils and vessels for eating and drinking or storing food. These included *yan* steamers, urns, cups, tripods, *lei* (urn-like vessels), jars, *bu* (bowl-shaped contain-

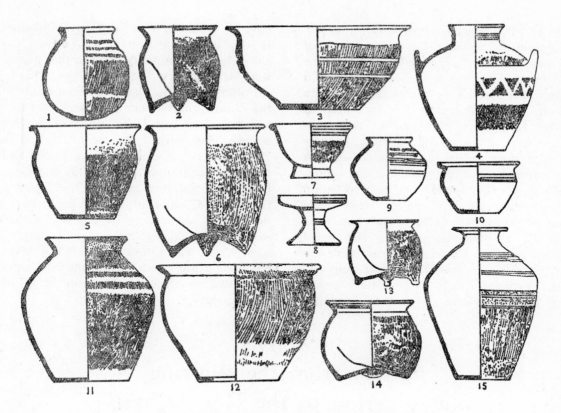

14. Pottery of Western Zhou at Zhangjiapo, Changan.
1.4.9.15. Jars. 2.6.13.14. *Li* steamers. 3. Basin. 5. *Zun*
wine vessel. 7. *Gui* food container. 8. *Dou* stemmed vessel.
10. *Yu* jar. 11. Urn. 12. *Zeng* steamer.

ers) ewers, *jia* wine goblets, *zeng* steamers, *zhi* goblets, *gui* food containers, *yu* jars, bowls and *li* (the bottom part of a steamer). This is a far greater variety of shapes than in the Xia Dynasty. The structures and types of vessels and their uses were practically identical with those of the contemporary bronzes (fig. 14).

Pottery-making in the Shang and Zhou dynasties was a relatively large-scale handicraft trade within which there was a marked division of labour. Workshops appeared for the exclusive production of pottery vessels for commercial purposes, a centre of such kilns having been discovered at the pottery site west of Minggong Road in

Zhengzhou, Henan Province. In addition to pottery-making tools, the site yielded large numbers of basins, *zeng* steamers and *gui* food containers, as well as unfired and malfired pottery. It is noteworthy that none of these has sand mixed in the clay. There were also pottery kiln sites at the late Shang Ruins in Xingtai, Hebei Province, but these kiln products were mainly sandy *li* steamers. Such workshops, specializing in a single type of vessels, certainly produced for the market, a trend that continued till the end of slave society.

Among Shang wares was a fine type known as white pottery which was made as early as in primitive society, the Dawenkou Cul-

ture of 5,000 years ago bequeathing no few white pottery vessels. The white pottery of Shang, however, is generally appraised as the best. This was made of white kaolin clay which gave a very fine paste, pure white colour and hard texture. It was fired at about 1,000°C. Ceremonial in shape, its forms were identical with the ritual bronzes of that time, while its decorative designs were also the *kui*-dragon (a legendary monster), *taotie* (ogre-mask) and square within square patterns. The pieces were finely engraved, the patterns being elaborately executed with meticulous care. The vessel shapes comprised ewers, *dou* stemmed vessels, *lei* (urn-like vessels) and *zun* wine vessels. Very few Shang white pottery vessels have been unearthed, and most of those that have are from the tombs of kings. Obviously, this fine white pottery was owned exclusively by the nobility, who in that period were slave-owners.

Pottery took its place in architecture in the Zhou Dynasty when plate and tube tiles and bricks for balustrade construction were made. This marked a great innovation in Zhou pottery, as from then on, bricks and tiles have been important building materials. Qin Shi Huang, founder of the Qin Dynasty (221-207 B.C.) and unifier of China, spared no effort in building palaces, as is described in the essay *Efang Palace*. This magnificent edifice was a conglomeration of halls, pavilions, towers and bridges, the bricks and tiles used in their construction being of rare perfection.

SECTION 2
Pottery from the Warring States Period to the Han Dynasty

Chinese history took a big step forward with the beginning of the Warring States Period in 475 B.C. It passed from slave into feudal society, representing another leap ahead for mankind.

Greater concentration in pottery production and a more specialized division of labour marked this era. Groups of pottery workshops have been discovered over large areas at the ancient sites of the secondary capital of Yan State in Yixian County, Hebei Province; Xigongduan in Luoyang, Henan Province and Gucheng in Niucun Village, Houma County, Shanxi Province. Unearthed pottery vessels were often inscribed or stamped with such place names as "Huyang", "Chengyi", "Pouli" and "Taoli". Other inscriptions made it possible to research into the nature and organizational form of pottery production and the potters'

social status in this period. All of this was much more complicated than in the pottery trade of slave society, and while the stamped-on or inscribed characters giving place names on pottery vessels unearthed in Luoyang and Guanzhong do not tell us much, we do learn the names of the potters from the inscriptions on vessels recovered from the sites in the secondary capital of Yan State. These were probably products of government-run handicraft workshops, while bricks inscribed with the characters "Senior Minister of Public Works" undoubtedly were products of government workshops using mainly the labour of convicts and slaves. A third type of inscription was the seal impression on pottery vessels: "A certain person in a given neighbourhood" or "Potter So-and-So in a certain neighbourhood". These were likely products of private owners' workshops.

The pottery of the Warring States Period was of four varieties: grey, red, dull brown and black. The dull brown pottery was painted with coloured patterns. The texture of some of the vessels was fairly soft and their colour tone impure. Many were used specially as funerary objects or at sacrificial ceremonies. Most, however, were of fairly carefully washed paste clay so that the pottery was hard in texture and pure in colour. Firing was controlled with fair accuracy. Representative of pottery art in this period are vessels unearthed from a Warring States tomb in Huixian County, Henan Province, and from the tomb of a prince of Zhongshan State in Pingshan County, Hebei Province. These are fine and attractive in shape and their surface is as lustrous as black lacquer. The vessel types include ewers, *ding* tripods, *yan* steamers, bowls, basins, plates and *dou* stemmed vessels. A special feature of this pottery was smoking the vessels heavily when the paste was partly dry so that charcoal grains infiltrated the fissures of the paste, making the surface of the vessels as black as the bottom of a pot. Then for cosmetic effect, the potter pressed and polished the vessel with a smooth, hard tool, which gave the paste clay a close-knit granular structure. The pressing and polishing also changed the arrangement of the tiny charcoal grains and those of mica and quartz in the paste from irregular to regular in the direction of the pressing so that the vessels gave a parallel reflection to light and had a high lustre. The pottery objects from the tomb of the Zhongshan prince have bright, delightful patterns and may well represent the development of pottery workmanship in the Warring States Period (fig. 15).

From the Warring States Period to the Qin and Han dynasties, Chinese feudal society developed unprecedentedly following the rise of a united country. Pottery too surpassed wares of any previous period in variety, quantity and quality as evidenced by archaeological finds in Han tombs in the Shaogou area of Luoyang, Henan Province. From 225 Han tombs excavated, 36 types of pottery vessels were found, a total of 4,713 pieces. Among these were grey and red clay pottery, red-bodied glazed clay pottery, red sandy pottery and red-bodied hard sandy pottery. Unearthed also were painted pottery vessels in a great variety of shapes: ewers, granary models, jars, urns, dressing cases, *zun* wine vessels, stoves, eared cups, *ding* tripods, *dui* grain containers, bowls, square boxes, low tables, plates, straight-sided mugs, shallow basins, basins, cauldrons, *zeng* steamers, *dou* measure, lamps, Boshan censers and well-head models (fig. 16).

Painted pottery has been of high artistic quality since the Han Dynasty. The designs were lively and bright in colour; they exhibited carefully executed composition and experienced drawing. The painted pottery basin unearthed from Dou Wan's tomb on a hill in Mancheng, Hebei Province in 1968 has vivid fish, bird and cloud patterns in dark red, white and black.

The Han Dynasty also produced lacquer-coated pottery, i.e., a layer of lacquer was applied to the vessels to make their surface lustrous black.

Glazed pottery of diverse types was manufactured in large quantities in the Han Dynasty, the glaze being a thin layer of vitreous material covering the surface of the pottery. Firing the pottery caused the glaze to melt with the rise of temperature and then to harden into a thin membrane that became glued to the vessel as the temperature fell. The result was a smooth and glossy surface. The abundance of mineral substances that were added into the glaze also showed up as different colours on the surface. Archaeological data place glazed pottery as first appearing in the Guanzhong area, Shaanxi Province, where glazed pottery

15. Black pottery unearthed from the tomb of the Prince of the
State of Zhongshan in Pingshan County, Hebei Province.

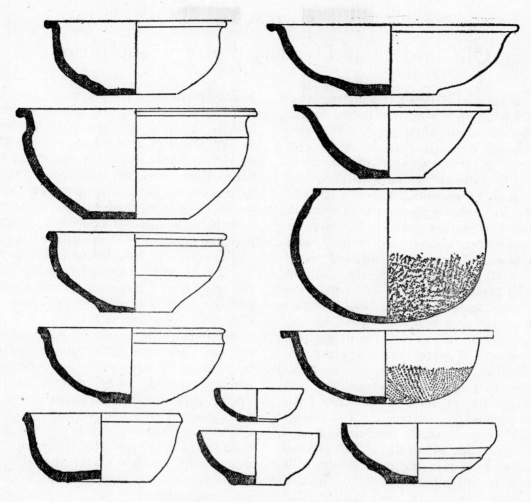

16. Pottery vessels of the Han Dynasty.

vessels were unearthed from a tomb of about the time of Emperor Wudi of Han (140-87 B.C.). During Wang Mang's regime (A.D. 9-22) there appeared pottery with a multi-coloured glaze of yellow, green and reddish brown. All exhibit a rich variety of vessel shapes, including models of houses, pavilions, corridors, animals and poultry, besides utensils of daily use. Glazed pottery was in green, yellow, black or brown, though the green predominated.

Pottery items were precious in the Han Dynasty, an ordinary pottery stove being equal to the price of two piculs of rice which in turn was exchangeable for two *mu*[1] of farmland. Yet pottery vessels of diverse shapes and good quality abounded in the tombs of landlords and nobles, reflecting the luxurious life of the landlord class and the stark class contradictions in Han Dynasty society.

[1] 1 *mu* is 1/15 hectare or approximately 1/6 acre.

Qin and Han Dynasty Pottery Sculpture

In the summer of 1974 a vast underground vault filled with life-size terra-cotta figures was discovered east of the mausoleum of Qin Shi Huang, the First Emperor of the Qin Dynasty, in Lintong County, Shaanxi Province. The several thousand stalwart, life-like figures of warriors 1.8 metres tall and of life-size horses were unearthed from an area of 1,260 square metres. The men are in battle-dress, armour and helmets, and carry bows and arrows or swords and lances. Every one is distinctly different, both in mien and posture, though all display the Qin troops' features of being "well-equipped with armour and weapons" and "fighting bravely for the country". The plump pottery horses, 1.63 metres high, have ears pointed in intent attention. The muscle structure of the horses is nicely modelled and shows the fine physique of the beasts. All the human figures look powerful and mighty, though there are visible differences in age, social status and personality. This ordered proud array of men and their mounts calls to mind the magnificence of the battles Qin Shi Huang fought to unify China. The successful firing of this huge contingent of life-size and life-like pottery warriors was unprecedented in the history of China's ancient pottery-making art and marked an important stage in the production of large sculptures in ancient China. The number, size and grandeur of these warriors and horses demonstrate striking artistic skill on the part of the ancient labouring people.

Pottery sculpture advanced also in the Han Dynasty, pottery figurines and other images attaining a high level in handicraft art, and objects gradually tending to reflect reality. Classic realistic art portraying people and their social life was especially being steadily perfected. Human images and activities included peasants and cooks, rice husking, hunting, acrobatics, story-telling, singing, dancing, and playing musical instruments. Animal motives included fowl, horses, cattle, sheep, dogs and swine. Architectural objects included miniature pavilions, towers, corridors, balustrades, waterside open halls, houses with courtyards, poultry pens and granaries. Most of these fine pottery images were moulded or carved in the round or in relief. Executed in concise lines, the art stressed "capturing the spirit", and presented objects in highly artistic condensation.

Ballad Singer is a work of highly artistic character portrayal. The figure holds the drum in his left hand and points downward with the forefinger of his right; his head is drawn back between shrugged shoulders while a broad smile narrows his eyes. Raised eyebrows and the creases on his forehead tell of long experience of misery. Although the figurine would scarcely pass anatomical muster, there is no doubt about its being life-like. Any exaggeration is purely artistic, for folk artists of the Han Dynasty were not satisfied merely with accurate depiction of objects but were more concerned with keen and thorough observation leading to a presentation of expression and action. Han folk artists were skilled at choosing and catching the fleeting moment in a motion that most represented that motion and its force. Apart from enhancing vitality, this method went somewhat beyond the general principles of plastic arts to achieve deletion and exaggeration and impart a feeling of the joy of life. *Ballad Singer* is a fine example in the ancient Chinese art tradition.

CHAPTER 3
Invention and Refinement of Porcelain

SECTION 1
Porcelain's Beginnings

Porcelain, one of China's great inventions, has contributed richly to mankind's well-being. Porcelain differs from pottery in the following respects. It uses china clay (including the pure white kaolin, feldspar and quartz, or porcelain stone containing these ingredients) to form the paste. Porcelain requires a coating of vitreous glaze on its surface which must be fired at a temperature of at least 1,200°C until a tough framework of needle-like crystals appears in the body with vitreous particles filling the spaces between the crystals. The vessel is then non-porous or very slightly porous and, when struck, produces a clear ringing sound like metal. A cross section of the biscuit (the clay shape after the first firing) has the lustre of silk, and well-fired porcelain is translucent.

Porcelain manufacture was possible only after the productive forces had developed to a certain stage and society had reached a definite technological level. Porcelain is both attractive and useful, and its smooth, glossy, vitreous surface makes it easy to clean. China's artistic and technical achievement in porcelain has been very much appreciated by her own people and those of other countries. The ware touches closely the life of all mankind, and today, after three millen-

nia of development, porcelain is ever more cherished as it is used in a wide range of people's pursuits and daily life.

When was Chinese porcelain invented? Chinese academic circles are still exhaustively discussing this question. Some scholars place its origin in the Wei and Jin dynasties after the 3rd century, though a number of scholars think that the Eastern Han Dynasty (A.D. 25-220) or the Three Kingdoms Period (A.D. 220-280) are more appropriate dates. The most recent concept, however, based on new data and chemical findings of 1972, is that porcelain goes back as far in Chinese history as the 16th century B.C., i.e. to the Shang and Zhou dynasties in slave society. China's earliest porcelain was proto-celadon.

China clay was used for the paste of this Shang and Zhou proto-celadon. Vessels excavated from a Western Zhou tomb in Tunxi, Anhui Province, for example, have a paste formed of a substance similar to Qimen china clay — the fine clay still used today by China's renowned Jingdezhen kilns. The only difference was that it was not so carefully washed and refined in those remote days. Firing temperature reached 1230°C — ±30°C, a temperature used throughout China's dynasties. The low

porosity and hardness of the body compared favourably with those same physical properties of the wares of later periods, which were universally acknowledged as porcelain by academic circles, identifying the Shang and Zhou proto-celadon as China's earliest porcelain.

Social development during the Shang Dynasty furnished the conditions for the production of proto-celadon, the establishment of slave society propelling Shang science and art forward. Agricultural development in this era is indicated by inscriptions on oracle bones and tortoise shells detailing entire series of farm production processes. There was an obvious division of labour between stockbreeding and farming, the latter providing an abundance of grain, which in turn led to the distilling of wines and liquors in the Shang Dynasty. Drinking having become a feature of Shang Dynasty life, sufficient vessels were needed for storing and drinking wine. Bronze wine vessels existed in Shang, but bronze production was limited in quantity and only pottery and porcelain vessels could meet the expanded need. Pottery and porcelain production for the tippler thus grew, and this busy handicraft work became a specialized occupation separated from farming. The second major division of labour was thus effected — that between handicraft and farm work.

Another favourable factor in the Shang period for the firing of porcelain was the development of metallurgy. Bronze casting workshops were manned by several hundred craftsmen who worked at rather specialized tasks among which according to studies of the workshops were ore dressing, preparing the ingredients, mixing tin into copper, making moulds, heating and casting. Bronze casting required temperatures of 1,000°-1,100°C, and the smelting of red copper ore containing 90 per cent copper or above required an even higher temperature. These, and the still higher temperatures required for iron smelting, were certainly obtained by the use of blowers in Shang Dynasty metallurgical technology.

Trade developed along with the growth of handicraft industry and a carefully worked-out and consolidated division of labour. Commerce was brisk in Shang times, trade being conducted not only between tribes within Shang territory, but far beyond Shang borders as well. South China Sea shells were transported to the north, and bronzes cast on the Central Plains (roughly the Yellow River valley) appeared in China's Sichuan, Gansu, Yunnan and the northeastern provinces. The flourishing of commerce enlivened the economy of the whole society, stimulated the expansion of urban and rural handicraft production and brought about rising handicraft trades. Several thousand years of pottery-making experience led to the discovery of the ideal raw material, china clay, and of a method for preparing the glaze, which in turn resulted in the introduction of porcelain as a handicraft.

The appearance of proto-celadon was a monumental advance in the development of Chinese ceramics, a truly epochal achievement.

SECTION 2
Celadon Becomes a Prime Product

Proto-celadon, with properties markedly superior to those of the pottery which preceded it, rapidly became a tremendously popular product which underwent con-

tinual improvement in quality, while the quantity made and used saw steady increase. This led to the new handicraft trade of porcelain, which kept abreast of the pottery trade.

In the Western Zhou Dynasty, which began in the 11th century B.C., the paste was fairly fine and the art of applying glaze noticeably improved. The glaze was thicker and more even than before, while vessel shapes showed greater variety. The expanse of the proto-celadon trade throughout the country is manifest in the shards found on the Yandun and Wufeng hills in Dantu and Wuxian counties of Jiangsu Province, at Pangjiagou in Luoyang of Henan Province, Zhangjiapo in Xian of Shaanxi Province, at Sufutun in Yidu of Shandong Province, at Lingtai in Gansu Province, on Beijing's outskirts, in Wucheng of Jiangxi Province, and in vast areas of the Yellow River valley.

The Warring States Period (475-221 B.C.) The development of Chinese celadon entered a new epoch in the early Warring States Period with the establishment of the feudal system. Archaeologists refer to the product of this stage as "early celadon". Its manufacture developed at a fairly great rate and in considerable quantity. Series and batches of celadon ware have been recovered from tombs, instances being the celadon found in the Warring State tombs at the site of an ancient market town in Niucun Village, Houma County, Shanxi Province, and in the Shaoxing area of Zhejiang Province. The celadon of this period exhibited a compact paste and regular shapes. Most of the vessels imitated contemporary bronzes such as the *he* water vessel (a pot with handle and spout), *ding* tripod with lid, *yi* wine vessel, *yi* water vessel and complete sets of chime bells. The glaze was fairly thick and glossy, its colour a rather dark blue-green.

Celadon in the Han Dynasty (206 B.C.-

A.D. 220). Complete sets of celadon vessels were manufactured as early as at the beginning of the Western Han Dynasty, i.e., in the 3rd century B.C. Judging from the items excavated from Han tombs in Shaoxing, Zhejiang Province, vessel shapes comprised ewers, *bu* deep-bellied containers, vases, jars, tripods, boxes, bells and *chunyu* bells. Late Western Han Dynasty digs have yielded larger amounts of celadon in yet greater variety. Especially in Zhejiang, Jiangsu, Hunan and Guangdong provinces, twenty to thirty vessels have often been excavated on one occasion, and besides the blue-green glaze there is also pale grey, yellowish green and brownish black. Remarkable is the fact that there is very little difference between the lighter bluish grey glaze of the late Eastern Han Dynasty and that of celadon of the Three Kingdoms Period and the Jin Dynasty.

Former sites of "dragon" porcelain kilns have been found in Shangyu and Ningpo, Zhejiang Province. These kilns followed the contour of small hillslopes, with the porcelain vessels stacked on racks above a fire at the bottom. The flames flowed naturally upwards, rising dragon-like up the winding slope, which helped to control them and produce a reduction flame. "Dragon" kilns were spacious enough to fire hundreds of vessels at a time. As celadon manufacture gradually matured, a foundation was laid for the development of porcelain in the Three Kingdoms Period, the Jin Dynasty and the Southern and Northern Dynasties.

"The Money Makers" chapter in *Records of the Historian* says that commerce flourished in the Han Dynasty. "Rich traders and influential merchants travelled the length and breadth of the empire, and goods of every kind circulated wherever men desired." Pottery and porcelain handicrafts were among the beneficiaries of this trade boom.

Porcelain's Advance in the Three Kingdoms, the Jin Dynasty and the Southern and Northern Dynasties

This era of the Three Kingdoms, the Jin Dynasty and the Southern and Northern Dynasties, was about 400 years long and was a period of turbulence and unrest in Chinese history. Wars undermined production and scattered people far and wide. The Han nationality people on the Central Plains, however, disseminated advanced production methods and the feudal relations of production and took their place among the local inhabitants. This stimulated the social production of many regions populated by minority nationals, propelling these regions also into feudal society. The economy of the Yangtze River valley now caught up with that of the Yellow River valley and the economic base of Chinese feudal society greatly expanded. There was some change in the relations of production and a gradual weakening in the relationship of personal subjection of the labouring people.

Celadon production in the Three Kingdoms Period, the Jin Dynasty and the Southern and Northern Dynasties developed mainly in respect to expanding production areas. In the Han Dynasty, Chinese celadon production centres were in Zhejiang and Jiangsu provinces and along the lower reaches of the Yangtze River. Now they spread to the upper and middle Yangtze and other areas, kilns for celadon manufacture having been discovered in Hubei, Sichuan, Jiangxi and Fujian provinces. Areas north of the Yellow River became porcelain producers on a fairly large scale (fig. 17).

Porcelain began to occupy an ever more important place among the people's daily used utensils, and porcelain vessels increased in variety. Frequently seen were goat-shaped and tiger-shaped vessels, ewers with dish-shaped mouths, chicken-spout and ox-spout ewers, eagle-shaped jars, plates, shallow basins, censers, spittoons, mugs, bowls and vases.

Porcelain ware of this period was decorated with incising, impressing, moulding and openwork techniques. Decorations included chequered and dotted designs, cloud patterns, *pushou* (animal head with a large ring in its mouth) motif, birds, beasts, human figures and coloured splashes. Southern celadon had granary jars of peculiar shape (fig. 18). Carved on the jars were pavilions, towers, halls and terraces, flocks of birds seeking food, maids and servants around the buildings, warriors, bands playing musical instruments, and acrobats performing variety shows. These jars were buried with landlords and officials and give some idea of the luxury in which the exploiting upper class lived at that time.

Celadon craftsmanship was the basis on which black porcelain was perfected in the Eastern Jin Dynasty (A.D. 317-420). Black porcelain required a higher standard in preparing the glaze colour and in firing technique than did celadon. Black porcelain in Eastern Jin was mainly made in and around Deqing and Yuhang counties in Zhejiang Province. The chief products were black glazed chicken-spout ewers and four-lobed ewers with dish-shaped mouths.

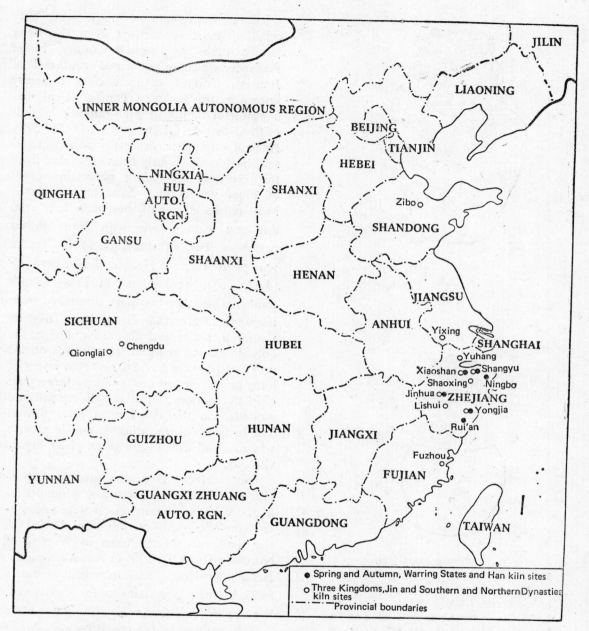

17. IMPORTANT KILNS OF THE SPRING AND AUTUMN AND THE WARRING STATES PERIODS, THREE KINGDOMS AND SOUTHERN AND NORTHERN DYNASTIES

Uncovered from tombs of the Northern Dynasties (A.D. 386-581) in Hebei, Henan and Shandong provinces were many celadon vessels of forceful and magnificent shape. The glaze was highly vitreous and bluish green in colour, some showing a slight yellow

18. Pottery granary jars.
1. Granary jar with an inscription of the third year of the Yongan reign (A.D. 260) of the State of Wu.
2. Granary jar with an inscription of the Yongning reign (A.D. 301-302) found in Nanjing.

tinge. Chemical analysis shows the glazes of this "northern" celadon to have used different materials from those of southern celadon. Representative of this ware were celadon vessels unearthed from the Feng family tombs in Jingxian County, Hebei Province, which were located southeast of Jingxian County in an ancient cemetery known as the Eighteen Tombs. Feng was a powerful family of high-ranking officials of the Northern Qi Dynasty (A.D. 550-577). Ancient rare relics, especially porcelain vessels, have continuously been excavated from this cemetery, including porcelain vessels of blue, yellow and dark brown glazes. Most representative of these were four celadon *zun* wine vessels with lotus flower patterns. Two of these, dated the fourth year of the reign of Heqing of Northern Qi (A.D. 565), were found in Feng Zihui's tomb. The other two were unearthed from the tomb of a certain Zu family. They are similar in shape and decorative design, the only difference being in the patterns on the necks of the vessels. Six or seven layers of lotus petals, carved and appliquéd, are their chief decorations. The vessels are tall and modelled in the shape of a lotus flower. The body is solemn, durable and in greyish white coated with bluish green glaze, highly vitreous.

The Northern Dynasties saw the important achievement of producing white porcelain. White porcelain vessels were unearthed from the tomb of Fan Cui buried in the sixth year of the reign of Wuping of Northern Qi (A.D. 575) in Anyang County, Henan Province, and represent China's earliest white porcelain so far discovered. White porcelain occupied an important place in daily life and laid the basis for subsequent ware with painted designs and for modern porcelain. It had far-reaching prospects, surpassing celadon and gradually becoming China's prime porcelain product.

Ceramics Flourish in the Sui and Tang Dynasties and the Period of the Five Dynasties and Ten Kingdoms

The Sui and Tang dynasties were an era of striking progress in the economy and culture of Chinese feudal society. The production of pottery ware followed this trend. Some of the pottery vessels of this period had colourful painted decorations (fig. 19). In the Sui, Tang and the Five Dynasties period, porcelain production entered a stage of all-round and rich development. Porcelain in the Sui and Tang dynasties was fired at high temperatures that gave its body sufficient compactness and durability to replace lacquerware and bronze. The production of porcelain thus came into its own in society.

SECTION 1
Sui Dynasty Porcelain

In A.D. 581, Yang Jian (later known as Emperor Wendi of the Sui Dynasty) unified China under the new dynasty designated as Sui, ending prolonged in-fighting among feudal cliques of landlord despots and independent regimes. And since the unity of a country facilitates national cultural and economic development, increased trade between the country's south and north soon stimulated commodity production of various handicraft trades. It was these social conditions that brought prosperity to the ceramic handicraft in the Sui Dynasty.

The Sui porcelain vessels that have been unearthed point to a wide diffusion of the ware. Vast areas east of Tongguan Pass and cen-tring on Anyang in Henan Province, known as the Guandong region, the Xingyang area in the vicinity of Zhengzhou also in Henan Province, the Guanxi area centring on Xian in Shaanxi Province, and the lower Yellow River centring on Jinan in Shandong Province have all yielded specimens. Porcelain kilns so far known include the Jiabi in Cixian County, Hebei Province; the Gongxian and the Zhaigou in Xingyang County and the Beiguan in Anyang County — these three located in Henan Province. All were large-scale celadon kiln sites. Porcelain kilns have been discovered in Zibo, Qufu and Taian in Shandong Province. Sui porcelain and its kiln sites were also discovered in

19. Dagoba-shaped pottery jar of the Tang Dynasty.

the southern provinces of Henan, Hubei, Jiangxi, Jiangsu, Anhui, Sichuan, Guang-

dong and Fujian (fig. 20). Sui porcelain vessels excavated from tombs are fairly abundant, more than sixty porcelain vessels having been recovered from one tomb alone at Zhoujiadawan in Wuhan, Hubei Province. Sui porcelain ware found in batches at archaeological excavations in quite a number of provinces and cities attest to the wide distribution of porcelain-producing areas and the extensive use of porcelain ware in daily life, all of which indicates a flourishing porcelain handicraft in the Sui Dynasty.

With this rapid development of porcelain in the Sui Dynasty, the ware began to replace not only pottery, but bronze and lacquer for utensils of daily use. Porcelain vessels came in a much greater variety of shapes, which were determined by use. Among the storing vessels are ewers, jars, urns, basins, vats and boxes, and among the vessels for eating and drinking were bowls, plates, *zun* wine vessels and mugs. Special vessels for bedroom use include tripod incense burners, Boshan censers, lamps and candlesticks, spittoons and pillows (porcelain pillows first appeared in the Sui Dynasty). Stationery items comprise inkslabs and small jars for rinsing writing brushes, while recreational items are waist drums and chessboards. Porcelain was also used to make models of such necessities as well-heads, cabinets, houses, teapoys and stools. There are porcelain figurines also of humans and animals.

The Sui Dynasty occupied a brief moment in Chinese history. But in porcelain achievement it left a significant mark, technically preparing for the remarkable porcelain of Tang. In the art of kiln firing, for example, the Sui Dynasty was far ahead of the Wei, Jin and Southern and Northern Dynasties. Even though the same raw materials and temperature were used, different products resulted due to different timing in the rise of temperature in firing, the nature of the flames, and cooling methods. Important

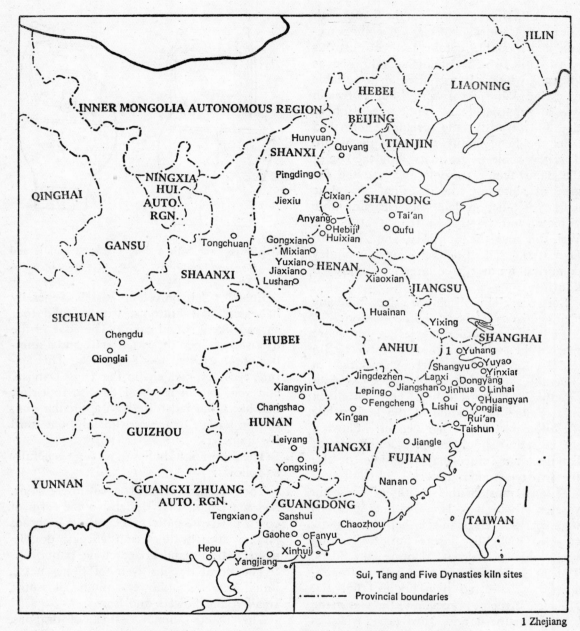

Map labels:

JILIN

HEBEI
LIAONING

INNER MONGOLIA AUTONOMOUS REGION

BEIJING
Hunyuan
Quyang
TIANJIN
SHANXI

QINGHAI
NINGXIA
HUI
AUTO.
RGN.
Pingding
Jiexiu
Cixian
SHANDONG
Tai'an
Anyang
Hebiji
Huixian
Qufu

GANSU
Tongchuan
Gongxian
Mixian
Yuxian
Jiaxian
Lushan
HENAN
Xiaoxian
JIANGSU

SHAANXI

SICHUAN
Huainan

Chengdu
Yixing
SHANGHAI

Qionglai
HUBEI
ANHUI
1 1
Yuhang
Shangyu
Yuyao
Yinxian
Jingdezhen
Lanxi
Dongyang
Xiangyin
Leping
Jiangshan
Jinhua
Linhai
Changsha
Fengcheng
Lishui
Huangyan
Xin'gan
Yongjia
HUNAN
Rui'an
Taishun
GUIZHOU
Leiyang
JIANGXI
Jiangle
FUJIAN
Yongxing
Nanan

YUNNAN
GUANGXI ZHUANG
AUTO. RGN.
GUANGDONG
TAIWAN
Tengxian
Sanshui
Chaozhou
Gaohe
Fanyu
Hepu
Xinhui
Yangjiang

○ Sui, Tang and Five Dynasties kiln sites

–·–·– Provincial boundaries

1 Zhejiang

20. IMPORTANT KILNS OF SUI, TANG AND THE FIVE DYNASTIES

factors in kiln firing are then the kind of flame, changes in wind direction and atmospheric pressure, and humidity. Most important and most difficult was controlling the oven temperature so that it rose according to the craftsmen's needs, and controlling and using the heat to produce a high-quality product. The Sui Dynasty improved

firing technique by managing the flames with fair accuracy during baking. Sui white porcelain had a stable colour tone of lustrous ivory white which connoisseurs praised as "warm" white. It was fired in a suitable oxidizing kiln atmosphere. Sui porcelain was also harder than southern celadon of the Jin Dynasty and celadon unearthed from the Feng family tombs in the north. This was achieved by controlling the rise of the flame temperature to increase the degree of sintering. In addition, the glaze colour of Sui porcelain was cleaner, more vitreous and crystal-like than that of the Wei, Jin and the Southern and Northern Dynasties. It had neither stain nor motley colouring, an asset due largely to improved kiln firing.

Sui porcelain displayed the following characteristics in shape and decoration:

First, jars and other like vessels were more graceful in shape than those of the Wei, Jin and Southern and Northern Dynasties. In general, they had short necks, straight mouths and bulbous bodies. There was a thick ridge round the middle of the body while the lower part was rather slender. Between the neck and shoulders were double sets of handles or a bridge-shaped handle, or else the two types alternately.

Second, most of the mouths of porcelain vases, *zun* wine vessels, ewers and spittoons were dish-shaped or in the shape of shallow cups with slightly flaring lips, fairly long necks and somewhat slanting shoulders. The Sui Dynasty had ewers with a dragon-shaped handle and twin bodies (fig. 21). No such shape of porcelain vessel was made in the Southern and Northern Dynasties or in Tang.

Third, chicken-spouted ewers and other such vessels were fairly slender in shape, the upper part of the body was bulbous and the lower part slender, while the chicken spout had a life-like robust head and stout neck. These vessels featured graceful lines.

21. Twin ewer with a dragon-shaped handle and a chicken-headed ewer of Sui Dynasty.

Fourth, Sui porcelain vessels generally had small flat bottoms, with a solid foot shaped like a round cake. The edge of the foot was scraped off with a knife and a number of vessels had low foot-rims. This feature became prevalent in the Tang Dynasty and was known as the jade disc foot-rim; i.e., like a flat jade disc with a circular concentric orifice of approximately one-third its diameter.

The decorations in Sui times were generally as follows:

The designs included cord impressions, mat markings, wave designs in the form of comb patterns, patterns of strings of beads and of straight lines and checks, double-circle patterns and coiled-cloud patterns.

The floral designs were of honeysuckle, lotus petals, sunflower, plum blossoms, small round flowers and leaves.

There were animal designs of dragons, phoenixes, chicken-head spouts and elephants.

The human figure was also used in embellishing porcelain ware.

Painted designs made their appearance for decorating porcelain in the Sui Dynasty. These were of two types: underglaze human

figures in black paint showing the eyes, eyebrows, hair, folds of costumes and sword sheaths; lotus flowers painted in red, yellow, green, black and white on the bases of porcelain vessels.

The decorations on Sui Dynasty porcelain ware broke with the reserved style of Wei and Jin and the Southern and Northern Dynasties and became varied and lively. This change laid the foundation for the blossoming of ceramic decorative art of Tang times.

Development of Celadon in Tang

The Tang Dynasty, founded in the year 618, was again an epoch of superb power and splendour in China's feudal society after Qin and Han. The Tang rulers adopted a new measure which allowed craftsmen to pay money into the imperial coffers as substitute for conscript labour and to work as hired labourers according to feudal practice. An independent stratum of handicraftsmen thus appeared in society and handicraft workshops in their true sense sprang up. Tang pottery and porcelain flourished.

Areas producing celadon widened and the quality of the product also improved considerably in Tang on the basis of development in the Three Kingdoms Period, the Jin Dynasty, the Southern and Northern Dynasties and Sui. Zhejiang Province, for example, which has the longest history of celadon, produced the ware only in Shangyu, Xiaoshan, Shaoxing, Yuhang and Deqing before the Tang Dynasty. Then, Xiangshan, Yuyao and Ningbo (Jinxian County) in northeastern Zhejiang, and Wenzhou and Jinhua in its southeast were added.

Jingdezhen porcelain excelled in quality. *Annals of Jiangxi Province* states that in the Southern Dynasties (420-589) the last emperor of the Chen Dynasty (557-589) ordered Changnanzhen (the contemporary name of Jingdezhen in today's Jiangxi Province) to make porcelain pillar bases. These failed, however, as they were fired at relatively low temperatures and were not durable. Crafts-

men in the Tang Dynasty did better. *Annals of Fuliang County* has it that during the reign of Emperor Gaozu of Tang a certain Tao Yu of Changnanzhen offered porcelain ware described as "jade-like" as tribute to the emperor. This put Changnanzhen on the map as famous for porcelain. "The Biography of Wei Jian" in *Old History of the Tang Dynasty* says that in A.D. 743 (second year of the Tianbao reign of Emperor Xuanzong), Wei Jian, a Tang official in charge of land and river transport, directed the Chanshui River to the area in front of Wangchun Tower and the water gradually accumulated into a pool which was named Guangyun. The story goes that when Emperor Xuanzong viewed the new pool from the tower, Wei Jian brought in several hundred ships used to transport grain and other goods on the Yangtze and Huaihe rivers. Wei assigned an official to seat himself on the first ship as captain and sing a song of joy after acquiring treasures. A hundred beautiful women in gorgeous costumes were on the ship and joined in the chorus, accompanied by drums, flutes and foreign musical instruments. Sailing past the tower, it was followed by the others loaded with grain and other local products. On each ship was written the name of its home prefecture. Among the local products offered as tribute was the porcelain of Yuzhang (the prefecture where Nanchang is located in Jiangxi Province). These included wine

vessels, tea kettles, vessels for warming tea and tea cups. The fact that Yuzhang Prefecture alone was mentioned in paying tribute to the emperor shows that Jiangxi Province had already distinguished itself for fine porcelain in Tang times.

Since liberation in 1949 archaeologists have discovered many sites of celadon manufacture in the Tang Dynasty. Some place names represented a group of kiln sites. Yue ware took its name from Yuezhou for a cluster of kilns there. Wuzhou ware was named for the porcelain workshops of Wuzhou in the Jinhua area of Zhejiang Province. There were 35 such clusters of kilns, accounting for 56.4 per cent of all Tang kilns so far discovered. But the figures are necessarily inaccurate, as many kilns of the Yue ware group of Yuyao County in Zhejiang Province have been discovered in the Shanglin Lake area, but all count as a single site.

Tang celadon was highly prized at large, and certain porcelain kilns were very influential. These porcelain kilns were named after the *zhou* (prefecture) where they were located, and became famous schools of porcelain manufacture in the Tang Dynasty. Their ware represented their respective areas.

The Tang hermit Lu Yu, who made a hobby of tea drinking, wrote *Canon of Tea* in the 8th century A.D. upon studying the many porcelain vessels he saw from different parts of the country. Besides listing the products of famous celadon areas of Tang times, his work judged the porcelain vessels and pointed out merits and defects of tea-bowls from different areas in terms of suitability for drinking tea. *Canon of Tea* says: "The best tea-bowls are those of the celadon of Yuezhou. Next comes Dingzhou, and then Wuzhou, Yozhou, Shouzhou and Hongzhou." Here we give a brief account of these porcelain wares in the above order:

1. Tang Dynasty Yue Ware Celadon

Lu Yu had reason to praise Yue ware celadon as the best of the time. The Yue ware kilns were within ancient Yuezhou in Zhejiang Province, the central kiln sites being in the vicinity of Shanglin Lake in Yuyao County. There are more than twenty of these sites. Archaeological excavations point to thirteen counties in this area, representing a major school of porcelain manufacture of the Tang Dynasty. Celadon manufacture was already widespread in northeastern Zhejiang Province, an area with a long history of porcelain production. No few porcelain kiln sites of the Spring and Autumn and Warring States periods have been discovered in the Jinhua district of Xiaoshan County. Shangyu and Ningbo invented the "dragon" kilns to fire large batches of porcelain in Eastern Han, while in the Tang Dynasty celadon manufacture reached a high degree of perfection. Lu Yu, who preferred the celadon of Yue above all, described it as "like jade", "like ice", "green like the colour of infused tea". Certainly the Yue ware celadon of Tang was delightfully splendid.

Excavated objects from Tang tombs and kiln sites, plus the literature on celadon of Yue ware, establish its paste as of fine clay. Selected, pounded with a pestle, washed and kneaded, the china clay was fired into a fine, close-knit paste. When well fired, it rang with a clear and melodious metallic sound. Celadon *bo* (straight-lipped bell) and *zhong* (flared bell) were made as musical instruments as early as in the Spring and Autumn and Warring States periods. Yue ware celadon was used also in Tang times to make instruments. Duan Anjie in his book *Random Notes of the Bureau of Music* recorded that Guo Daoyuan, a Tang musician, arranged twelve bowls of Yue ware celadon and Xing ware white porcelain in order, and

after pouring varying volumes of water into each bowl performed on them with amazing effect.

Celadon of Yue ware was refined in shape, while its pale blue-green glaze was translucent and lustrous. A porcelain vase of Yue ware from Li Shuang's tomb dating from the first year of the reign of Zongzhang of the Tang Dynasty (A.D. 668) unearthed at Yangtouzhen in Xian had a grey paste with pure blue glaze that shone like a mirror. Tang celadon vessels of Yue ware excavated at Zunyi Road in Ningbo, Zhejiang Province showed great variety in shape. Celadon of Yue ware was also a tribute item to the reigning imperial court. "Geographical Section" in *New History of the Tang Dynasty* says that porcelain vessels were paid as tribute to the court by the governor's office in Guiji Prefecture of Yuezhou. Wang Renyu's *Anecdotes from the Reigns of Kaiyuan and Tianbao* (A.D. 713-755) recalls celadon wine cups of Yue ware in the court storehouse of Tang Emperor Xuanzong. *Anecdotes* describes them as being paper thin with marks like entangled silk floss so that when wine was poured into them they seemed to emit steam. The term ascribed to them was "self-warming cups".

And Tang Dynasty society gave warm response to the Yue ware celadon, Tang poets composing poems in its praise. Lu Guimeng in the 9th century wrote a poem to describe the "Mi Se" Yue ware. "Mi Se" or "secret colour" was the misty green reserved for the use of the rulers. The poem had the following lines:

> In full autumn wind and dew the kilns of Yue open;
> A thousand peaks are despoiled of their halcyon green.
> Let us fill Yue cups at midnight with wine like nectar from the sky;
> Let us drink with the poet Ji Kang whose capacity vies with his verse.

By late Tang and the Five Dynasties the celadon of Yue ware was produced in large quantities, while production skills were steadily perfected. Xu Yin, a contemporary poet, says in his poem *Secret Colour Porcelain Teacup, a Leftover Tribute Piece*:

> Blend green and blue into a refreshing hue,
> We offer new porcelain as tribute to the throne;
> The cups intriguingly fashioned like the full moon softened by spring water,
> Light as thin ice, setting off green tea,
> Like ancient mirror and dappled moss placed on a table,
> Like dewy budding lotus blooms bidding the lake farewell,
> Green as the fresh brew of Zhongshan's bamboo leaves,
> How can I drink my fill, ill and frail as I am?

The merits of Yue ware celadon led to a number of its kilns coming under government control. The government kilns brought together excellent craftsmen and obtained the best raw materials, and neither effort nor money was spared to turn out superb porcelain, which served the needs mainly of the upper strata in the ruling class.

Apart from many original features in workmanship and shape, celadon of Yue ware was remarkable for its incised decorations. Development over a long period and the contributions of countless ceramic artisans gradually moved this art of incised decoration to a unique artistic style which took a wide range of themes. Among these were Tang Dynasty life, customs and habits, popular flowers such as the lotus (fig. 22), rosette, small flowers, birds (fig. 23), butterflies (fig. 24), landscapes, and episodes in people's lives. The painting was realistic, meticulous, delicate and detailed in style, the carving graphic and the patterns in harmony with the vessel shape.

22. Incised lotus-flower decorations on
Yue ware celadon of Tang Dynasty.

23. Incised decorative designs on Yue
ware celadon of Tang Dynasty.

24. Incised butterfly designs
on Yue ware celadon.

The Tang potters of Yue ware had an eye for both utility and artistic creation.

2. Celadon of Dingzhou Ware

Canon of Tea placed Dingzhou next only to Yue ware, ranking it as also illustrious. Judging by the circumstances of ancient porcelain production in the Dingzhou area of Shaanxi Province, its kilns were likely located at the site of the present-day Huangbao kilns in Tongchuan, Shaanxi, where Yaozhou kilns were set up in the Song Dynasty. The Institute of Archaeology of the Shaanxi Academy of Social Sciences surveyed and excavated at Huangbaozhen, Lidipo, Shangdiancun and at Chenluzhen in Tongchuan in 1959 and found the vessels in the lower cultural layer of Huangbaozhen had plain surface, most coated with black or white glaze, though green or yellow, and occasionally blue glaze was used. An exception was a type of white porcelain cosmetics case with blackish brown patterns. This had neither carved nor impressed decorations. The bowls, plates and ewers were low-stemmed and had flaring mouths and flat bottoms; the ewers had a handle on one side and short spout on the other. In the middle of the bowls were traces of triangular studs which had served as pads in firing. Uncovered from the cultural layer were bronze coins of the reign of Kaiyuan (A.D. 713-741), placing the likely firing time at around early Tang, while found in a slightly later layer were mid-Tang vessels. Among the finds of late Tang were porcelain cosmetics cases, boxes with well-fitting lids, and small porcelain vases and toys shaped like monkeys and horses.

On our investigation and excavation tour of the Huangbao kiln sites in 1976 we found quite a number of white porcelain shards with foot rim shaped like a flat jade disc with small circular concentric orifice. They exhibited obvious Tang Dynasty features in the art of porcelain vessel making. Most of the bowls had been fired one on top of another with triangular studs placed as pads inside each bowl. They had no unglazed white base, and both the opaque glaze and paste were thick. Wu Renjing and Xin Anchao say in *A History of Chinese Pottery and Porcelain* that Dingzhou ranked next to Yue ware and specialized in white porcelain. This in fact is what was found at the Huangbao kilns.

Dingzhou in the Tang Dynasty was an important porcelain producing centre, within the Jingyang, Fuping and Tongguan (present-day Tongchuan) area, where blue, white, and black porcelain was made. Dingzhou at that time produced more ware and of higher quality than Shouzhou or Hongzhou, and Dingzhou ware was highly prized.

3. Celadon of Wuzhou Ware

Wuzhou ware represented another famous school of celadon. The Wuzhou kilns were located in the area of present-day Jinhua County, Zhejiang Province, and porcelain workshop sites have been discovered in a dozen places around Hanzao Commune. There are also kiln sites in the vicinity of Tangxizhen and heard of others in Wuyi and Dongyang counties. Wuzhou ware was manufactured mainly in the area where the hills and plains of Jinhua Prefecture meet.

Jinhua is located in central Zhejiang Province, between Yuyao and Longquan. The products of its porcelain kilns exhibit certain features of both Yue and Longquan ware celadon.

Celadon of Wuzhou kilns was mainly greyish blue, bluish yellow and yellowish brown.

Its better vessels were kingfisher green, light bluish green and grass green, all fairly lustrous. The Wuzhou kilns began producing celadon as early as in Eastern Han and continued up to the Five Dynasties or even Northern Song, though their best period was Tang.

4. Celadon of Yozhou Ware and Changsha Ware

Yozhou ware also represented a school of porcelain ware with a long history. In Tang times Yozhou (in present-day Hunan Province) was a renowned celadon manufacturing centre ranked as fourth by Lu Yu, who said: "The porcelain of Yuezhou, like that of Yozhou, is green. Being green strengthens the colour of the tea." The Hunan Provincial Commission on Cultural Relics discovered the kiln site in 1952. This was at Tieguanzui in Xiangyin County of Hunan Province, where porcelain was manufactured as early as in the Southern Dynasties, while celadon manufacture became prevalent in Tang times. Celadon kilns were fairly widespread and their products abundant. Celadon vessels have been unearthed in considerable numbers from Tang tombs.

Yozhou celadon had a greyish-white paste which was not as close-knit as that of Yuezhou. Its glaze colour was mainly pea green, though some was reddish brown, creamy yellow or purplish blue. The glaze layer was rather thin and highly vitreous with fine-mesh crackles. But not all celadon vessels were of Yuezhou ware celadon quality. Some, of inferior workmanship, had a surface glaze that did not blend well with the body and tended to flake off.

Another Tang Dynasty celadon kiln was the Wazhaping at Tongguan in Changsha in the region of present-day Hunan Province, whose products were mainly various types of ewers to meet the needs of daily life. There were also cups, brushwashers, bowls, dishes, small cups, shallow basins, plates and jars. Wazhaping porcelain kilns broke with the traditional single-colour glaze and the decoration in carving by using underglaze brown and green to produce decoration in several colours. Celadon comprised at least twelve varieties including blue glaze, blue glaze with appliqué and impressed designs, blue glaze with brown mottles, blue glaze with brown mottles and appliqué designs, blue glaze with brown and green patterns or splashes, blue glaze with engraved patterns in brown and green, green glaze, brown glaze with appliqué designs, brown glaze with green splashes, white glaze with green splashes and blue glaze with inscriptions of poems. All this decoration is underglaze. The new varieties greatly influenced the history of Chinese ceramics.

5. Porcelain of the Shouzhou and Xiao Kilns

The Shouzhou kiln was famous in the Tang Dynasty for its yellow porcelain. Lu Yu ranked it fifth in his book, and in fact it had a prominant place in society. A Shouzhou kiln site discovered at Guanjiazui in Huainan, Anhui Province in February 1960 yielded a wealth of porcelain vessels, some dating from the Sui Dynasty. Its porcelain was much finer than the ware of the kilns in Hebei, Henan or Sichuan provinces. There were two-lobed or four-lobed ewers and jars and long-stemmed plates. Incising, impressing and appliqué were used for decoration.

In Tang times porcelain production flourished in this Anhui area, the Majiagang, Shangyaozhen, Quanjiagou and Waiyao kiln sites having been discovered at Shangyaozhen in Huainan. The Sui Dynasty saw the

manufacture of celadon. In Tang, thanks to improved workmanship, potters succeeded in controlling oxidizing flames and fired the yellow-glaze porcelain which became a distinctive Tang variety. The Shouzhou kilns were geographically confined to the Huaihe River valley, which was effectively controlled by the northern political power from the Wei, Jin and Southern and Northern Dynasties. Only a river separated the region from the political power south of the Yangtze. Northern political power and the influence of the northern traditional handicraft art enriched the handicrafts of this region with the special features of the north, as clearly shown in the porcelain vessels of the Shouzhou kilns. The flat-bottomed bowls, short-spouted ewers, head-rests, or pillows and cups from these kilns had pastes coated with a protective white glaze whose quality and the colour of the vessels were close to those of northern porcelain. The glaze of northern celadon was made yellowish by the raw materials and flame control. Rarely had they the delicate green of southern celadon. The northern kilns were round, hemisphere kilns. Shouzhou ware had typically northern features entirely different from those of porcelain ware made south of the Yangtze and belongs therefore to the school of northern porcelain.

Good-sized porcelain kilns have been discovered at Baituzhai in Xiaoxian County, Anhui Province, and identified as the Xiao kilns mentioned in ancient books. Kiln remains were found on the eastern, northern and western sides of Baituzhai. Judging by archaeological survey and trial excavation, porcelain vessels with white, yellow and black glazes were found in a lower layer in two places. Among the finds were bowls with wide foot-rims, vases, jars and ewers, so similar to Shouzhou kiln ware of the Tang Dynasty in Huainan City that they should be classified as of one school.

6. Celadon of Hongzhou Kilns

Until recently scholars knew little about the Tang Dynasty porcelain vessels of the Hongzhou kilns. Some made estimates based on Lu Yu's description in *Canon of Tea* but had no actual objects as evidence until 1978 when archaeologists in Jiangxi Province discovered a group of celadon kiln sites dating from the Six Dynasties (the Wu Kingdom, Eastern Jin and four Southern Dynasties in the 3rd-6th centuries) to the Sui and Tang in the Luohu Production Brigade of Qujiang Commune in Fengcheng County.

These ancient kiln sites are located on rolling red-soil land about one kilometre from the western bank of the Ganjiang River. The porcelain firing area covered over 15,000 square metres, with deposits as high as five to six metres. The period of manufacture (from the Six Dynasties to Sui and Tang) was three centuries long. In Tang times, with the development of feudal economy, the Hongzhou kilns flourished, celadon with light-colour glaze tinged with yellow in blue being the chief product. One type had a bluish green glaze, popularly known as crab-shell green, which had a good lustre. In Tang there were also many porcelain vessels of yellowish brown or dark brown glaze. As described in Lu Yu's *Canon of Tea*, "The porcelain of Hongzhou is brown, and the tea appears black." Fengcheng is undoubtedly the Tang site of the Hongzhou kilns, as the city was administered by Hongzhou in Tang times.

The Hongzhou kilns, however, were not confined to Fengcheng. The site of a large group of porcelain kilns whose ware was the same as that of Fengcheng was found near Fengcheng in Xingan County, also under the administration of Hongzhou in Tang times, so that the two wares really belong to the same school. A porcelain kiln was

built in Linchuan County as well, which was likewise under Hongzhou's administration. The Linchuan kiln was larger than the others and its period of manufacture longer, continuing up to late Tang and the Five Dynasties. Xingan and Linchuan were producing after Fengcheng had stopped, so Lu Yu saw Hongzhou celadon after mid-Tang and ranked it sixth among the famous Tang porcelain wares.

SECTION 3
White Porcelain in the Tang Dynasty

Tang Dynasty white porcelain was greatly improved over that of Sui as attested by the considerable number of white porcelain vessels retrieved from Tang tombs. In addition to being found in economically well-developed regions such as the Central Plains, Guanzhong (present-day central Shaanxi Province) and the Yangtze delta, objects were found in Tang tombs in Sichuan, Guangdong, Fujian and Gansu provinces, and in Xinjiang. White porcelain sites found at archaeological excavations and white porcelain-producing centres recorded in books include Hebei Province — Xing and Quyang kilns; Henan Province — Gongxian, Hebiji, Xiguan, Quhe, Heihudong, Huangbao, Xingyang's Zhaigou and Anyang kilns; Shanxi Province — Hunyuan kiln; Shaanxi Province — Huangbao kiln at Tongchuan and Yuhuagong kiln; Anhui Province — Xiaoxian kiln; Guangdong Province — Xicun kiln; Sichuan Province — Dayi kiln.

In the Tang Dynasty both white porcelain and celadon were manufactured, forming two prevailing schools of porcelain ware. The Tang poet Bai Juyi wrote the following two lines praising white porcelain in the seventh volume of his *Collected Poems of Bai Xiangshan* (pseudonym of Bai Juyi):

We eat rice and celery,
Using white porcelain bowls and green bamboo chopsticks....

Xing ware was the most important white porcelain of Tang. The contemporary Li Zhao wrote in *Supplement to National History*: "The white porcelain cups of Neiqiu and the purple stone inkslabs of Duanxi were used by high and low alike throughout the empire." Other records say that white porcelain of Xing ware which was made in Neiqiu County, Hebei Province was produced in large quantity and distributed over vast areas, being used by both nobles and ordinary people. A large number of white porcelain vessels of Xing ware have been unearthed from Pingliang Prefecture in remote Gansu Province. Many white porcelain shards of Xing ware have also been discovered at the site of the prosperous West Market of Changan (today's Xian) of the Tang Dynasty.

The "Geographical Section" of *New History of the Tang Dynasty* recorded that white porcelain of Xing ware was a local product fit to be presented as tribute to the Tang imperial court. The magnificent Daming Palace of Tang used no few porcelain vessels of Xing ware, as archaeologists found quite a number of white porcelain shards while excavating the Daming Palace site. Some white porcelain vessels dug up from the Tang tombs of the reign of Kaiyuan (713-741) on Xian's western outskirts were inscribed with the characters Han Lin (Academician of the Imperial Academy).

Xingzhou was established as an administrative unit when the Tang Dynasty was founded. The book *Supplement to National History* recorded observations by the author

Li Zhao between the reign of Kaiyuan and that of Zhenyuan (713-804), from which it is learned that white porcelain of Xing ware was widely popular throughout the country. Xing ware was not an innovation at that time but had already undergone considerable development. In the 33rd year of the reign of Guangxu (1907) the tomb of Li Ji of the Tang Dynasty was discovered in Dingzhou (in today's Hebei Province). The date of burial was the fourth lunar month of the second year of the Xianheng reign (A.D. 671). This means that white porcelain of Xing ware was uncovered from this tomb of early Tang. In fact, only Xing ware and no other school of white porcelain was recorded and admired in this period.

In the latter part of the 8th century the manufacture of southern celadon of Yue ware flourished, and its social impact gradually grew. Other porcelain kilns such as the Dingzhou (in present-day Hunan Province) and the Wuzhou were developing apace. The scholar Lu Yu, who evaluated porcelain vessels of various places, preferred celadon of Yue ware to Xing, though he remarked that some persons "perhaps regard Xing ware superior to Yue". Xing and Yue wares are thus seen as more or less on a par.

Tang poets of the 870s and 880s praised both porcelains. During the reign of Emperor Xianzhong, Pi Rixiu wrote these lines in *Ode to Teacups*:

Craftsmen of both Xing and Yue
Show skill in making porcelain vessels,
Round as the moon fallen from the sky,
Light as clouds lifted in the air;
Tea leaves whirl in cups,
Tender, the aroma lingers on the
teeth....

Until as late as 1980 the location of the Tang Dynasty kiln sites remained a mystery to specialists both at home and abroad. In that year ancient Xing kiln remains were discovered at Shuangjing, Qicun and Gang-

tou in Lincheng County, Hebei Province. Lu Yu in *Canon of Tea* uses "silver-like" and "snow-like" to describe the white glaze of Xing ware. These porcelain vessels were made of a fairly white clay with close-knit grains. The glaze was lustrous and mostly white, though some pieces had a light yellow tinge. This ware includes jars, bowls, vases, plates and lamps, all flat-bottomed with curved rim on whose outer edge is a raised line. The paste is quite heavy, the typical vessel a ewer with short spout in the shape of a straight tube. A curved handle joins shoulders to mouth-rim. Some of the smaller ewers have curved handles shaped like an animal with shrugged shoulders and extended forelegs, the animal's head stretching into the vessels' mouth-rim. This design embodies vigour, simplicity and poise.

As white porcelain of Xing gradually declined in late Tang, the ware was seldom mentioned, to be replaced by the southern celadon of Yue ware which was flourishing at that time and whose manufacture spread to northeastern and central Zhejiang Province. In workmanship this Yue ware improved steadily, accounting for its surpassing white porcelain of Xing in social impact. Then another school of white porcelain — Ding ware of Dingzhou (in today's Hebei Province) — arose in the north, became increasingly prestigious and gradually replaced the white porcelain of Xing ware.

The White Porcelain of Ding Ware

The Ding kilns were noted for their white porcelain in the Song Dynasty. Located at Jianci Village and Beizhen town in Quyang County, Hebei Province, they have yielded porcelain shards of Tang Dynasty style, no different from white porcelain vessels found in Tang tombs. In time sequence, Ding ware was later than Xing and became yet

another major school of white porcelain arising in its wake. Ding ware in Tang Dynasty style included bowls, plates, ewers, cups, saucers and lamps, their shapes being equally exquisite and imaginative. Judging by the white porcelain vessels of Ding ware found in Tang tombs in various sites, Ding kiln products found a widespread market. White bowls retrieved from a tomb of the 12th year of the Dazhong reign of Tang (A.D. 858) in Guangzhou in the far south were identical with Ding ware vessels of Tang, showing that at that time the products of the Ding kilns in Hebei Province were so plentiful as to be available at great distances from the production centre.

Kiln Sites in the Henan Area

Henan Province in the Tang Dynasty had several white porcelain kiln sites. The large Gongxian kilns, discovered only after liberation, were located at Xiaohuangye, Tiejianglu and Baihexiang. The vessels included bowls, plates, vases and dishes, the bodies of which were coarser than those of Xing ware white porcelain, the glaze white with a yellowish tint. The bowls and plates were coated with glaze on the inside, while only the upper part of the outside was glazed, the lower part and the foot-rim being unglazed. According to the "Geographical Section" in *New History of the Tang Dynasty*, white porcelain ware was presented as tribute to the imperial court during the reign of Kaiyuan, and the vessels kiln-dried in Gongxian County, Henan, may very well have been among the tribute items.

Xiguan Kilns in Mixian County

Mixian County is another Tang site where white porcelain ware was discovered shortly after the Gongxian County finds. This porcelain centre apparently produced mainly bowls and ewers. Its glazes also included black and yellow, and also blue, though these were rare. The Xiguan kilns improved white porcelain by using for decoration the new method of underglaze incised designs in flowing, detailed patterns executed in forceful strokes. The designs used fine, closely spaced small circles representing pearls to set off and emphasize the patterns. This method partook of contemporary gold, silver and bronze art craftsmanship and so raised incised porcelain-ware decoration to a new level, which beneficially influenced other porcelain workshops. The Dengfeng kilns were the first to benefit; then those of Jiaxian County, Lushan and Baofeng all in Henan Province, and the Xiuwu and Cizhou kilns in Hebei Province. The incised pattern method was used over a wide area and for a long time, coming into vogue for decorating northern white porcelain in the Song Dynasty.

Quhe Kilns in Dengfeng

In style and variety, the porcelain ware from the kilns of the adjoining counties of Dengfeng and Mixian had several features in common. White glazed porcelain vessels were the staple product of both. White-glazed ewers with short spouts and bowls with low foot-rims shaped like a flat jade disc perforated with a circular concentric orifice were practically identical. Apart from white porcelain, the Quhe kilns in Dengfeng made porcelain vessels including ewers and bowls with brownish yellow glaze. The Quhe kilns are another newly discovered site of white porcelain ware in Henan Province, following the excavation of the Xiguan kilns in Mixian County.

Two Kilns in Jiaxian County

This was another site of Tang white porcelain ware, discovered in Henan Province in 1964. One of the kilns was located in present-day Heihudong Commune in Qingyuan County, the other in Huangdao Commune, Huangdao District. The main product of both was white porcelain, a subsidiary product being white glazed porcelain decorated with green splashes, and yellow glazed porcelain. The white with rich dark green splashes from the Jiaxian kilns was a high-quality variety, the best of all such porcelain vessels found in Henan Province.

SECTION 4

Tang Dynasty Black Glazed Porcelain

The Tang Dynasty in its vigorous development of the porcelain craft featured black porcelain in addition to the white, and celadon. Tang black porcelain craftsmanship far surpassed that of the Eastern Jin and Southern and Northern Dynasties. Vessel shapes were regular but simple and unsophisticated. The vessels themselves were durable and had heavy, substantial bodies. The glaze was evenly coated and the black colour had the sheen of lacquer. Black glazed porcelain decorated with yellow, greyish blue and brownish green splashes was also discovered at the Jiaxian kilns, the Duandian kilns in Lushan and the Xiabaiyu kilns in Yuxian County. The splashes were natural and unrestrained, some resembling coloured clouds or tree leaves. Some were painted on the shoulders of the vessels, some all over, while others were grouped in attractive designs, the glaze and splashes blending in a harmonious whole. This decoration marked a striking new achievement in Tang ceramic manufacture. Concerning the type of porcelain waist drum decorated with coloured splashes unearthed at Duandian in Lushan, Henan Province, the important mid-9th century book on music *Notes on the Deerskin Drum* says: "If not made of Qingzhou stoneware, the drum-rim was certainly of Lushan's coloured porcelain." Many exquisite coloured porcelain objects were retrieved from Tang tombs in Zhengzhou, Biyang, Jiaxian and Yuxian counties in Henan Province, and in Xian, Shaanxi Province.

Black porcelain shards excavated from Tang porcelain kiln strata at Huangbaozhen in Tongchuan, Shaanxi Province exhibit a black glaze of superior quality. Some vessels were decorated with various flower designs painted with liquid black glaze — a decorative method of distinctive artistic style that contributed to making Tang black glaze porcelain the best of its time.

SECTION 5

The Superb Tri-Colour Pottery of Tang

The well-modelled, lustrous tri-colour glazed pottery figurines and utensils of daily use produced in the Tang Dynasty are art treasures to be seen in museums throughout the world. The works of nameless artisans, these exquisite art objects provide insight into

the skill and intelligence of toilers on the lower rungs of Tang society. Like Tang Dynasty poetry, prose, calligraphy and painting, Tang tri-colour pottery took definite place in the sphere of Chinese national art and literature.

At what point of time during the three centuries of Tang rule did tri-colour glazed pottery appear? Scholars concerned with this question have not yet arrived at a definite answer, though judging by the maturity of ceramic production and development of glazed pottery art, the tri-colour logically arose very early.

Concentrations of tri-colour glazed pottery figurines and utensils of daily use have been unearthed near Xian in Shaanxi Province and in Luoyang, Henan Province, including objects from the tombs of members of the royal family, nobles and high-ranking officials of the feudal ruling clique. Bowls, plates and groups of figurines were found in Princess Yongtai's tomb, while likenesses of musicians and dancers on camel back, architectural ensembles, jars, water basins and cabinets have been unearthed in Zhongbaozi Village, Tumen, Sanqiao, Zaoyuan and Hanshenzhai in Xian, Shaanxi Province. The earliest tri-colour pottery objects discovered were made during the Shenlong reign (705-707) of the Tang Dynasty Emperor Zhongzong. But these vessels found in the tombs showed mature workmanship and so were obviously not early specimens.

Yellow and green glazed pottery figures decorated with painted designs numbering 466 were excavated from the tomb of Zheng Rentai, listed in 1972 as a satellite tomb of that of Emperor Taizong. Zheng Rentai was buried in the first year of the reign of Lingde (A.D. 664). A blue glazed pottery jar was retrieved which demonstrated a glaze-making art similar to that of the later tri-colour, though less mature and of one colour. The pottery figures had only yellow and green glazes but were finely made. The glaze surface was adorned with several colours, adding the art of painting to sculpture though the painted designs were applied to the glaze surface and not produced by mixing mineral substances into the glaze ingredients. The colours were less attractive than those which appeared after firing and fusing with liquid glaze. This latter method resulted in the prized polychrome glazed pottery which superseded pottery adorned with painted designs on the glaze surface.

Many tri-colour glazed pottery vessels and shards were found in a satellite tomb of that of Emperor Gaozu (Li Yuan), founder of the Tang Dynasty, the satellite tomb being discovered in 1972 in Lücun Production Brigade of Lücun Commune, Fuping County, and excavated in September 1973. The tomb occupant was Prince of Guozhuang (Li Feng), 15th son of Emperor Gaozu. The prince died in A.D. 674 and was buried with his wife (née Liu) after her death in A.D. 675 (the second year of the Shangyuan reign of Emperor Gaozong).

Among unearthed funerary objects was a tri-colour glazed double-centred plate. The inside and rims were decorated with splashes of green, blue and yellow glazes in key-fret patterns, and the bottom had four stems shaped like horse hooves. There were also two rectangular pottery couch models and the shards of about a dozen tri-colour pottery vessels. The date of this tomb fixes the Tang Dynasty as the era when tri-colour pottery appeared.

Large numbers of good-quality tri-colour pottery vessels and figures appeared in the late 7th century and the mid-8th, i.e., from the reign of Empress Wu Zetian to that of Emperor Xuanzong. Most were manufactured during this period, except for the products of Xian and Luoyang.

Kiln sites of tri-colour glazed pottery so far discovered have been in Gongxian County, Henan Province, three being at Xiaohuangye, Tiejianglu Village and Baihexiang. Xiao-

huangye was the main tri-colour workshop, where vessels of blue glaze were also made. Next came Baihexiang which manufactured mainly white porcelain and pottery of yellow or green glaze. Shards scattered on the ground at Tiejianglu Village included fragments of high-quality tri-colour glazed pottery vessels.

The Henan Provincial Commission on Cultural Relics has re-examined and probed the kiln sites in Gongxian County many times in recent years, learning that the county produced tri-colour glazed pottery vessels of great variety for a fairly long time. Among the pottery-making tools found were many stamps for impressing designs.

Were there tri-colour glazed pottery kiln sites in other areas? Surveys in Dengfeng, Mixian and Lushan counties indicate that these kiln sites began making porcelain in Tang but that the craft reached its peak in these counties in Song. Deposits of porcelain shards were found in the Song cultural layer, superimposed on tha of Tang, the exposed Song cultural layer containing many fine tri-colour objects.

Tang tri-colour served the luxurious living of that dynasty's feudal ruling class and its pompous burials. The figurines were generally inspired by superstition, the number of funerary objects being stipulated according to the official rank of the dead. Tang tri-colour glazed pottery was important among burial accessaries. In fact, finds from tomb excavations of nobles and high-ranking officials indicate that the number of funerary objects including Tang tri-colour glazed pottery far exceeded the government stipulations.

While the figurines were intended to serve the dead, Tang tri-colour glazed pottery vessels served both as funerary objects and the living. Close-knit in structure and fired at a temperature of 900°C., these vessels were almost as hard as today's pottery. Its glazed surface was non-porous. Tang tri-colour has been unearthed from palace and flourishing market sites of the dynasty, such as the West and East Markets in Changan (Xian), and from ancient monastery sites in Japan, confirming that these objects were used for funerary, daily life and ornamental purposes.

Tri-colour glazed pottery kiln-site excavations in Gongxian County tell us that the objects were made in porcelain kilns, studies of which indicate that their products were of remarkable workmanship in the following respects:

1. The tri-colour pottery vessels were made of kaolin, or china clay. Though some had a slightly red tinge, many were fine, smooth and spotlessly white. Tri-colour pottery figurines and vessels were generally sculpted or moulded, and were easily distorted after shaping. Some vessels were miniature, as for example the 2.7 cm-high tri-colour glazed pottery plate recovered from Princess Yongtai's tomb. In contrast is the pottery figure of Lokapala (Deva King) retrieved from a Tang tomb in Taian, Gansu Province which is 162 cm high. Firing would have been difficult to control in turning out such a large piece. Tang Dynasty tri-colour glazed pottery objects uniformly show a craftsmanship that gave them regular and accurate shapes. How was such perfection attained? In the first place, the raw material was carefully selected kaolin, which the potters thoroughly washed to rid it of minerals or organic impurities. Then a good job of kneading and leavening made the paste pure white and increased the mechanical strength of the object when dried. Ceramic workmanship required kaolin with few impurities for kneading and moulding large or fine objects, to ensure their stability. Tang tri-colour, with its rich variety of shapes and complicated structure, attained a craftsmanship that was remarkable in ancient ceramic art.

2. Exquisite workmanship was required in shaping tri-colour pottery vessels. The clay was processed on a wheel, the vessel directed accurately at its centre and rotated very evenly so that the grains in the clay were well arranged in the direction of the motion of the potter's fingers in operating the wheel. The vessels varied in thickness with their size. In designing, the potters fully considered the possibilities of distortion in semi-finished vessels, so that they would not become distorted during firing.

3. The potters possibly used baked kaolin or unglazed biscuit in manufacturing tri-colour pottery so as to make the vessels stable, neither contracting nor distorting in the kiln after glazing. Even temperature had to be maintained, ensuring uniform contraction and expansion, obviating distortion in tri-colour and also ensuring uniformity of colour.

4. The glaze of tri-colour pottery was bright and lustrous. Its main ingredient was lead silicate, the principle of its manufacture the same as that used for lead glass today. The potters found little difficulty in preparing white, light yellow, brownish yellow, bright green, dark green, sky blue, brownish red and aubergine purple — one, two, three, or more colours as desired. Craftsmen already understood the principle of using various metal oxides as pigments, brownish red and brownish yellow from iron, bright yellow from iron or antimony, various greens from copper or chromium, and purple from manganese. Aluminium was used as flux to enhance the lustre of colours. The glaze and body of tri-colour pottery united well, so that the glaze seldom peeled.

5. The heads of human figures were generally unglazed to enhance texture, with white powder applied to the face and lips painted vermilion, while the pupils of the eyes, eyebrows, moustaches, beards, buns and caps were blackened with ink. Boots were mostly unglazed too, with black ink applied to indicate leather.

6. Tri-colour glazed pottery was decorated with appliquéd, engraved or impressed rosettes, lotus flowers and leaves, pearls, cloud patterns, and animal and human figures. Great use of metals produced varying unpredictable colour effects by melting and infiltrating the glaze. Dotting and linear drawing techniques were used to form patterns like those on silks and satins made by the tie-and-dye method. Mottled patterns in a riot of colour depicted the muscles and feathers of animals and birds. Other crafts of the time were often no match for tri-colour pottery in beauty and magnificence. Tang tri-colour craftsmanship reached a peak in Chinese ceramic art in feudal society and is in fact rare in world arts and crafts history.

Tang tri-colour pottery included vessels for water and wine — *zun* wine cups, ewers, vases and jars. In drinking and dining vessels there were bowls, plates and small water jars and cups. Cosmetics or ointment boxes, spittoons, incense burners and headrests (pillows) were available for the bed chamber. Models were fashioned of houses, storerooms, mortars and pestles, rockeries and cabinets. Human figures included Lokapalas (Deva Kings), warriors, officials, aristocrat ladies, young women, boys, attendants, beauties in masculine attire, horses and camels with their respective grooms, both of a northern minority nationality; musicians and dancers, riders and hunters or drummers on horseback. Among animal figures were horses, camels, donkeys, oxen, lions, tigers, sheep, dogs, chickens, ducks and rabbits.

Tang tri-colour glazed pottery articles were turned out for use in all aspects of life. The tri-colour potters of Tang used the fine modelling and decorative art not only in various pottery and porcelain articles; they also copied bronzes, lacquer and

rattan ware and daily-use vessels for China's various nationalities and for other lands, bringing together many wonders in their tri-colour pottery.

The figurines were superbly sculpted, the potters drawing vivid images from Tang Dynasty life. They skilfully moulded the soft clay from inside to outside, depicting details and bringing to life many types of images. In 1955 a blue glazed pottery donkey was recovered from a Tang tomb in Xiaotumen Village in Xian. Its open belly allowed one to see how it had been moulded layer by layer. A tri-colour glazed pottery horse, dominantly brownish yellow, found in Xianyi Tinghui's tomb, still showed traces of engraved details. Tang tri-colour glazed pottery blended sculptural and painting art, bringing out the strong points of the latter. Some pottery figures are dressed in well-fitting garments with many fine folds in the style of Cao Zhongda, a painter of Northern Qi (550-577). Others are depicted in flowing robes with sashes flying in the wind in the fluent style of the Tang painter Wu Daozi. These figures capture both the mood and appearance of their subjects, as Guo Ruoxu remarks in his book *Information About Painting*: "Sculptures and statues also originate from the style of Cao and Wu." Subjects were carefully chosen and themes elaborated so that various artistic images express specific feelings and characteristics.

A pottery camel with a troupe of musicians and a dancer on its back, 58.4 cm high, excavated from Xianyu Tinghui's tomb succeeded artistically in presenting a new theme. The camel, head thrown back, stands pertly on robust legs on its rectangular pedestal. A lustrous cream glaze covers its entire body, with superimposed brown glaze applied around its neck and woolly upper forelegs. Black stripes are painted on its face, the eyes made prominent with black pigment and the colour of pearls at the corners. The camel's two humps are covered with an oval blanket with a blue hem, the blanket engraved with rhomboid patterns and coated with yellow, white and green glazes. A wooden frame rests on the blanket, and another long blanket with green tassels hangs down on both sides. This is bordered in yellow with a string of white dots painted on. The blanket is adorned with parallel stripes in white, blue, light green, light yellow and brownish yellow.

On the camel's back are four musicians, sitting two on each side of the wooden framework, while a figure dances in the centre. A northern minority national has a *pipa* (balloon guitar) in his left hand; his right is clenched in a fist. The *pipa* is loquat-shaped and fashioned in the Persian style of curved neck with four strings. The poet Bai Juyi's *The Guitar Song* has the following two lines:

At the song's end, from the guitar she drew out the central stop:
The four strings made one sound, as of rending silk. . . .

This pottery sculpture presents a true scene from Tang Dynasty social life. The musician of Han nationality at rear left wears a green robe with round collar. He blows a bamboo flute. The musician at right front wears a pale yellow robe, long and also with round collar. Another musician of a northern minority nationality at the right rear and clad in a brownish yellow robe with a turndown collar is beating a drum. This carving breathes of jubilance and shows China's different nationalities performing together in harmony.

Aristocrat ladies are depicted in green blouses with narrow sleeves and low round neck. Their yellow skirts reach the ground. *New History of the Tang Dynasty* describes noble ladies of the time as follows: "In the early years of the reign of Tianbao, Imperial

Consort Yang often wore an artificial bun and was fond of yellow skirts."

A poet worte:

A lady's high coiled switch is let down into the river,
Her yellow skirt follows the current.

Some servant figures have their hands in front of them as though holding objects. Their heads incline slightly to observe their master' every mood, or they stand with heads bowed and eyes down in subservience.

A warrior shooting an arrow on horseback excavated in 1972 from the tomb of Heir Apparent Yi De of the Tang Dynasty, is especially lively, its glazes unconventional. A dappled horse throws back its head, eyes staring in their sockets, mouth agape as it gallops. In the saddle of this sturdy mount sits a turbaned warrior clad in a round-collared long flowing robe with narrow sleeves. A sash at his waist holds a long sword on one side and an arrow quiver on the other. His feet firmly in the stirrups, he bends forward as he aims the arrow in his bow. The warrior looks brave, his steed vigorous.

The superb skills of nameless Tang artists are demonstrated in these images. They possessed a keenness in sculptural art that enabled them to grasp the crucial moment in an act that portrayed the complete character. Animal figurines appealingly complement the characters.

The sculptors of animal images in tricolour has studied well the morphology and special features of their subjects. The simple, vigorous and lively art style made even depictions of such mundane and awkward animals as camels, oxen and donkeys appear agile, because their creators captured typical episodes, movements and expressions.

Horses were the prime subject among animals sculptures, no doubt because horses occupied a prominent position in Tang Dynasty life. No scene, whether at frontier defence outposts, on the battlefront, or on emperors' and nobles' spring excursions, was complete without horses, as commerce, transport and production by all nationalities in China required them.

Emperor Xuanzong was especially fond of horse and ordered painters to depict his favourites from among the fine equine specimens offered from Dayuan (Farghana) and other faraway places as tribute to the imperial court, and also the horses of the Central Plains. Xuanzong's imperial stables kept 400,000 horses. *Miscellaneous Episodes of Emperor Minghuang* tells of horses dancing in the palace: "Emperor Xuanzong ordered a hundred horses trained to dance. The animals were arranged in two groups on either side and were trained by persons whose pride they became. Fine horses presented by minority peoples beyond Tang frontiers, also as tribute, were assigned by the emperor to imperial departments teaching singing and dancing. The horses acquired marvellous skills, and the emperor had them draped in silks and embroideries, their manes adorned with gold and silver, pearls and jade. Accompanying music was titled *Drink to the Full and Be Merry*. All of this accounted for the horse image being depicted so frequently and superbly in Tang tri-colour glazed pottery.

Tang horses feature a small head, long neck, plump, robust body and bright piercing eyes. The artists captured the horses' high spirit in unconventional ways, whether in throwing back their heads or rearing up. Inner strength was depicted in outward appearance.

These tri-colour glazed pottery horses have diverse stamped, carved and applied ornaments on their bodies. The glaze that was brushed over the clay washed downwards during firing, resulting in layered shades. Still, the glaze is natural and lustrous and complements the effect of the sculpture.

Tang tri-colour glazed pottery has been highly valued by artists and art admirers the world over. Like the celadon and white porcelain of Tang, its tri-colour has been unearthed in Korea, Japan, India, Egypt, Iraq, Iran, Pakistan and Indonesia.

Pottery and Porcelain in the Five Dynasties and Ten Kingdoms Period

The Five Dynasties and Ten Kingdoms period (A.D. 907-979) was still one of Chinese feudal society. The Tang empire reached its peak of power after nearly three centuries of development, gradually declined and finally collapsed. These seventy years were a time of social unrest; war devastated the land for several decades; social production suffered. In late Tang, local viceroys expanded their power and swelled their armies, appointed their own officials and refused to pay taxes to the central government. Proclaiming themselves emperors or kings, they passed their titles on to their sons or lieutenants and so carved the Tang domain into independent regimes.

Later Liang, Later Tang, Later Jin, Later Han and Later Zhou, successive dynasties in north China for 53 years, became known in history as the Five Dynasties. In south China and in Shanxi Province, ten warlords also set themselves up in power in what came to be known as the Ten Kingdoms.

These independent regimes were however economically interdependent, and the exchange of goods between north and south continued even in times of war. The economic ties of this time far surpassed those of the Three Kingdoms and Southern and Northern Dynasties period.

The south suffered less from war than the north during the Five Dynasties and Ten Kingdoms, its economy improved and many northerners were attracted south, providing labour power and their abundant experience in production. The north also gradually recovered. Luoyang, where in A.D. 887 "corpses were everywhere in wilderness overgrown with brambles, the place having less than one hundred households", forty years later, in Later Liang and Later Tang, "had nearly every available *mu* planted to mulberry trees or hemp plants". In Later Zhou, the northern economy recovered more rapidly.

Trade with other countries expanded. Fuzhou and Quanzhou in the Kingdom of Min became major ports for foreign trade in the Five Dynasties and Ten Kingdoms period. Guangzhou expanded its foreign trade more in Southern Han than in Tang, and merchant ships thronged the Qiantang River during the Kingdom of Wuyue. Goods from China's north and south converged on the Yongjiang and Yuyao rivers in Mingzhou (Ningbo) for shipment to Korea and Japan. More porcelain vessels from the Five Dynasties and Ten Kingdoms have been found in Asian, Arab and African countries than from the Tang Dynasty.

Economic recovery and development with accompanying urban prosperity brought about more frequent exchanges of handicraft products and skills. Expansion of foreign trade spurred ceramic production in the Five Dynasties and Ten Kingdoms period till it surpassed that of Sui and Tang, and ceramic production centres in the various parts of the country formed a unified network.

The making of Yue ware celadon began in northeastern and central Zhejiang Province where, besides the central Yue ware kiln in Shanglinhu in Yuyao County, this celadon was made in large amounts at Dongqianhu and Xiaobaishi in Yinxian County, at Xiangtang in Dongyang County, Wuzhutang in Jinhua County, Tantou in Yongjia, and at the Western Hill kiln in Wenzhou. Yue ware celadon was in its heyday.

Decoration was elaborate but in good taste, and rich in themes. Many were incised designs, mostly floral, though in richness and variety, again they excelled Tang decor. Besides flowers, there were hundreds of designs of birds, butterflies, cranes, parrots, dragons in clouds or sea, flying phoenixes, and episodes from stories (figs. 25-28). The Five Dynasties was a period of excellence in incised designs in Yue ware celadon.

Beginning from late Tang, a number of kilns of Yue ware were controlled by the government, and these manufactured only high-quality porcelain in "secret colour", a term for the misty green fine Yue ware used exclusively by the rulers. Then, in the Kingdom of Wuyue, the ruling Qians began exporting the ware to balance the royal budget. They also offered celadon as tribute to the more powerful regimes of Later Tang, Later Jin, Later Zhou, Liao and Song. The purpose of this tribute, which sometimes amounted to hundreds of thousands of pieces on one occasion, was to gain the protection

25. Plate with incised parrot and scrolls pattern of Yue ware of the Five Dynasties.

26. Dragon decorations on Yue ware celadon in the Five Dynasties.

27. Pictures retelling famous anecdotes are incised on Yue ware of the Five Dynasties.

28. Pictures of famous anecdotes are incised also on Yue ware celadon in the Five Dynasties and Northern Song.

of such powerful governments for their independent regimes.

Yangmeiting and Shihuwan in Jingdezhen, Jiangxi Province were producing high-quality white porcelain during the Five Dynasties and Ten Kingdoms period, as attested by archaeological discoveries in these places.

Celadon kilns at various sites in Sichuan Province continued producing in the Five Dynasties. Apart from the green-glaze porcelain vessels from the famed Qionglai kiln, there were also green-glaze with brown or brownish green splashes as well as with simple designs painted in brownish green. The works as a whole reveal the Qionglai potters' skill at assimilating the workmanship of other porcelain schools to enrich their creations with fresh innovations from old styles.

The Five Dynasties and the Ten Kingdoms was a time of great development in northern porcelain, several famous schools of Northern Song arising in this period. The white porcelain vessels of the Ding kiln in Quyang County, Hebei Province, founded late in Tang attained fairly high quality in a comparatively short time.

Archaeological excavations have revealed a Ding kiln site in the Five Dynasties stratum at Cicun Village in Quyang, Hebei Province, containing white porcelain bowls, basins, plates, lamps, head-rests or pillows, jars, vases and small water jars. The bodies of the vessels were very thin and regular in shape, showing exquisite craftsmanship. The paste had fine, compact and hard grains, the glaze was yellowish white and lustrous and adhered firmly to the surface. There were lotus petal-shaped bowls and plates the shape of water-chestnut blossoms. Potters obviously borrowed from the shapes of gold and silver objects for their porcelain-making.

The achievements during the Five Dynasties and Ten Kingdoms prepared for the rapid development of porcelain manufacture as witnessed in the Song Dynasty.

CHAPTER 5
The Art of Porcelain in the Song and Yuan Dynasties

SECTION 1
Ceramic Production Reaches a New Level in Song

The Imperial Guards of Later Zhou, last of the Five Dynasties, under the command of General Zhao Kuangyin, in 960 mutinied near Kaifeng in Henan Province. General Zhao seized power, proclaimed himself emperor, founded the Song Dynasty and continued the unification of the country on the basis of his regime's steady development. His younger brother, Emperor Taizong named Zhao Guangyi, in 979 led troops to Taiyuan where he destroyed the political power of Northern Han, ending the disintegration that had been going on throughout the country, a partition which lasted from the independent regimes of viceroys after mid-Tang to the Five Dynasties and Ten Kingdoms period.

The Song government instituted the system of hiring craftsmen, abolishing the old system of using unpaid labourers in turn for the government workshops. Control over the personal liberty of artisans and technicians slackened somewhat, which facilitated the development of ceramic production and that of various related trades and professions.

Professional and influential handicraft workshops and even towns cropped up, cities prospered in Song times and tea drinking and tea-tasting contests became popular, filtering down from the upper strata of the ruling class. The demand for pottery and porcelain vessels and utensils for tea drinking greatly increased, spurring porcelain production.

Coal mining was a well-developed technique in the Song Dynasty, and all Song porcelain kilns in the north were located in coal-producing areas. Coal has the advantages of rapid ignition and a high, lasting temperature, properties that allowed the clay, glaze and pigments to fully react chemically and resulted in better quality.

Song merchants traded porcelain vessels on a larger scale than merchants of the Sui, Tang and the Five Dynasties. Stone monuments were erected near quite a number of Song porcelain kilns, some of these by porcelain merchants. Inscriptions on the monuments recorded the activities of merchants who engaged exclusively in transporting porcelain to distant regions for sale and were

known as "porcelain merchants". To advertise their wares, certain workshops stamped their porcelain vessels with exclusive inscriptions in the nature of a trade mark. Vessels of the school of Cizhou ware were often inscribed as "Made by the Zhang family", "Made by the Zhang family in Guxiang", "Made by the Chen family in Guxiang" and "Made by the Shen family" or "Xiang Zheng" and "Gao He" of the school of Longquan ware.

In the Song Dynasty porcelain manufacture spread over vast areas in different parts of the country. Various schools of porcelain ware, each with a distinctive style, appeared in different places, depending on the characteristics of the raw materials and fuels, traditions of workmanship and people's customs and habits in the areas making and selling the porcelain (fig. 29). · Song, with a much wider range of porcelain varieties than Tang, boasted of its porcelain schools which were fairly stable and had prominent features. There were celadon, white porcelain, black porcelain, Yingqing ("misty blue"), white porcelain with black designs, copper-red glaze, ever-changing crystalline glaze and furnace transmutation of the various porcelain schools. Chinese porcelain art indeed reached its zenith.

Famous Schools of Song Dynasty Porcelain

1. The School of Ding Ware

Ding kilns were among famous porcelain kiln sites in ancient northern China and among the five renowned kilns in China's porcelain history. Ding ware was mainly white porcelain, its central kiln site located in Jianci Village in Quyang County, Hebei Province. Products of the same type were well-known and influential in the Zhanghe and Fenhe river valleys in the north, in present-day Hebei and Shanxi provinces. These formed a major school mainly producing white porcelain.

Artistic features and craftsmanship of Ding porcelain ware: Scientific excavations at Ding kiln sites show the central kiln at Jianci Village to have covered an area of 1.17 million square metres, manufacturing mainly white porcelain. It also made porcelain vessels of green, black and dark brown glazes. Some porcelain vessels were inscribed with the names of Song government institutions such as "Provisions Bureau",

"Medicine Bureau" and "Mansion of the Fifth Prince". A considerable number of vessels were decorated with dragon and phoenix patterns. But the strict social rank system of feudal society barred their use to ordinary citizens, and even officials and nobles. The dragon and phoenix were symbols of emperor and empress — the supreme rulers — and only they were qualified to use such vessels, the manufacture of which was exclusively for the imperial court. Yet studies show that the kilns produced many vessels for the common people, among which were no few highly artistic objects.

Ding ware was of excellent quality, being made of fine, durable, pure white clay. The body was soft and thin and the vessels were regular in shape and evenly glazed, the glaze containing titanium oxide. Firing turned the white glaze slightly yellow, resulting in a subdued ivory-white ware.

The Ding kilns used the new technique of stacking porcelain vessels during firing to increase output, again facilitating porcelain

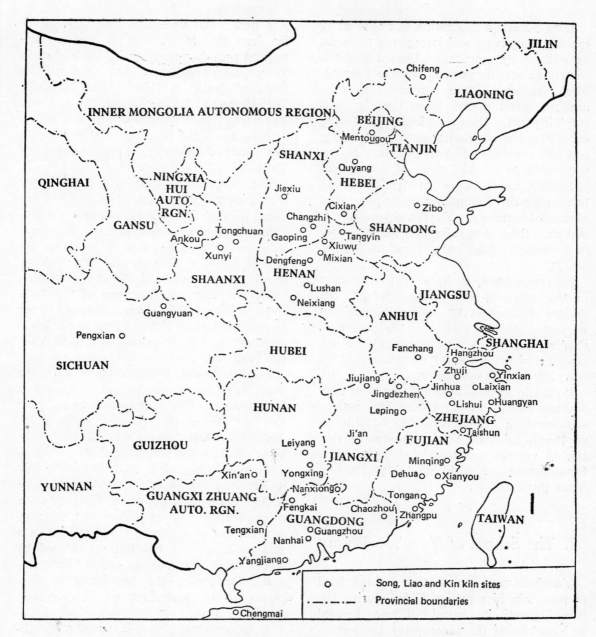

29. IMPORTANT KILNS OF THE SONG, LIAO AND KIN DYNASTIES

production. As the vessel mouth-rims could not be glazed lest they stuck to the pads between the vessels and became rejects, Ding mouth-rims were generally unglazed and rough, as described in books of the time. But the royal family, high-ranking officials and nobles were unwilling to use such vessels, so potters smoothed the mouth-rims with gold, silver or copper rings, making Ding white porcelain even more costly.

Ding porcelain decoration was applied by incising, engraving and impressing patterns, as well as by moulding. Incised patterns were often used for vessels of the early period. Tools shaped like fine bamboo slips were used to incise curves when the clay was still fairly soft. Ding ware had the following decorative characteristics: prominent theme, concise, vigorous strokes and various designs such as plucked twigs of flowers, interlocking flowers, wave patterns, swimming fish, or a pair of mandarin ducks as symbol of marital harmony. The flowers are vividly depicted, the waves swirl, and the fish jump in the water; all are natural and lively (figs. 30-32).

Impressed designs were fairly prevalent on the vessels of late Northern Song. The designs were engraved on the moulds and impressed on the vessels in the course of shaping them. They were meticulously arranged and often similar to the designs on currently famous silk fabrics.

Porcelain vessels of Ding ware were popular and widely valued for their high artistic achievement. Different places vied with one another in imitating Ding techniques, giving rise to several sub-schools of Ding ware. Manufacture continued up to the Jin and Yuan dynasties.

2. The School of Yaozhou Ware

Yaozhou ware was another major school of porcelain in northern China during the Song Dynasty, its central kiln being located in Yaozhou at the present-day Huangbaozhen in Tongchuan, Shaanxi Province. The Institute of Archaeology of the Shaanxi Academy of Social Sciences made an investigation and excavation at Huangbaozhen, Lidipo, Shangdiancun and Chenluzhen in March 1959, retrieving remains and relics of porcelain manufacture in the Tang, Song,

Kin and Yuan dynasties. Exhaustive studies show that Huangbaozhen was an important porcelain-making site established in Tang. Its development continued till the reign of Jingkang (1126-27) in Northern Song, from which time it gradually declined. The Yuan Dynasty still saw the manufacture of Yaozhou ware, however, and its site was likely that of the famous Dingzhou ware of Tang.

The porcelain school of Yaozhou ware spread over a wide area, extending east beyond Shaanxi Province to influence the Ruzhou celadon school in Henan Province, while in the west it spread to Xunyi on the border between Shaanxi and Gansu provinces. The Xunyi kiln, discovered in May 1977, produced celadon ware of the Yaozhou school. The characteristics of the celadon of the Qin kiln in Tianshui of Gansu Province mark it as belonging also to Yaozhou celadon.

Records credit Yaozhou ware with the same social status as the Hebei, Tang and Deng wares. The celebrated Song poet Lu You said in the second volume of his *Notes in an Old Scholar's Studio* that Yaozhou celadon was similar to "Mi Se" ("secret colour") porcelain of the Yuezhou kiln in Zhejiang Province. It was durable and widely used by the populace. *Qing Yi Lu*, a work dealing with miscellaneous subjects, admires the concise and simple shape of a shallow bowl with flat bottom devised by Yaozhou potters. It was called "little seagull", illustrating the popularity of porcelain vessels manufactured in Yaozhou kilns.

In its early stage, Yaozhou ware of Northern Song had rather coarse body and glaze and the vessels were mainly trumpet-shaped bowls. Teapots with a handle and short spout were externally decorated with some roughly incised lotus petals and peonies. Few had impressed designs. In the middle period most porcelain vessels had thin bodies

30. Impressed and carved decorations on Ding ware porcelain of Northern Song.

31. Dragon decoration on white porcelain plate of Ding ware of Northern Song.

tended for five kilometres. People often called it the "ten-*li* kiln site". According to archaeologists' measurements the kiln furnaces were generally 3.36 to 4 metres high and 2.16 metres long by 3.36 metres wide. Judging by the capacity of the saggers, some 2,590 bowls, plates and other items could be fired at one time — no mean size for a northern porcelain kiln. A "Monument in Memory of Marquis Deying" erected in the seventh year of the reign of Yuanfeng (1084) at Huangbaozhen remarks: "The inhabit-

and were evenly glazed. Fired at high temperatures, they were durable. There was greater variety in shapes — bowls, plates, dishes, jars, saucers, boxes, censers, *zun* wine cups and lamps. One type of decoration consisted of bold, attractive motifs of flowers, human figures and animals engraved in incisive strokes. Impressed designs were also very popular, and those covering the entire vessel inside and out were exquisite. Designs included flowers and grasses, fish, ducks, dragons, phoenixes, ocean waves and floating clouds. The patterns of interlocking blossoms and plucked sprays of flowers were widely used, the best being peonies, chrysanthemums and lotus flowers.

The vessels with still thinner bodies of the later period were prettier than those of the middle period. The designs were impressed, mostly at the bottom inside the bowls and plates; the finer ones depicted the phoenix gently touching peonies or a flock of cranes and children at play. The decorative art of Yaozhou ware was very influential in the development of Song arts and crafts (figs. 33-35).

Yaozhou kilns produced on a large scale. The kiln site of Huangbaozhen alone ex-

32. Incised designs on Ding ware.
Upper: Twin ducks.
Lower: Lotus flowers.

33. Impressed and carved design of plucked sprays of peony at the base of the inner wall of green glazed bowl of Yaozhou ware.

ants made profits and earned their living from ceramic vessels," pointing to porcelain manufacture as widely practised in the locality. "Geography Section" in *History of the Song Dynasty* states in an item on Shaanxi: "Chongning has 102,667 households.... It presents porcelain ware as tribute to the imperial court."

Unearthed from a Yaozhou kiln site were porcelain vessels decorated with dragon and phoenix motifs, showing mixed production of the simple, coarse vessels used by ordinary people, and a number of exquisite porcelain objects for the royal family.

"Article on Industry and Commerce" in *Annals of Tongguan County* (Volume 12): "Huangbaozhen.... It is a pity that as a result of war disasters in the Kin and Yuan dynasties all the town's potteries were burned down. The art of its porcelain making was lost.... With the oblivion of the art of Huangbaozhen, the towns of Lidi, Shangdian and Chenlu arose. Now Lidi and Shangdian no longer make porcelain. Only Chenlu does." These data indicate the Yaozhou kilns' gradual decline in Kin and

Yuan, and the removal of the porcelain-making centre elsewhere.

3. Porcelain Schools of the Linru and Ru Kilns

The Linru kiln located in Linru County, Henan Province represented another major celadon school arising in northern China in the Song Dynasty. Manufacturing porcelain mainly for household use, its production areas were widespread: at Dayudian, Donggou, Yegou and Huangyao in Northeast Township, at Yanhedian in South Township, at Daying in Baofeng, at Qinglongsi and Yiyang, all in Linru County. Linru celadon was rather crude and heavy, its liquid glaze fairly thick and greener and brighter than the celadon of Yaozhou.

Most of its vessel shapes and decorations were influenced by the techniques of Ding ware on the east and by Yaozhou ware on the west. Linru ware was decorated mainly with impressed designs, though some were carved. Its craftsmanship and decoration took mostly from Yaozhou ware, but the designs do not stand out so clearly. Most vessels were plates, bowls and vases. Curio dealers called Linru celadon northern Li-shui ware.

Ru kiln refers to a government kiln in Linru County catering for the Northern Song rulers, its products being known as Ru ware porcelain. *Notes in an Old Scholar's Studio* by Lu You, the famous Song poet, records the emergence of Ru ware: The Northern Song rulers, considering the white porcelain vessels of Dingzhou unsuitable for use because of their rough mouth-rims, sent personnel to establish porcelain kilns in Ruzhou to manufacture celadon. In the eyes of the people of Song the celadon

34. Carved and impressed designs on Yaozhou ware of Song Dynasty.
1. Plucked spray of peony. 2. Twining sprays of peony.
3. Twining sprays of chrysanthemum.

of Ru ware ranked first in quality among all northern celadons.

The Ru kilns supported the vessels with studs during firing so that their mouth-rims and even their foot-rims were entirely covered with a layer of smooth vitreous glaze. The studs were no larger than sesame flowers and hardly noticeable. Ru ware porcelain had a thick lustrous green glaze with a sapphire-like blue tinge. The vessels had fine crackles over the entire surface. Potters are said to have mixed agate powder into the glaze ingredients in making porcelain vessels for the exclusive use of the imperial court. The feudal rulers did not count the cost of their luxuries. In making celadon at the Ru kilns the amount of iron in the raw materials and the reduction flame were carefully controlled, demonstrating maturity in Chinese celadon manufacture.

4. Porcelain School of Guan Ware

The school of Guan ware consisted of several porcelain kilns run by the Song imperial court in Bianliang (present-day Kaifeng) and in Hangzhou. The earliest record of the Northern Song government's establishing porcelain kilns in Kaifeng appeared as follows in *Random Notes While Basking in the Sun* by Gu Wenjian of the

35. Porcelain decorations on Yaozhou ware of Song and Kin dynasties.
1. Phoenix sporting with peony. 2. Twin cranes. 3. Moths.
4. Chrysanthemum. 5. Cranes and antiques.
6. Twining sprays of peony.

Song Dynasty: "In the reigns of Zhenghe [1111-18] and Xuanhe [1119-25], potteries were set up in the capital to manufacture porcelain. They were called Guan [government] kilns." Their output was exclusively for court use. The actual kiln site has not been discovered, due perhaps to geographical changes in the vicinity of Kaifeng where the sediment deposited by the overflowing and shifting Yellow River buried the civilizations of the Tang, Song and following dynasties several metres underground. However, quite a number of vessels of Guan ware were preserved by the imperial courts of different dynasties, the Qing expecially taking great care to collect such vessels. Emperor Qianlong, who prized Guan ware, wrote poems in its praise and had the bottoms of Guan porcelain vessels inscribed.

The porcelain of Guan ware used china clay with a fairly high iron content, the paste showing the colour of iron black. The rather thick glaze applied gave it the lustrous, bright finish of fine greenish white jade. Its colour was paler than the celadon of Ru ware. As the glaze was fired at high temperature, it melted and streamed down the vessels, leaving the glaze on the mouth-rims thinner so the paste colour showed through. And, as the mouth-rims were separated by the vitreous glaze, the colour had a purplish tinge. The foot-rim was unglazed with the iron-coloured paste fully exposed, showing its special feature of "purple mouth-rim and iron foot" — important in identifying Guan porcelain. Another characteristic of the ware is criss-cross, fairly large crackles like overlapping ice cracks.

After the collapse of Northern Song, Emperor Gaozong of Southern Song moved his capital to Linan (present-day Hangzhou) where the royal family continued its life of luxury and dissipation. Carrying on the system of the former capital, the rulers established two government potteries in Hang-

zhou, which people called the Guan kilns of Southern Song. One was located at Xiuneisi (an office for the maintenance of imperial buildings, including imperial kilns), its product called the Guan ware of Xiuneisi. The other kiln was at Jiaotan, on the capital's outskirts. The Jiaotan kiln site was discovered at the foot of Tortoise Hill in Hangzhou.

Random Notes While Basking in the Sun describes the Guan ware of Southern Song as follows: "Potters wash the clay and make moulds out of it. The glaze colour is lustrous and transparent. The vessels are treasured by people all over the country." The porcelain vessels of Guan ware of Southern Song have often been discovered in the tombs of nobles and high-ranking officials in Nanjing and elsewhere. Although their quality is inferior to those of Guan ware of Northern Song, they are still excellent celadon specimens.

5. Porcelain School of Longquan Ware and Ge Ware

The porcelain of Longquan ware represented a great school of southern celadon arising in the Song Dynasty. It was manufactured in fairly vast areas in southwestern Zhejiang Province. The sites of former celadon kilns and workshops are found throughout the counties of Lishui, Suichang, Yunhe, Qingtian and Longquan on the upper Oujiang River. There were also many kiln sites in Songxi and Pucheng in northern Fujian Province.

Since Longquan County had been under the administration of Chuzhou, some records referred to Longquan kilns as Chuzhou kilns, and Longquan celadon as Chu ware. The region was rich in materials for porcelain manufacture: good quality porcelain clay and purple gold earth con-

taining metal ore for preparing glaze ingredients, inexhaustible pine firewood and plenty of water from the many rivers.

Despite mountain barriers the Oujiang River was navigable throughout the year, crossing Lishui and Qingtian to Wenzhou and Yongjia to reach the sea. Longquan celadon made rapid progress in the Song Dynasty due to its close contacts with commercial cities and towns, and to foreign trade. It had a good market in different parts of China and dozens of other countries and regions.

Archaeological workers investigating Longquan celadon producing areas discovered the sites of 150-plus porcelain kilns and workshops. The centre of ancient Longquan porcelain was around Dayao in Liutian township, where the workers made scientific excavations at selected spots. In Song, the "dragon" kilns, 50 to 80 metres long, yielded close to 10,000 bowls and other vessels at one firing.

Liutian township reportedly had 72 kilns in full-time operation, indicating a flourishing of the Liutian porcelain trade. Unearthed were simple and crude rectangular workshops, large and small brick-covered grounds for washing raw materials, many hard stone pestles and iron implements for pulverizing china stone as well as rectangular earthen ovens. Remains of potters' huts were found in the living quarters, cramped and miserable housing for the craftsmen who fashioned this exquisite porcelain.

The finds at the excavations show that celadon manufacture started on a small scale in Northern Song. The vessel shapes and glaze colours at this initial stage show this celadon to follow the tradition of the Yue ware celadon in Tang and the Five Dynasties. After developing in late Tang, celadon production of Yue ware in northeastern Zhejiang Province reached its pinnacle in the period of the Five Dynasties and Ten Kingdoms, then gradually declined after Northern Song. Longquan celadon, however, developed in Northern Song after stimulation in the Five Dynasties and Ten Kingdoms. Northern Song was the early period of Longquan celadon, representative works being double-handled ewers with covers, ewers with multiple spouts, vases with prunus blossoms, and bowls, all bearing stamps indicating their manufacture in 1080. Longquan celadon excelled after Southern Song.

Longquan ware was also known as Di (younger brother) ware. It was said that two brothers, the elder named Zhang Sheng the First, and the younger Zhang Sheng the Second, were skilled at porcelain making, and their wares won great fame among the people. *Annals of Chuzhou Prefecture* states: "Zhang Sheng the Second directed Liutian kiln. We do not know when he lived. All vessels from Zhang Sheng the Second's kiln were remarkably blue and transparent, without blemish and like fine jade. A single vase or bowl often cost more than ten taels of silver." Of Chinese southern celadon, Southern Song Longquan ware boasted the best craftsmanship. Bluegreen glaze was of many varieties, the best being kingfisher green, powder blue and plum green. The paste was white with a blue tinge, fine, compact and durable. The main vessel shapes were bowls, plates, shallow basins, vases, jars and alms bowls.

Ge kiln was reportedly in Longquan County, but so far no site has been discovered. According to *Annals of Chuzhou Prefecture* the vessels made by Zhang Sheng the First were called Ge ware, known from the many specimens handed down. These vessels were light in colour, powder blue, pale white or the yellow of parched rice. They had not the kingfisher green of the glaze of Di ware. The glaze of Ge ware was crackled, large and small crackles interspersed, the large crackles jet black and the small ones brownish yellow. "Golden

wires and iron threads" was the popular description.

Crackles appeared because the ingredients of the paste and the glaze had different compositions and so expanded to different degrees during firing and cooling. Accidental at first, the crackles were later intended, as it was thought they gave the vessels a touch of classic elegance. And so this original blemish became a special feature of Ge ware, succeeding generations vying in its imitation. Potters consciously arranged the grains of the ingredients in a given direction to produce crystals which resulted in crackles of varying sizes on the vessels' surface.

Ge ware paste was iron black, the objects mainly censers, vases and bowls.

6. Porcelain School of Jun Ware

Jun ware was a famous school of porcelain manufacture arising in the Song Dynasty. Its central kiln site was in Yuxian County, Henan Province. The best porcelain vessels were unearthed from the Bagua Cave kiln site, also the largest in scale. Kiln sites were fairly dense in the vicinity of Shenhou, while various places in Yuxian County produced numerous ceramic products. Porcelain kiln sites have been discovered in Jiaxian, Dengfeng, Xinan, Tangyin and Anyang in Henan Province, while Cixian County in Hebei Province was another pottery and porcelain area.

Yuxian County which belonged to Yingchang Prefecture in the Song Dynasty was renamed Junzhou in the 24th year of the Dading reign (1184) in the Kin Dynasty, the Kin rule possibly being responsible for the renaming. Some workers place Jun ware as a Kin Dynasty product, though archaeological data place its initial manufac-

ture in the Tang Dynasty. Sites of multicolour glaze porcelain manufacture have in fact been discovered at Duandian in Lushan, Huangdao in Jiaxian County, and Shenhou and Xianbaiyu in Yuxian County. This glaze appears creamy white or purplish red, and looks like fleecy, rosy clouds or tree leaves. The coloured glaze and splashes of Song Dynasty Jun ware are identical to this in craftsmanship and artistic styles. The obvious continuity between this multicolour of Tang and Jun ware would seem to establish Tang ware as the forerunner of Jun.

Sites of large-scale porcelain kilns were excavated at Bagua Cave in Yuxian County. The unearthed products and bronze coins inscribed with the reigns of emperors have shown that after the long development from the Five Dynasties to Northern Song, Jun ware reached a production peak in late Northern Song, when excellent quality ware was produced, though this quality was maintained for but a relatively short period. Northern Song was then conquered by the Kin Dynasty, under whose protracted rule the manufacture of Jun ware continued in and around Henan. Wars became less frequent after the Dading reign in Kin and society was fairly stable so that the economy recovered to some degree from the ravages of war. This development included Jun ware, its production expanding up until the Yuan Dynasty.

Jun ware was outstanding for its firing of copper-red glaze, which contained large amounts of copper oxides. Fired with reduction flame, the copper in the glaze became colloid particles at high temperatures, and iridescent red furnace-transmutation colour appeared on the glaze surface. The main feature of Jun ware was a body of sky-blue or moon-white interspersed with rose purple. With a thick lustrous glaze and ritualistic in shape, it is a gem in Song art porcelain history.

In late Northern Song, Emperor Huizong spared no efforts in ordering convoys of ships to transport flowers, shrubs and rocks to the Eastern Capital (today's Kaifeng in Henan Province) to add to the pleasures of his luxurious life. To adorn his imperial court, he sent officials to obtain exotic flowers and plants and rare rocks from the south by force or cunning. He ordered Jun and other kilns to make flower pots and other porcelain vessels for the imperial court, and complete sets of these in varying sizes and shapes, with serial numbers inscribed on the bottom, have been unearthed at the Bagua Cave kiln site in Yuxian County.

7. Porcelain School of Cizhou Ware

Cizhou porcelain was a type of ordinary household ware manufactured in the region of Cizhou during the Song Dynasty. The central kiln located at Guantaizhen in Handan, Hebei Province was then under the administration of Cizhou, which gave the ware its name. Archaeological investigations locate the Cizhou kilns over a large area — far beyond the confines of Cizhou in Song times. Production flourished most in southern Hebei Province and northern and central Henan Province, including Handan, Pengcheng, Cixian, Yuxian, Xiuwu, Hebiji, Lushan, Baofeng, Dengfeng, Mixian and Tangyin on the Central Plains. Shanxi, Shaanxi and Shandong provinces also produced this porcelain ware.

Cizhou porcelain came in many glaze colours: white, black, yellow, brown, green, and also a blended glaze.

Cizhou's most outstanding achievement was applying the traditional Chinese art of painting on porcelain, the painted decoration on white glaze being mostly black or brown, or black on green or yellow glaze.

There were also incised, engraved, carved and embossed designs on white glaze, all showing proficient skills.

Cizhou motifs were fish, aquatic weeds, flowers, birds, galloping deer, frolicking rabbits, acrobats, legends, poems and essays. A head-rest portrays a boy fishing. On the white glaze surface is drawn in black glaze a vast expanse of river, with the little boy on the bank. The concise, vigorous strokes demonstrate the rich, vivid effect of Song ink paintings.

Another example is a white glazed jar with carved designs, combining grandeur and grace. The paste surface was coated with a white protective glaze, the jar body painted all over with entwining peony sprays. Excluding the designs, the white protective glaze was removed from the ground to expose the greyish brown paste. After finishing the product, potters covered the whole piece with a light vitreous glaze, the designs showing in relief. The flowers were pure white and vivid and the ground was brown, presenting a strong contrast in colour tone. The style of painting was bold and unrestrained, striving to capture the theme. A few strokes brought the motif to life. A covered jar of white glaze with black designs (fig. 36) and a white glazed head-rest with a lion in black show strong colour contrast and original composition. These masterpieces exemplify the historical decorative art of Cizhou ware.

8. Porcelain School of "Misty Blue"

Misty blue porcelain is generally known as the school of Yingqing, its glaze being between blue and white. Compared with Song white porcelain its glaze appeared more bluish green and it had a better lustre, but it was whiter than celadon and its glaze was much thinner. Its paste was thin, fine

36. White glazed porcelain of Cizhou ware with black designs
(chrysanthemum and twining sprays of peony).

and close-textured and vessel shapes were graceful. Misty blue porcelain formed a distinctive school founded in Jingdezhen, Jiangxi Province. Its transparency reached 1.19 per cent (counting the paste as 1.5 millimetres thick) and its whiteness 76.8 per cent — the best of all contemporary porcelain schools. In Jingdezhen the misty blue porcelain was made mainly in Hutian and Xianghu. Scores of the potteries have been discovered elsewhere in Jiangxi and in certain places in east and south China. Relatively famous were Jiangshan and Antai in Zhejiang Province, Tengxian County in Guangxi, Fanchang in Anhui Province, Jian in Jiangxi Province, Dehua and Jinjiang in Fujian Province and Guangzhou in Guangdong Province. But Jingdezhen in Jiangxi Province may be regarded as producing the best and artistically the most representative of misty blue porcelain. Its period of production is also the longest, from Northern Song to the Yuan Dynasty. Objects have been unearthed from tombs and kiln sites over vast areas south of the Yangtze River, on the Central Plains, in Inner Mongolia, and in northwestern, north and northeastern China.

According to *Annals of Fuliang County*, Jingdezhen before the reign of Jingde (1004-07) was called Changnanzhen, a town south of the Changjiang River well-known for porcelain. The "Trade Section" in *Administrative Statutes of the Song Dynasty* records that during the reign of Chunhua (990-994) the emperor's storehouse contained porcelain wares of Mingzhou, Raozhou, Dingzhou and Qingzhou for court use. Jiang Qi of the Yuan Dynasty says in *A Brief Account of Ceramics* that the porcelain vessels of Jingdezhen in Song were "pure, white and without blemish. So when sold elsewhere, they were known as 'jade-like'".

Most kiln sites of misty blue porcelain in Song were located in the valleys of the East and South rivers. Exceptions were Jingdezhen city and Ziyunyan (Purple Cloud Crag). The kilns were centralized in the

feldspar-producing hilly area in the South River valley. The typical early Song kiln sites comprised the potteries of Xianghu, Huangnitou and Stone Tiger Bend. Mid-Song sites were at Hutian, South Market Street, Liu Family Bend and Xiaowu, Hutian continuing through late Song sites along with Jingdezhen.

Early products had a rather thick, off-white paste and relatively coarse grains. The misty-blue glaze had a rather heavy grey or pale yellow tone. Most of the vessel shapes were bowls, cups and ewers, the bowls and cups having fairly high foot-rims. The ewers were shaped like melons, a popular style from the Five Dynasties, while none of the vessels were decorated. Bowls and cups were generally placed separately in saggars for firing, with thick pads inside the foot-rims to protect the bottom of the vessel. Most vessels were undecorated, and there was little variety in types. The feature of Yingqing (misty blue) was not yet distinct, yet it excelled average Song celadon and its ordinary household porcelain.

Yingqing glaze porcelain became typical of the mid-Song period, when bowls and plates were produced in large quantity and the variety of vessel shapes increased. Flower vases, censers, porcelain head-rests and such art porcelains as sculptures appeared over the years. Household porcelain took on regular and graceful shapes and the paste became thinner. Large vessels with engraved or carved designs including plum blossom vases and warming vessels were products of this period. Potters engraved or carved the designs with superb skill, or they combined the two techniques in concise strokes and fluent lines. The highly artistic motifs included wave, aquatic weeds, peony, lotus flower, swimming fish and flying phoenix.

In mid-Northern Song the method of stacking one vessel on top of another in firing was used, one vessel being placed on a support ring which fitted closely with the next. This method of stacking in the kiln enabled output to be multiplied. But glaze could not be used on the mouth-rims, as it acted as glue, sticking the vessels to the kiln equipment. The mouths of most bowls, plates, basins, small cups and other vessels were therefore rough. And so potters coated the mouth-rims with gold or silver to satisfy the aesthetic taste of the upper ruling class. The products of this period were indeed exquisite.

Hutian and Xianghu were the best among the different kiln sites for workmanship in manufacturing misty blue porcelain. The paste was fine and close-knit and the vessels, with very thin walls and regular shape, reached the standard of modern porcelain in transparency and hardness. The bright glaze showed a lustrous sheen. They had subdued colour shades and concise decorative designs in quiet and unconventional taste. In craftsmanship, misty blue porcelain fully represents the porcelain artistry of Song.

9. School of Black Porcelain Represented by the Jian and Jizhou Kilns

Song Dynasty black porcelain was fairly widespread, being manufactured in most parts of the country. The following wares were among the best:

Jian ware: Also known as Wuni (black earth) ware, it was first produced at Shuijizhen in Jianou County, Fujian Province and later in Jianyang and other places. The black porcelain of Jian ware had a purplish black paste and thick lustrous black glaze. A silver sheen showing through the black glaze looked like rabbit's hair, partridge feathers, or oil mottles.

Small "rabbit-hair" cups were the most popular items of Jian ware. These rabbit-hair cups of Jian ware were preferred for the tea-tasting contests prevalent in Song times.

The black porcelain of Jian ware enjoyed great popularity abroad as well. In the 16th year of the Jiading reign of Southern Song (1223) Kato Shiro and Saemon Kagemasa of Yamashiro, Japan, came with the monk Dogen specially to Fujian to learn the art of manufacturing black porcelain and set up black porcelain factories in Owari and Seto upon their return, initiating Japan's pottery and porcelain craft.

The Jizhou porcelain kilns located at Yonghezhen in today's Jian, Jiangxi Province, flourished in Song. Records show that in the reign of Jingde (1004-07) the government established an office in charge of the town's porcelain production and that several thousand households engaged in its production.

Jizhou ware was mainly of two varieties: white glazed porcelain with black designs and black glazed porcelain. The Jizhou kilns excelled in crystallizing ferrous oxide for the latter, controlling the changes of the silicic acid in the glaze, the firing temperature and cooling time. Jizhou kilns made a good glaze resembling the mottled, brown and yellow pattern of a tortoise shell by spraying glaze outside in large splashes, while the ground colour inside was fairly fine and thin.

The black glazed porcelain with oil mottles and feathery splashes of Henan Province, and with iron-rust patterns of Shanxi Province was also of good quality, again demonstrating the proficiency and porcelain craftsmanship of the Song Dynasty.

SECTION 3
Innovations in Yuan Dynasty Porcelain

New data concerning the quality of Yuan Dynasty porcelain that have come to light, followed by exhaustive study, have gradually corrected a faulty view that Yuan ceramics were poorly made and of inferior quality.

The Yuan Dynasty was established by Kublai Khan, who in 1279 conquered Southern Song after succeeding his elder brother Mangu, the Mongolian Great Khan, on the elder brother's death. Nationality and class contradictions were extraordinarily sharp throughout Yuan times, popular uprisings against the rule occurring continually. But many wars waged by Mongolian nobles involved trends backward, and folk handicraft trade which flourished in Tang and Song was undermined and craftsmen suffered. Handicraft products including ceramics declined in quality and quantity. Song porcelain schools in the north such as the Jun, Cizhou and Linru went downhill one after another, and kilns that continued producing were scattered and reduced in size and output. Ding and Linru wares were all but forgotten.

An important historical fact cannot, however, be ignored. The Yuan Dynasty founded by Kublai Khan did unify China and restore it somewhat to its Tang proportions, promoting China's development as a unified, multi-national country. Kublai, a Mongolian, pursued a policy of "emulating the Han people in all aspects of life". He offered amnesty to Hans who had gone into exile and encouraged all to reclaim land, in some measure promoting social-economic

recovery and development. Areas south of the Yangtze River suffered comparatively less war damage than the north, and the social-economic structure there essentially followed that of the Hans, changing little from Southern Song. In some respects production surpassed the Song due to the industriousness of the various nationalities in the south.

Many Yuan porcelain shards were discovered underground in buildings near the rear gate of Beijing's Palace Museum in 1974. They represented 200-plus vessels including Longquan celadon, blue-and-white and Jun porcelain, but misty blue porcelain was in largest quantity. As the buildings originally housed emperors, empresses and imperial concubines in the Yuan palace, the discovery pin-pointed the types of porcelain used by the Yuan royal family. The misty blue porcelain from Jingdezhen in Jiangxi Province had a paste that was fine, close-textured and well fired. Its blue-tinged white glaze was lustrous and transparent.

On excavating a Yuan site on Beijing's old Drum Tower Street, workers found comparatively large amounts of misty blue porcelain, though this ware was mainly found in southern provinces. Misty blue was the only porcelain unearthed from tombs of the first and tenth years of the Dade reign (1297 and 1306) in Beipei and other places near Chongqing by the Chongqing Museum of Sichuan Province from 1952 to 1954. Hoards of misty blue porcelain vessels were found in Deyang, Sichuan Province and Hanzhong, Shaanxi Province, indicating the quantity and market of Yuan misty blue porcelain.

Yuan misty blue glaze was admittedly not so pure, white or translucent as that of Song porcelain. Chemical analysis shows Yuan blue-and-white porcelain to have a higher aluminium oxide content than that of Song, increasing from 16.41 per cent in mid-Song to 19.86 per cent in Yuan. Yuan glaze was the bluer, having an iron oxide content of 2.33 per cent as compared with 0.99 per cent in Song. The glaze, applied somewhat unevenly, appeared dot-like or allowed the paste to show through at the foot-rim or around it.

Yuan misty blue porcelain featured porcelain statues. One of these of a seated Guanyin (Goddess of Mercy), 67 centimetres high, excavated from Dadu (today's Beijing), capital of Yuan, shows the superb sculptural skill of Yuan craftsmen, the potters making full use of the transparency and subdued quality of misty blue porcelain to enhance the figure.

Porcelain vessels for daily use had thicker, more substantial and unsophisticated biscuits. Potters focused attention on the effect of curves for vessel walls. The decorative designs were sparse and simple, assimilating the patterns and ornamental effect of Yuan brocades, such as patterns of coiled clouds, lotus petals and stringed beads. Yuan misty blue porcelain objects with ornamental bands of underglaze red were among the exhibits of cultural relics from several provinces in the Palace Museum in 1978. Song porcelain had not achieved these ornamental red bands.

Misty blue porcelain production in the Yuan Dynasty expanded over larger areas than in Song times. Apart from Jingdezhen there were kilns in Jizhou and Leping in Jiangxi, Zhenghe, Minqing, Dehua, Wanyaoxiang in Quanzhou and Dingqi in Tongan, Fujian Province, Xinan Third Village in Huiyang and Wanyaojing in Zhongshan, Guangdong Province and in Jiangshan and Antai, Zhejiang Province. Utility was the keynote of misty blue porcelain produced in these areas, with plates, bowls, ewers and small water jars of pleasing shape and impressed with simple, concise designs. Many such objects were retrieved from Yuan tombs in southern China, and even discovered outside China in countries of Southeast Asia.

The Longquan celadon of Zhejiang Province did not decline in the Yuan Dynasty. On the contrary, expanding markets increased its production to several times that of Song. Archaeologists discovered 200-plus kiln sites on the banks of the Oujiang River and the upper Songxi River (fig. 37), showing marked progress in shaping and firing the ware to a degree of excellence. Vases were almost a metre high, while plates had a diameter of two-thirds of a metre. Regular in shape, the glaze surface was also smooth and unblemished. Incising, impressing, appliquéing, embossing, engraving and painting were common techniques in decoration.

Jingdezhen in Jiangxi assumed increasing importance in China's porcelain production. Building on Song porcelain technique, potters evolved new and rare varieties of blue-and-white porcelain, underglaze red porcelain, red-glazed, blue-glazed, and blue-glazed painted with gold.

Yuan porcelain vessel shapes showed grandeur and vigour and painted designs surpassed those of Song. Incised, engraved and impressed decorative designs continued, as did sculptures. Potters chose scrolls, banana leaves, chrysanthemums, lotus flowers, sunflowers, waves and flowing streams as border designs for porcelain vessels, the patterns forming pictures as beautiful as silks, satins and brocades. Most motifs were peony, banana, melon, fruit, fish and water weeds, dragon or phoenix in clouds, pairs of mandarin ducks in a lotus pond, occasional sprays of lotus flowers, flying birds, ancient pines, green bamboos, stories about people and mythological legends. Such a rich variety of painted designs was unprecedented and opened vast prospects for the art of painting on Ming porcelain.

Concerning blue-and-white porcelain and underglaze red porcelain of the Yuan Dynasty, blue decorative designs painted under the glaze of white porcelain produced the decorative blue-and-white porcelain. After finishing the clay shapes and partially drying them, potters used cobalt oxide as the main colouring agent in pigment for painting designs, which they drew on the wares following models, and covered them with white glaze. The raw wares were then kiln-fired at high temperatures. Blue-and-white porcelain was reportedly introduced in Tang or Song; however, among archaeological finds recovered are many objects of blue-and-white porcelain made in the Yuan Dynasty. But Yuan blue-and-white porcelain certainly underwent a process of emergence and development to attain its high artistry. Cobalt, in the form of oxide for colouring, is generally found close to copper deposits, and in a certain sense cobalt is an associated product of copper.

Chinese potters very early used copper as colouring agent for decorative designs on porcelain. The Changsha kiln and the Gongxian County kiln for making tri-coloured pottery, both of Tang, and the Jun kiln of Song used copper extensively in porcelain-making. It was entirely possible that the Tang and Song dynasties used cobalt ore as colouring agent. Judging by the existing objects, the shards of blue-and-white porcelain unearthed from the sites of Tang handicraft workshops in Yangzhou had blue designs. And Hong Kong is among sites that have yielded white-glazed porcelain with blue splashes, both facts indicating that blue-and-white porcelain was made in Tang, though the question requires further investigation.

A connoisseur's appraisal of Yuan blue-and-white porcelain is that it had pure, white paste and bright blue designs, deep crystalline splashes often accenting blue flowers. This splendid Yuan ware provides specimens of Chinese art porcelain.

Copper red glaze and underglaze red porcelain of the Yuan Dynasty carried on the tradition of Jun ware. The red glazed porcelain of Jingdezhen was already showing

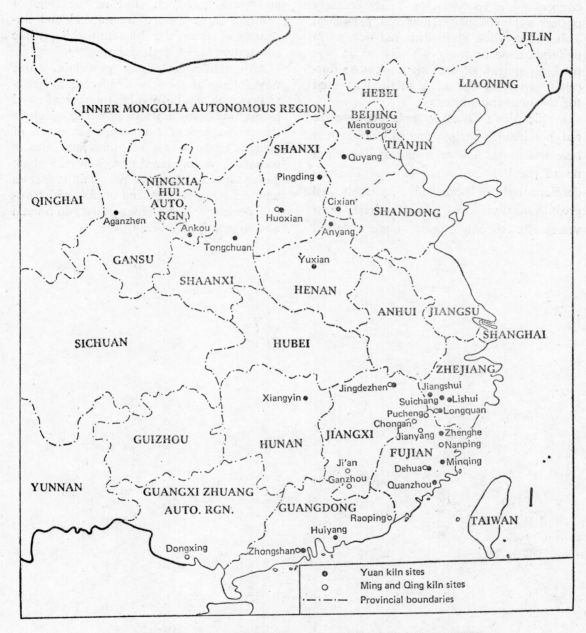

Yuan kiln sites ⊗
Ming and Qing kiln sites ○
Provincial boundaries -·-·-

37. IMPORTANT KILNS OF THE YUAN, MING AND QING DYNASTIES

distinctive features. The red glaze was evenly applied over the entire body. Using copper red as decoration, Yuan Dynasty potters achieved underglaze red porcelain. This had a white glaze with red designs in underglaze decoration. Copper oxide was used in pigment for drawing designs on porcelain, applying the same method as used for the blue-and-white.

In the Yuan Dynasty, fewer underglaze red porcelain vessels were produced than blue-and-white, and craftsmanship was not up to the blue-and-white either. The underglaze red on porcelain vessels showed great variation. Insufficiently fired, most vessels showed only a faintly discernible red tinge; bright red was rare. Decorative motifs were practically the same as for blue-and-white porcelain. But in the style of painting some were more natural and unrestrained than the blue-and-white, while some were quiet and elegant.

Although other Yuan porcelain wares were inferior to those of Jingdezhen in Jiangxi Province, a considerable number of good pieces have come down to us. These include the production of Jun ware over much of Henan, Cizhou ware of Hebei and Henan provinces, white glazed porcelain with black designs and black glazed porcelain in Henan and Shanxi provinces, and objects with iron-rust designs and tri-colour pottery in Shanxi and Gansu provinces.

CHAPTER 6
Pottery and Porcelain of the Liao and Kin Dynasties

Like the Han, China's many other nationalities have contributed significantly to the country's ceramic development. Liao and Kin, political powers established by minority peoples, dominated the northern half of China for a very long time, and the Liao and Kin northern pottery and porcelain were a part of Chinese ceramics. Let us make a general survey.

Variety and artistic style of Liao and Kin ceramics indicate the richness of Chinese pottery and porcelain between the 10th and 13th centuries. Ceramic workmanship has been deeply rooted in the life of China's various nationalities. Influenced by the porcelain art of the Hans, ceramic art of various minority nationalities matured, but each in its own style. Studies of Liao and Kin pottery and porcelain help in understanding the economy, culture, customs, habits and history of various nationalities in northeast China, and also show the close ties between these peoples and the Han nationality on the Central Plains.

SECTION 1
A Look at Liao Porcelain

The Khitans were a nomadic people who lived in the upper reaches of the Liaohe River (in today's Zhaowuda League in Inner Mongolia). In 916 Yelü Abaoji, chief of the league of tribes, proclaimed himself emperor, modelling after the dynasties of the Han. He founded a slave state, and the Khitan society advanced rapidly. His son Yelü Deguang ascended the throne and established the Liao Dynasty (916-1125). In 936 he marched southwards with a powerful force and conquered Later Tang. He had annexed to his territory sixteen strategically important prefectures in Hebei and northern Shanxi provinces.

After Zhao Kuangyin founded the Northern Song Dynasty, Liao was his greatest menace to the north. Pressed by Liao's armed forces, Zhao's Northern Song government could only compromise. Armed strife between Song and Liao relaxed for a time after the reign of Emperor Zhenzong (998-1003) and there was trade and cultural exchange between them. Pottery and porcelain trade flourished in Hebei, Henan and Shanxi provinces in north China. Itinerant craftsmen who entered the land of the Khitans carried their ceramic art with them, promoting the development of Liao porce-

lain and giving it prominence in the history of Chinese porcelain art.

Knowledge of Liao porcelain came mainly from pieces retrieved from the large tombs of Liao nobles and from Liao porcelain kiln sites. Five of the latter are so far known to have existed in the three provinces of northeast China and in Inner Mongolia, namely, the Jiang and Tun kilns in Liaoyang, the Gangwa and Tun kilns in Chifeng County, Linhuang and Southern Hill kilns of the Upper Liao Capital in Lindong, and Baiyingele kiln in Lindong.

Linhuang Prefecture in the Upper Liao Capital was located in Boluo Town near the old Lindong County seat in Balin Left Banner of Inner Mongolia. Adopting the kiln system of Northern Song, the prefecture set up government kilns and a supervisory office. The kiln site was inside the imperial city of the old Linhuang prefectural seat of the Upper Capital. Many white porcelain vessels inscribed "government" or "new government" recovered from Liao tombs were products of these kilns. No few pottery vessels of tea-green glaze were discovered in Baiyingele kiln, while the Southern Hill kiln turned out tri-colour glazed pottery.

In structural style, the round "frog" kilns, modelled after those on the Central Plains, were identical to those in present-day Pengcheng, Hebei Province, and in Boshan, Shandong Province. Coal-burning, they produced oxidizing flames.

The white porcelain of Liao was successful, its glaze colour and shape combining the special features of Xing and Ding wares and that of the Khitans. The cockscomb ewers excavated from Liao tombs after the reign of Chongxi (1032-55) became swing-handled instead of using a single hole or twin holes of the early period. Potters manufactured ewers of this shape in imitation of utensils of daily use by the Hans when the Khitans began a new settled life and no longer wandered wherever water and grass were plentiful.

Liao porcelain had not the quality of Xing and Ding white porcelain wares. Its decoration was quieter; fewer objects had carved or incised designs. The white glazed porcelain vessels with black designs among Liao wares show the influence of Cizhou ware in style. Black glazed porcelain jars shaped like a chicken leg were numerous and of high quality.

One Liao product was a glazed pottery fired at low temperatures. Many had a single-colour glaze — yellow, brown, green or white — while others had two or three colours, the latter known as Liao tri-colour pottery. The workmanship of these vessels was influenced by their Tang counterpart, though the Liao product was coarser in quality, looser in texture and the glaze was not so evenly applied. There were, however, high-quality pieces in Liao ceramic products. Fine sand was added to the paste to strengthen it in firing, making the pottery fairly hard and the colours glossy.

Liao porcelain was mainly bowls, plates, vases, jars, mugs, boxes and ewers. It had features in common with northern porcelain, especially the Ding ware of Hebei Province. There were also phoenix-head or chicken-spout ewers, jars with swing handles and chicken-leg jars with distinctive local and Khitan characteristics.

The decorative designs of Liao porcelain were applied directly on clay shapes or with coloured glaze. The former consisted mainly of incised or impressed designs, and carvings. The incised or impressed designs were rather monotonous and carelessly executed, while the carvings had unique features. Potters first impressed or carved the designs and then appliquéd them on the vessels. Such designs included intertwined dragons, peony and human figures, all vividly presented. Although the decorations of

coloured glaze were not as attractive as those of Tang tri-colour pottery, they did rival those of Song tri-colour. It was the art of Tang tri-colour pottery, however, that blossomed and took root in the ceramic art of China's various nationalities.

Kin Dynasty Pottery and Porcelain

The Nüzhens, a minority nationality in northeast China, founded the political power of the Kin Dynasty. They had lived in the region of the Heilong River and Changbai Mountains from time immemorial. The Liao Dynasty classified the Nüzhens as "uncivilized" and "civilized". The founders of the Kin Dynasty were the "uncivilized" Nüzhens who lived north of the Changbai Mountains and in the Songhua (Sungari) River valley. A hardy, hard-working people, they engaged in farming, fishing and hunting.

In the year 1113, Akutta, leader of the Wanyan tribe of the Nüzhens, became chieftain of the league of all tribes, which he united to resist the Liao oppressors. Two years later, Akutta founded the Kin Kingdom after defeating the Liao troops.

Kin ceramic development should be divided into two periods: before and after Wanyan Liang, King of Hailing, moved the capital to Yan (today's Beijing). Prior to this, Kin pottery and porcelain developed mainly on the basis of Liao porcelain in northeast China. After moving to Yan, the Kin carried forward the tradition of Northern Song ceramic production.

Archaeological studies of finds from Kin tombs reveal early kiln sites including the Sanguantun kiln in Liaoyang County and Daguantun kiln at Fushun, both in Liaoning Province. The northern white porcelain was coarse and the white glaze had a slight blue or yellow tinge. Many were white glazed vessels with black designs in imitation of Cizhou ware of Hebei Province. Coarse materials were used, and designs were simple and carelessly executed.

Had these objects not been found in Kin tombs, they would be scarcely distinguishable from Liao porcelain, and in fact are traced to the same origin. Most Kin vessels were utensils of daily use — bowls, plates, vases and jars. More remarkable were the extremely rare four-lobed vases of black glaze or white glaze with black designs found in Liao tombs and northeast China. More slender and graceful than Yuan vessels of the same type, these typified Kin porcelain.

A considerable number of chicken-leg vases of black glaze or greyish green glaze were unearthed from the Daguantun kiln site. The slender vases had raised lines all over the body, small mouths with raised lines curving outward and flat bottoms. The paste was yellowish brown and the texture hard and coarse. These vessels were manufactured both in the Liao and Kin dynasties. The chicken-leg vases (also called jars) unearthed from Liao tombs were rather plump in shape, while those of Kin were relatively slender. Both were utensils of daily life used by northern nomadic nationalities for storing wine and other liquids.

A gourd-shaped porcelain vessel of white glaze with black designs excavated from Zhangwu Commune in Liaoning Province is decorated with carving and appliqué. A ewer has a dragon-shaped handle; its spout has an old man riding on it. Decorated with a rhombus design in black dots, the lower part of its body is bordered with lotus petals in relief. A covered jar of white glaze

— 75 —

with black designs excavated from Desheng Commune in Jinxian County has smooth fluent patterns and soft, lustrous glaze. A porcelain *zun*-wine cup of black glaze with iron wire designs unearthed from Kalabi Banner has animal-head designs and flower sprays carved on the body. These objects tell something of the historical conditions of ceramic production in northeast China during Kin times.

After the Nüzhens extended their territory to south of the Great Wall, they moved their capital to Yan (today's Beijing) and expanded their influence to the Central Plains. Social economy was seriously undermined in the heat of war, and especially when a backward nation attacked one with advanced productive forces and relations, it burned, killed and looted. Ceramic production was harmed, the famous Dingzhou, Ru and Yaozhou kilns suffering extensive damage. But pottery and porcelain were utensils of daily use and their production could not be entirely stopped. Porcelain kilns were always located wherever raw materials were available, generally far from cities, where production could go on. Some thought that no porcelain was produced in the Kin Dynasty after the reign of Jingkang (1126-27) when Kin troops kidnapped Emperor Qinzong and his father Huizong, who had abdicated. But this view does not conform to historical conditions.

While a Chinese cultural delegation was in Japan in 1963, they saw an ancient Chinese green-glazed porcelain head-rest. The impress of a rectangular seal on the piece read: "Made by the Zhao family." On the front of the head-rest was a narrative description indicating that a number of northern kilns continued production during or after the reign of Jingkang. The inscription begins with Bai Juyi's poem, *Feelings While Looking at the Moon When Separated from My Brothers* and goes on to record an experience in the years of war:

> Hard times, a famine year,
> a worthless patrimony;
> We brothers, wayfarers
> to the west and the east.
> Our fields and gardens run to waste
> after the fighting,
> Kinsmen wandering homeless
> on the high roads.
> In my own shadow I trace
> the far-flying wild geese;
> Torn from my roots I drift
> like autumn's winged seeds.
> Surely we are all watching the bright
> moon with falling tears
> On this night of homesickness spent
> in five different places.

When I was travelling in Yingchuan, I heard that the Kin troops were marching southward. I saw corpses scattered all over the roadside. It was indeed a pitiful sight. The road was blocked and I found it hard to proceed. So I had to return to the original prefecture. There I again heard noises everywhere and felt restless. Laden with sorrow, I sighed. When we are at home we feel at ease, but when we are away even for a short while, difficulties beset us. My mind was slightly at ease only when I wrote poems. I had to live in a frontier city for six months and, with my friends, ordered some twenty porcelain head-rests made. It was on the fifteenth day of the eighth lunar month in the autumn of the third reign year of Shaoxing [A.D. 1133].

"Travel Notes in Japan", an article by Wang Yeqiu published in the December 1963 issue of the journal *Cultural Relics* deduces that the author of the inscription was a small merchant planning to leave Yingchuan (today's Yuxian County, Henan Province) for Linan, capital of Southern Song.

— 76 —

This description is important for its data on the history of pottery and porcelain of the time. It at least answers the following questions:

First, it tells that even in the war years ceramic production continued.

Second, it appears that ceramic production flagged in the period of war between Song and Kin, and orders had to be placed for porcelain head-rests with carved inscriptions, the articles to be taken away after firing, upon payment.

Third, the brutality of the wars between Song and Kin is indicated by the corpses along the roadside and blocked roads. With people having to live on the frontier, commerce, transport and handicrafts including ceramic production were bound to be affected.

Did northern pottery and porcelain production develop then in the more than one century when the north was under the rule of Kin? Obviously, it did. The following data are enlightening.

"Red and green" overglaze porcelain in bright colours, also known as "painted porcelain of Song", was first made in northern China in the Jun kilns, Lushan and Neixiang in Henan Province, Changzhi in Shanxi Province, and Zibo and Dezhou in Shandong Province. This was white-glazed porcelain painted with chrysanthemum, peony, magpie and flying bird designs in red, green, brown and black. It excelled in the portrayal of human figures. Formerly regarded as multi-colour glazed porcelain of Song, the ware was actually made in the Kin Dynasty.

The Palace Museum has collected a number of porcelain objects of red and green glaze, assessed to be the products of the Bayi kiln in Changzhi County, Shanxi Province. The inside of a white-glazed bowl is inscribed with the following verse:

We were three scholar-officials in an office with gates
Decorated by bronze horses — the jade hall of the Imperial Academy.
Two of us have now become idlers
Enjoying the refreshing breeze and brihgt moon at our ease.

Some of these porcelain objects were similar to those found in the tombs of the Dading reign (1161-89) of the Kin Dynasty excavated in Houma, Shanxi Province, adding importance to the hoard by throwing light on the historical aspect of Kin pottery and porcelain.

First, let us examine Jun ware of Kin times, whose origin is Yuxian County, Henan Province. Porcelain manufacture leapt forward in Northern Song. To serve the imperial court's taste for exotic flowers, plants and rocks to beautify imperial gardens, potters made wares with moon white, sky blue and purplish red glazes.

The largest pottery for making Jun ware was Bagua Cave in Yuxian County, a giant kiln controlled by the Northern Song government. It produced ware of red as well as green glaze, white with black designs and other varieties. Similar kilns were located at Shenhouzhen, Liujiamen, and Lower and Upper Baiyu in Yuxian County. At Bagua Cave was a post-Northern Song cultural layer where a typical example of Kin red-and-green glazed porcelain manufacture was unearthed. Excavation indicated continued high output when Kin renamed Yuzhou as Junzhou, giving red glazed porcelain the name Jun ware after that of its home prefecture.

Jun ware was also unearthed from several Kin tombs. Two porcelain bowls of Jun ware were retrieved from the Dabaotai site of Kin in Fengtai District, Beijing. With greyish blue paste and of irregular shape, they were of moon-white glaze with flaring mouths, shallow body and low foot-rim.

Their greyish yellow glaze was inferior to the glaze of Jun ware of Northern Song.

Discoveries of northern Jun ware have shown that Kin expanded its production. In Northern Song, Jun ware was mainly manufactured in Yuxian County, Henan Province; in Kin times it obviously expanded to other areas in Henan and even to Shanxi Province. The Hunyuan kiln in the Yanbei area, Shanxi Province yielded white porcelain, some with red mottles and splashes, and quite a number of shards of Jun ware. There were shallow, round, straight-backed saggers glued to porcelain vessels of Jun ware, confirming that the Hunyuan kiln manufactured Jun ware. The area was never controlled by Northern Song. In the late Five Dynasties, Shi Jingtang, Emperor of the Later Jin Dynasty, ceded sixteen prefectures (in present-day Hebei Province) to the Khitans and these prefectures remained under Liao till its fall, when they came under Kin rule. The products from this kiln site pre-dated the Yuan Dynasty, and were obviously porcelain ware of Kin. Jun ware consisted mainly of bowls and plates. Their paste was rather hard and close-knit, greyish brown in colour. The glaze colours included moon white, sky blue and purplish red. They were regular in shape and showed fairly high craftsmanship.

Some shards of Jun ware were unearthed from Kin tombs at Jianci Village in Quyang County, Hebei Province. They had fine, durable paste and purplish mottles or tiny black dots. These objects of Jun ware were of higher quality than those of the Hunyuan kiln.

The Lushan kiln of Kin was in Duandian Village, ten kilometres north of the Lushan County seat in Henan Province. The kiln site was very large in scale and had a very long history of porcelain manufacture. Tang manufactured black porcelain and multi-coloured glaze porcelain; Song made white, black and tri-colour glazed porcelain.

Kin produced white porcelain decorated with glaze of other colours, as well as white porcelain, white-glazed bowls with black rims, black glazed bowls and chicken-leg jars. Its black glazed bowls were practically the same as the small shallow cups for tea-tasting contests popular in Southern Song. All these were typical Kin porcelain objects. The large Duandian kiln in Lushan already used nearby coal to fire porcelain vessels in Kin.

Cizhou ware was first made in private kilns that appeared in north China in late Tang and the Five Dynasties, and thrived in Northern Song. Its manufacture spread to Hebei, Henan, Shanxi and Shandong provinces, its vessel shapes and decorations proving popular. Its typical kiln site, in Guantaizhen, Hebei Province, was under the administration of Cizhou in Song times, explaining why it was called Cizhou ware.

An archaeological team of the Hebei Provincial Cultural Bureau conducted a scientific excavation at Guantai kiln site in Hebei Province in 1957 to study the conditions of the kilns in the Song, Kin and Yuan dynasties. A wealth of products of Cizhou ware of Kin were excavated from the dynasty's cultural layer where bronze coins minted in the reign of Zhenglong (1156-61) during the Kin Dynasty had been dug up. The unearthed ware included white, black and yellow-and-green glazed porcelain. Most typical and numerous, however, was the white glazed porcelain with black designs.

The vessel shapes included bowls, plates, jars, dishes, cups, saucers, wine cups, vases, tripod censers and head-rests. The inside of the bowls, plates and dishes were generally decorated with incised designs. White-glaze porcelain excavated had a light, thin paste and graceful shape. The glaze had a bluish tint. The objects were decorated mainly with flower and grass designs. White-glaze vessels with black designs comprised jars, basins and head-rests. A few

concise strokes brought flowers, leaves, twigs and flying birds to life. Yellow-and-green glazed porcelains included square, handled vases, vases with two animal faces each holding a ring in its mouth, a lampstand with the motif of a lion and lotus flowers and small bowls with veiled decorations.

Many fine works of Cizhou ware dating from Kin are now in the collections of large Chinese museums. A tiger-shaped head-rest, or pillow, from the second year of the Dading period of Kin (1162) is housed in Shanghai Museum. Shaped like a reclining tiger with head outstretched, its back serves as the head-rest surface. With black stripes on brownish yellow, the tiger image is vivid and awe-inspiring. On the head-rest surface is painted an expanse of river and a few clusters of water weeds on the riverside. A long-tailed aquatic bird perches on the weeds, searching for food, while in the sky is a pair of flying wild geese. "Made by Zhang... on the sixth day of the sixth lunar month in the second year of the Dading period" is inscribed in black at the base of the head-rest. The Museum of Chinese History has in its collection a porcelain jar inscribed with the characters "Buddhist benevolence saves all mankind, made by Zhang Tai in the second year of the Daan period [1210]". The jar has a flaring mouth, narrow shoulders, round body and foot-rim. It is coated with white glaze above the base.

Since liberation Kin porcelain vessels of Cizhou ware have often been discovered in Heilongjiang, Liaoning, Shandong, Shanxi and Henan provinces as well as Beijing, placing Cizhou ware's development in Kin, following Song.

Ding ware formed an important northern porcelain school in Northern Song. Archaeologists' excavations of Ding kilns have verified that many well-preserved Kin por-

celain vessels of Ding ware were unearthed from the Kin cultural layer. Among them were diverse styles of bowls, plates and vats. Their paste was white and fine, their glaze white with a slight blue tint, their shapes solemn and quiet. Potters continued to use the Northern Song method of placing vessels with their mouths downward in firing, though most were fired one on top of another with sand rings between. A small number of plates and bowls were decorated with engraved or incised designs. The decorations were rather simple and the glaze colours not as varied as in Northern Song. Production was on a small scale. The large potteries and workshops catering to the royal family of Song probably no longer existed.

There were quite a number of good works of Ding ware among the funerary objects in some Kin tombs, for example, the white porcelain objects of Ding ware unearthed from a tomb of the 17th year of the Dading reign of Kin (1177) in Tongxian County on Beijing's outskirts, in a Kin tomb in Suibing County, Heilongjiang Province, and in a Kin tomb at the Temple of Agriculture in Beijing. Some were carved with day-lily design, some incised with double outlined lotus flower designs. The mouth-rims of some bowls were in the shape of eight sunflower petals, and the paste was light, thin and graceful, the glaze colour fine and white, decorations concise and lively. Although they could not rival the Song white porcelain of Ding ware, they were excellent for Kin white porcelain.

For more than one century when Kin ruled the northern half of China, the Yaozhou kiln in Shaanxi Province, Cicun kiln and Podi kiln in Zibo, Shandong Province, and the kilns in Jiexiu, Hunyuan, Huoxian and Changzi in Shanxi Province also manufactured porcelain. The products of the Yaozhou kiln at Tongchuan, Shaanxi Province were of fairly high quality and their dec-

orative designs were lively. These eloquently explain that from the 12th to the 13th century northern China did not cease but in fact progressed in ceramic production. Kin pottery and porcelain has its place in the history of development of Chinese ceramics.

CHAPTER 7
Ceramic Craftsmanship Excels in the Ming and Qing Dynasties

SECTION 1
Ming Dynasty Porcelain Ware

In the peasant wars at the end of the Yuan Dynasty, a large part of the Mongolian and Han landlord class was eliminated or overthrown, somewhat changing the situation of farmland being in the hands of the few. Society slightly stabilized after Zhu Yuanzhang founded Ming in 1368. Peasants and craftsmen worked hard to develop the social economy and, faced with its decline, the ruling clique headed by Zhu Yuanzhang instituted a series of measures to retrieve it so as to maintain its rule. One was to encourage the peasants to move to sparsely populated areas and reclaim waste land, the emperor decreeing that they could legally own the land they reclaimed. In the first ten years of Ming, newly reclaimed land accounted for nearly half of all farmland. These policies helped recover and develop Ming social economy.

The development of cities and commercial economy, extensive circulation of currency, wholesale and retail trade all surpassed those of Yuan. Famous handicraft cities and towns appeared. Iron smelting, steel making, shipbuilding, ceramics, textile and building trades expanded. Jingdezhen in Jiangxi Province became the national porcelain centre. It was said that "all the finest and most beautiful Ming porcelain was made in Jingdezhen". The porcelain town had nearly three hundred government and private kilns. "White smoke covered the sky by day and flames rose into the air at night." This was indeed unprecedented prosperity!

In Ming times porcelain craftsmen at Jingdezhen improved the tools for making the clay shapes and invented the art of blowing glaze. Kiln furnaces were oval in shape rather than hemispheric. This furnace remodelling increased the number of vessels fired per kiln and enabled the potters to control the firing to produce porcelain of excellent quality.

The flourishing of sea navigation and the export of porcelain promoted production of the ware. In early Ming, foreign trade was conducted in the form of tribute to the court. To receive foreign merchants coming to China for trade, offices in charge of sea navigation, shipbuilding and foreign trade were set up in Ningbo, Quanzhou and Guangzhou in the Hongwu period (1368-98), another such office being set up in Yunnan Province in the Yongle period (1403-24). For a time goods were imported tax-free,

attracting many foreign merchants. More than 1,200 envoys and merchants from other countries came on one occasion in the 21th year of the Yongle period, 1423. The Ming government itself conducted the trade. Between 1405 and 1433, Zheng He sailed to more than thirty countries in the South Sea and as far as the Red Sea and the eastern coast of Africa, visiting and trading with the local people. He took with him a large collection of porcelain.

In Ming times the royal house directly controlled the porcelain production of government kilns. Imperial factories and kilns were set up and regularly engaged in porcelain production, different from the offices which formerly supervised ceramic production and levied taxes. They procured the best raw materials and brought in master craftsmen to make exquisite porcelain objects designed for the emperors, sparing no effort and cost. Ceramic craftsmanship thus improved.

The production of private kilns represented commodity economy. They could use locally available materials, prospect for and utilize natural minerals fully to manufacture wares of distinctive local style. It was the fashion in the Ming Dynasty for the royal family, the families of feudal bureaucrats, landlords and ordinary urbanites to use porcelain vessels, the greater demand coming from the upper social strata. Apart from porcelain objects bestowed by emperors as rewards, most of this demand was met at the market. Porcelain production was stimulated and privately owned Ming porcelain trade developed on a larger scale than before.

Porcelain craftsmanship attained the following distinguished achievements:

1. In white porcelain it surpassed that of any previous time. The white glaze was fine, pure and lustrous. According to our knowledge of white porcelain objects and historical records, white porcelain of different periods in Ming had predominant characteristics. White porcelain in the Yongle reign (1403-24) had a thin paste and lustrous glaze known as "sweet white" glaze for its soft and pleasant whiteness. White porcelain of the Xuande reign (1426-35) was praised "as moist and smooth as lard and as lustrous as fine jade", that of the Jiajing reign (1522-66) as "pure without blemish". White porcelain of the Wanli reign (1573-1620) was lauded as "translucent and bright".

White porcelain ware in Dehua County, Fujian Province also reached high levels. The Song Dynasty began the manufacture of this white porcelain, which was greatly improved in Yuan. Ming white porcelain of Dehua had its own style. Its glaze was warm, soft and beautiful with good transparency, appearing ivory white. The most renowned white porcelain objects of the Dehua kilns were art statues, and many porcelain sculptors came to prominence. Images of Bodhidharma[1] and Guanyin Bodhisattva, popularly known as the Goddess of Mercy, were brought to life with sleeves fluttering. Carved in fine, graceful lines, their appeal lies in presenting motion in tranquility.

2. Blue-and-white porcelain ranked first in Ming porcelain production. In the Ming Dynasty blue-and-white porcelain at Jingdezhen had pride of place for three hundred years and ranked first among Chinese porcelains. It was an exquisite variety for the people of China and other countries as well. According to *Administrative Statutes of the Ming Dynasty*, a celadon bowl made in Chuzhou was valued at 150 strings of cash abroad, while a blue-and-white porcelain bowl fetched 300. The blue-and-white vessels were much more easily made than the

[1]Bodhidharma who introduced the Chan (Zen) sect of Buddhism to China in the sixth century. It is said that Bodhidharma sat in meditation before a rock wall for nine years.

celadon, however, so Jingdezhen blue-and-white porcelain naturally replaced Chuzhou celadon, and Jingdezhen became China's porcelain centre after the 14th century.

Blue-and-white porcelain had varied styles in different periods, that of the Yongle and expecially the Xuande periods (1403-35) representing Ming porcelain at its best. The blue-and-white of the Xuande period "blazed a new trail for succeeding generations". Smalt blue or Mohammedan blue imported from Persia was used as pigment. The colour is deep and blends brightness and simplicity. Like the *cun* method of texture wrinkles, a traditional Chinese painting technique for portraying mountains and rocks, the painted designs were vivid and natural, in harmonious nuances of dark and light shades. During the Chenghua reign (1465-87), cobalt blue on blue-and-white porcelain vessels was quiet in colour, but patterns and strokes were elaborate and composition detailed like Gongbi (meticulous brushwork) paintings. In the Jiajing period (1522-66) blue-and-white porcelain was painted in deep cobalt blue with a purplish tint. During the Wanli reign (1573-1620) it was done in subdued greyish blue. These fine wares supplied both home and foreign markets. At present many objects are still preserved in Europe, Southeast Asia, Central Asia, Arab and African countries and have become treasures of ancient art in the world's museums.

Red glaze and underglaze red were great successes. Ming red-glaze porcelain was called ruby red because it was as bright and lustrous as the gem. However, legend has it that ruby red was produced by using actual gems from Southeast Asia, such as amethyst from Sriwidjaja (ancient Sumatra) and purplish carmine gem from ancient Brunei, these being ground into powder and mixed into the glaze. The "vessels are smooth, lustrous and seldom become coarse", so legend said. As a matter of fact, potter used copper as colouring agent to make ruby-red glaze, the material changing into a colloidal state upon heating. After the raw clay was coated with glaze, it was fired at high temperature using reduction flame. The colour was stable and penetrating and the glaze neither flowed off nor peeled, giving the object a sparkling radiance.

Underglaze red was made by painting exquisite red decorative designs under the glaze on white glazed porcelain. The white glazed bowl with red fish design on display in the pottery and porcelain gallery of the Palace Museum in Beijing is an example. Under thick white glaze artists painted the fish in copper red in the traditional Xieyi (freehand) style, which after firing appear to be darting to and fro, vanishing at times, in tranquil water.

The yellow-glaze porcelain of Ming was also highly successful. The main ingredient of yellow pigment was antimonic acid lead. Zinc oxide, antimony oxide, nitric acid aluminium, tin oxide, iron oxide and lead oxide were used in the yellow pigment which was applied to vessels already fired. The vessels were refired with oxidization flames at low temperature. The glaze colour was pure, smooth and lustrous like blooming sunflowers, tender, delicate and sparkling.

Ming craftsmen carried on the art of porcelain-making of previous dynasties, but devised many new varieties. Ming painted porcelain had bright and varied colours including Doucai (contending colours), devised during the Chenghua reign. This new variety combined underglaze and overglaze colours in an organic whole. Cobalt was used to outline the designs on the raw clay, which was then coated with white glaze, placed in the kiln and fired at high temperature. The next step was to paint designs of yellow, green, red and purple within the blue-and-white outline. Then the piece was fired again. Multiple layers of colours on

porcelain vessels "contended for beauty" and decorative art rose to a new level. The technique of Gongbi (meticulous brushwork) was used in composing designs.

Another technique was to outline only a part of the patterns such as the stems, veins, twigs and leaves of the flowers; flower stamens and pistils as well as fruit were not outlined. After the vessels had been fired, the designs were painted on the glaze, allowing the artists to give full rein to their imagination in the use of line and hue. The results were lively and colourful. The painted porcelain of the Chenghua reign was assessed as the best of all the eight better-known Ming reigns — Yongle, Xuande, Chenghua, Hongzhi, Zhengde, Jiajing, Longqing and Wanli. The book *Tang's Investigation of the Market* recordes: "Emperor Shenzong was fond of porcelain vessels. He had a pair of cups made in the Chenghua reign which cost 100,000 strings of cash. They were already so expensive in late Ming." Porcelain vessels of the Chenghua reign were certainly highly valued. After the invention of "contending colours" for decorative designs in that reign, the designs were first used on small vessels and later on were more widely applied, with unusually good decorative effect.

Polychrome porcelain was manufactured in the reigns of Jiajing and Wanli (1522-1620), the un-outlined patterns in blue and white. After the vessels were fired, decorative designs were painted freely in a greater variety of hues on white glaze. Most representative famous works of polychrome were jar with the motif of fish and water weeds of the Jiajing reign, and a polychrome vase with open-work design of a phoenix in clouds of the Wanli reign.

Ming also had another distinctive painted porcelain, known as "three quiet colours", using yellow, green, white and purple as predominant colours for the design. As the potters excluded red from the designs, the decorations appeared subdued in tone, and people called it quiet three-colour glazed porcelain. This Ming porcelain blossomed into popularity in the reigns of Hongzhi (1488-1505) and Zhengde (1506-21), and production continued thereafter.

Shanxi was an important region of northern ceramic production. There, apart from long-time manufacture of white and black porcelain, a type of pottery with enamel designs appeared probably in late Yuan. This art improved greatly in Ming, when exquisite works were turned out in large quantity. This enamel-design pottery had the following characteristics: patterns in relief, deep, thick glazed colours and beautiful hues. The blue looked like sapphire, the purple like amethyst, the yellow like wax and the green like jadeite. There were also designs in appliqué. The unrestrained conch shell designs also showed ingenuity. Of the pottery utensils for people's daily use this was a unique rare variety that enjoyed great popularity. Even in Jingdezhen where skilled craftsmen gathered and many factories of imperial wares were located, potters vied with one another in modelling after it. They painted enamel designs on vessels of white china clay with unusually attractive results.

SECTION 2
Porcelain Craftsmanship in the Qing Dynasty

The reigns of Kangxi, Yongzheng and Qianlong, from 1662 to 1795, were the golden age of Chinese pottery and porcelain in Qing Dynasty (1644-1911). The Qing gov-

ernment changed the legal status of employed workers several times. If in the Qianlong reign the employer and the employee were not "master and servant", they should "sit together, take meals and greet each other as equals". Such employed workers were treated as "ordinary people" (*Cases Involving Laws and Regulations in the Qing Dynasty*, Volume 810 "Ministry of Law, Criminal Code, Fights"). This change in productive relations in Qing provided the conditions for developing the productive forces.

The textile, mining, sugar refining, shipbuilding and other trades progressed rapidly, and ceramics took a step ahead of what Ming had achieved. The porcelain centre of Jingdezhen had two to three hundred private kilns, several thousand households engaged in porcelain-making, and more than a hundred thousand craftsmen — substantial increases over Ming, while quality also improved.

Beginning from the Kangxi reign (1662-1722), Qing resumed porcelain-making at Jingdezhen and created a number of fine varieties. In the reigns of Yongzheng (1724-35) and Qianlong (1736-95) striking progress was made in porcelain craftsmanship, which reached its ultimate peak. Qing porcelain craftsmanship excelled in the fllowing respects: fine paste, lustrous glaze and exquisite carving. Blue-and-white, polychrome in the Kangxi reign, *famille rose*, cloisonné enamel and coloured glazes in a great variety of shades in the reigns of Yongzheng and Qianlong surpassed the achievements of Ming.

Blue-and-white porcelain made during the Kangxi reign was decorated with pure domestic blue pigment, and pictures painted on it appeared in perspective. Cobalt blue was bright and fresh-looking. Decorations covered a wider range of themes and presented more magnificent scenes than those of Ming. Painted on porcelain vessels during this period were landscapes, genre paint-ings, flowers-and-birds and episodes from classical novels such as *Outlaws of the Marsh*, *Stories of States of the Eastern Zhou Dynasty* and *Romance of the Three Kingdoms*, all popular themes.

The most artistic Qing polychrome porcelain was that of the Kangxi period. Red, green, brown and purple were the predominant colours, but gold, cobalt blue and black were also used — indeed a riot of colours. As the decorative designs on polychrome porcelain vessels used bold, strong colour tone, and after the painting of designs the vessels were fired at fairly high temperature, porcelain researchers and connoisseurs called them "strong colours". More common designs included banana-leaf pattern, brocade pattern, concentric band, flower, bird, insect, fish and butterfly. Among the multi-colour glaze porcelain of different dynasties, stories of people painted in diverse colours on porcelain vessels of the Kangxi reign had the highest artistic value.

Porcelain, being three-dimensional, presents great limitations in painting, compared with paper. Yet, high artistry was shown in depicting stories of people, magnificent scenes appearing on porcelain by appropriate arrangement and clever use of pigments. Some paintings pictured episodes from novels or from history. There was Zhou Chu slaying the flood dragon, a mythical creature capable of invoking storms and flood. Huangfu Duan is depicted judging horses, and Yue Fei's troops are pictured resisting Kin invaders. Some show farm scenes in the early Qing Dynasty. Some were large flower-and-bird paintings. The painting technique was on a high level.

The *famille rose* of Qing exhibited a new type of porcelain decoration which had its inception in the Kangxi reign. Artists painted the designs on fired porcelain glaze and then fired the vessels again. *Famille rose* porcelain had soft, quiet colours, and the

picture showed perspective, each vessel being a painting in *famille rose*.

Most *famille rose* paintings depicted flowers and birds, which together with insects and butterflies seemed to come to life. *Famille rose* porcelain became very popular in the Yongzheng reign, surpassing all other porcelain varieties and showing high craftsmanship. Quite a number of fine works of *famille rose* of this period have survived. However, it became more popular in the Qianlong period, and it was even applied with other coloured glazes on the same porcelain vessel with splendid effect. Throughout the two hundred-plus years of the Qing Dynasty *famille rose* accounted for much of the decoration on both art porcelain and porcelain utensils for daily use.

Porcelain with cloisonné enamel, following European decorative techniques, was a new type in the Kangxi reign. The pigments for painting the designs were prepared with modern chemical methods. Their artistic style incorporated certain elements from nascent capitalism — wholesome, lively and vital. The Qing court highly valued and strictly controlled this art porcelain. It had pure, fine white porcelain ware made at the government kilns at Jingdezhen and then, selecting one piece out of a hundred, had these choice pieces transported to the imperial office charged with making and furnishing vessels for the emperor. Here court painters or artists invited from European countries drew designs on the white porcelain pieces and fired them. The pigments were specially prepared and the designs painted with oil-painting technique, bringing out dimensional effect. Actually, as the pigments were fine and lustrous, the designs showed up better on porcelain than oil on canvas. The high quality of Qing white porcelain and the European art of painting merged to create conditions for large-scale production of this fine porcelain.

But cloisonné was also marked with no little traditional Chinese painting of flowers, birds and figures, and these were inscribed with poems in Chinese calligraphy. The most common flowers were rose, geranium, plum-blossom and orchid; usual figures were celestial boys and girls, though such European figures as angels, women and infants were also used. Exquisite porcelain decorated in cloisonné enamel shows superb skills, and the ware is a gem in the history of Chinese arts and crafts.

However, porcelain decorated in cloisonné enamel was not an easy craft so products were few, and these were "only for the imperial court". Even ministers could not own it. All existing porcelain objects decorated in cloisonné enamel were made in the reigns of Kangxi, Yongzheng or Qianlong. An exquisite specimen was as valuable as jade. After the Qianlong period, however, when porcelain-making declined, no craftsmen could be found to undertake this art.

Qing porcelain decorated in "contending colours" varied more widely, skilfully combining *famille rose* with underglaze blue-and-white. Its artistry surpassed that of Ming. Such decorations were widely applied on porcelain utensils for daily use. Output greatly increased and decoration was varied, some using the techniques of exaggeration and setting off by contrast. Designs included circular floral patterns, sprays of flowers and leaf designs. The craftsmen stressed symmetrical designs and meticulous arrangement, in all giving a rich decorative effect.

New techniques of porcelain-making were devised in the Qinglong period, the craftsmen fully mastering manifold skills, accurately using flames, and controlling firing temperature and the properties of the paste and glaze. Their products ingeniously imitated bamboo and wood articles, lacquer ware, bronzes, stone objects, ivory carvings and sea animals and plants, all true to life. Porcelain

connoisseurs were astonished at the potters' "seemingly supernatural skills". The craftsmen also produced Linglong (pierced work) porcelain, which involved piercing the object and filling the holes with glaze. Large, finely carved vases with reticulated exterior and independently revolving interior, and vases with revolving necks, appeared at this time.

During the more than two hundred years of Qing rule many new creations and developments were achieved on monochrome-glaze porcelain. Jingdezhen made powder blue, red glaze, furnace transmutation, cowpea red (red glaze from copper, with patches of brown or green), crab-shell green, eel (greenish) yellow, aubergine, turquoise and many other glaze colours.

Decline of Chinese Porcelain in the One Hundred Years Before Liberation

Several thousand years of advance gave Chinese ceramic handicraft abundant experience and wide absorption of the best in Chinese and foreign culture, resulting in whole sequences of unique craft methods. This craftsmanship reached a peak in the mid-Qing Dynasty, during the reign of Qianlong. Potters mastered superb skills and produced prolifically, their works representing maturity in Chinese ceramic art.

In about half a century of aggression by capitalist powers, from the mid-19th to the early 20th century, Chinese society gradually sank to the level of a semi-colonial, semi-feudal state. In 1840 (the 20th year of the Daoguang reign), Britain launched the first Opium War, a turning point in the history of Chinese feudal society onto the course of semi-colonialism and semi-feudalism. China's pottery and porcelain industry also saw rough times. Ceramic craftsmanship with its long tradition gradually went downhill, and the industry went from standstill to decline. China, the "home of porcelain" became a place for dumping the wares of capitalist and imperialist countries.

SECTION 1

Period of Ceramic Handicraft Decline in Feudal Society

The Chinese feudal empire, which had closed its doors to international intercourse, was defeated in the Opium War in 1840. Two years later, in 1842, British aggressors forced the Qing government to sign the Sino-British Treaty of Nanjing (Nanking), the first unequal treaty signed by China with a foreign power. It stipulated the opening of Guangzhou (Canton), Fuzhou (Foochow), Xiamen (Amoy), Ningbo and Shanghai as ports to foreign trade. Capitalism crashed China's gates, and Chinese territory became a dumping ground for foreign goods.

The Treaty of Tianjin (Tientsin) followed in the wake of the Treaty of Nanjing, which stipulated that all import and export articles were to pay an ad valorem duty of 5 per cent, calculated on their market value, and foreign goods that were transported to the interior of China were to be taxed an additional 2.5 per cent of the current price, but exempted from local taxes. This opened

China's gate wide for the dumping of foreign goods including pottery and porcelain. It strangled China's ceramic industry. While foreign porcelain brought into China could be sold in trading ports upon payment of a 5-per cent tax, then shipped to China's hinterland after paying a tax of 7.5 per cent, the porcelain produced by China's home industry was subject to all sorts of local taxes at every outpost along the way from production centres to markets.

Two kinds of taxes were levied on Jingdezhen porcelain in Jiangxi Province alone: one on the spot at Jingdezhen, and another at Hukou, not far from Jingdezhen, the two amounting to 12 per cent. And this was padded by extortions from tax collectors.

A book entitled *More Information on China* written in the Guangxu reign (1875-1908) records in Volume 180: "In former years Jingdezhen brought in five million taels of silver a year from its sale of porcelain vessels. Now the conditions are deteriorating and it gets less than half from its annual sales. Critics say the laws have not been properly drawn up and the taxes are too heavy!"

Legitimate taxes alone on foreign porcelain were 4.5 per cent less than on domestic porcelain — the result of the corrupt and traitorous policy of the Qing government, which capitulated to foreign powers while suppressing national industry. Each passing day saw a decline in Chinese pottery and porcelain production under this dual blow.

After the Sino-Japanese War in 1894 and the signing of the Treaty of Shimonoseki, foreign firms were allowed to establish factories in China. Imperialist economic influence continued its penetration of China's hinterland and extorted profits as from a colony. Imperialist powers had at their disposal China's excellent raw materials and labour power to make and sell porcelain products within China without paying import tariff. Mechanizing production, they improved quality over that of ordinary coarse porcelain ware while using traditional Chinese artistic style. In this way they avoided the label of foreign goods.

Commercial porcelain controlled by imperialist powers thus flooded the Chinese market and paralyzed China's ceramic handicraft industry. The Dahua Ceramic Company of Japan operated in northeast China; the Taishan Ceramic Company was set up in Shandong, and the Edison Electric Porcelain Factory was established in Shanghai by Britain; Japan set up the Zhongyuan Porcelain Factory in Shanghai, while the Qixin Porcelain Factory in Tangshan was set up jointly with local Chinese and British capital — all representing export of capital by imperialist powers to establish ceramic enterprises in China.

The huge sum of indemnity imposed on China by the Treaty of Shimonoseki was paid through a number of foreign loans with China's Customs revenue as security, opening the country's Customs to foreign control. The export of Chinese pottery and porcelain was restricted, and her ceramic industry was unable to continue developing.

Meanwhile, pottery and porcelain manufacturing grew by leaps and bounds in capitalist countries, their technical advance in the 19th century gradually freeing their ceramic production from the limitations of handicraft production and machines replacing hands in the trade. Britain, Germany and France, especially, supplied more and more ceramic products for the international market. German porcelain was durable, low in price and very popular round the world. In the East, Japanese ceramics were not far behind, and Japan became a world leader in the export of pottery and porcelain.

Chinese ceramics could not compete. Jingdezhen porcelain production declined, its river transport channels silted up, ceram-

ic workmanship deteriorated with kilns scarcely operating. By the reign of Guangxu (1875-1908), the Ming and Qing imperial kilns had long been abandoned. Although Jingdezhen still had some 110 private kilns, most showed mediocre workmanship while only a few famous painters of designs imitated ancient porcelain objects.

But the decline of Chinese ceramic production was not an isolated phenomenon — all professions and trades in China went downhill. Chinese feudal society came to an end, but feudal relations of production continued to shackle development of the productive forces. Moreover, imperialist aggression brought endless disaster to the Chinese people. With its vitals undermined and mortally sick, Chinese society stood in urgent need of a great revolutionary change to unshackle it and provide the conditions to achieve the motive force for renewed development. The miserable decline in ceramic production pointed up this social phenomenon.

SECTION 2
China's National Ceramic Industry in Troubled Times

With its long history and national tradition, China's pottery and porcelain handicraft stubbornly resisted the aggression of imperialist powers. People in many different localities set up small ceramic factories to meet the needs of the people. Despite backward work methods they covered the country and were of a popular nature, satisfying to some degree the local people's daily needs by continuing handicraft production from ancient times. They were able to use China's wealth of fine raw materials and manufacture pottery and porcelain objects with local characteristics and life's flavour.

There were several social conditions which made it possible for China's ceramic industry to continue production in this difficult period.

First. China has vast territory, almost every region of which has fine china clay, abundant water sources, firewood and coal. For several thousand years most of China's fifty-some nationalities had their skilled ceramists. In slack seasons or with failure in the agricultural economy, the peasants organized and set up kilns for ceramic production wherever raw materials were abundant.

Second. With the utterly miserable living conditions of the people and rural production going bankrupt, labour became cheap. A meagre living was sufficient to keep production going, so that ceramic workshops and kilns could be set up.

Third. The fine traditional ceramic techniques and the popular nature of the products gave them a wide market.

Fourth. Chinese national capitalism grew to some extent in this period, a number of merchants, landlords and bureaucrats investing in a new ceramic industry. Workshop owners in Jiangxi, Fujian, Henan and Shandong provinces expanded their shops, adopted new methods and set up modern-style kilns. Establishing modern porcelain factories became quite in fashion for a time.

Fifth. This profitable enterprise did not escape the notice of the Qing government, which sought thereby to offset war expenses and national debts. With both the government and people favouring the establish-

ment of factories, ceramics became one of the "industries to be developed".

From late Qing to the early years of the Chinese Republic, twenty-two factories were established nation-wide. But this pottery and porcelain upsurge was short-lived due to the dual oppression of foreign imperialism and domestic feudalism.

The situation of the Jiangxi Porcelain Corporation at Jingdezhen and of the Hunan Porcelain Corporation in Liling, Hunan Province illustrate this.

In 1903 (the 29th year of the Guangxu reign), the Qing government accepted the proposal of Ke Fengshi, Military Governor of Jiangxi Province, to allocate 100,000 taels of silver for establishing the Jiangxi Porcelain Corporation at Jingdezhen in 1910 (the second year of the Xuantong reign), the enterprise to be jointly financed and run by the government and individual merchants. Hebei, Hubei, Jiangsu, Anhui and Jiangxi provinces provided the investment, initially set at 400,000 silver dollars. Actually 200,000 were collected and the factory was set up at Jingdezhen, with a branch in Poyang and an affiliated ceramic technical school to teach new, improved methods. Production was to be mechanized and the kilns re-designed to use coal instead of wood for fuel. Retail outlets were set up in Jiujiang, Hankou and Shanghai.

The corporation produced mainly for the market and was capitalist in nature. Still, it was in the hands of the Qing dynastic government and influenced by feudal abuses including embezzlement by officials. The Jiujiang and Hankou outlets also suffered a loss of some 100,000 dollars due to war. Remaining capital was concentrated at Jingdezhen.

During and immediately after World War I, when imperialist powers were too busy elsewhere to focus on the Far East, the Jiangxi Porcelain Corporation made some comeback. Its production gradually expanded in 1919-20. All its wares were modelled along new lines and showed exquisite workmanship despite old methods, so that they were little inferior to the porcelain of Qing imperial kilns and won medals at the Nanyang Industrial Exhibition in China and the Panama Trade Fair. The enterprises, however, suffered from limited capital and the numerous restrictions on business management; managers did not dare to introduce advanced modes of production. Foreign wares poured in once again after the war, and with slack market and natural disasters for years running, the companies gradually declined and went bankrupt.

In 1905 (the 31st year of the Guangxu reign) Xiong Xiling petitioned Duan Fang, Military Governor of Hunan Province, for permission to establish a porcelain technical school in Liling, where raw materials were plentiful. Japanese technicians would be invited as teachers. Permission was granted and brought fairly good results. The Hunan Porcelain Corporation Ltd. was formed after shares amounting to 50,000 silver dollars had been sold. But Xiong Xiling overspent and was forced to resign within the year. By 1910 (the second year in the Xuantong reign) the squandering of funds plunged the corporation into the debt of Daqing Bank to the tune of 160,000 taels of silver. With bankruptcy inevitable, the provincial treasury in 1913 allocated funds to purchase all shares and made the corporation a government enterprise. It lasted until 1920.

The Hunan Porcelain Corporation at Liling manufactured fine ware and created underglaze porcelain of fairly high artistry. Between 1907 and 1911 Liling porcelain several times won the First-Class Gold Medal and cash award at the Nanyang Industrial Exhibition and Panama and Italian trade fairs. Though Liling had the facilities to

compete with foreign porcelain, corrupt and incompetent bureaucrats' mishandling of money nullified the favourable conditions and led to the corporation's closure.

Some Management Gains in Ceramic Production

After the Opium War of 1840, Chinese national industry and commerce made certain management changes to compete with economic pressures of the capitalist powers. Porcelain production, as all contemporary enterprises of the time, was of a semi-colonial, semi-feudal nature.

Then some new phenomena appeared in Chinese ceramic production, most noteworthy of which was the setting up of ceramic research institutes in Beijing and the provinces of Shandong, Shanxi, Jiangsu, Zhejiang, Guangdong, Guangxi and Jiangxi. Pottery and porcelain manufacture gradually turned from handicraft to machine production.

The feudal rulers of the various dynasties in China were arbitrary in their approach to ceramic production, government kilns operating when ordered and lying idle when no imperial order was on hand. None of their wares were allowed to be sold, nor would anyone dare to own them. Furthermore, in shape and decorative motif they were not suitable for the common people's use even had potters been permitted to make them. The penalty for infringing on these prohibitions was beheading of the offender and his entire extended family.

Most wares of the government kilns catered to imperial taste. A wooden model was first carved, then personnel sent to supervise the making. The best raw materials and master craftsmen were brought in to execute even a few porcelain pieces so long as they were for the royal family. Cost was no issue. *Tao Ya*, a book on pottery-making, remarks: "The court appoints special officials to supervise the work so that many potters cater to the taste of a single person." The government also requisitioned or confiscated desired wares from private ceramic workshops, playing havoc with their business.

After the 1911 Revolution, with the removal of dynastic restriction, ceramic production gradually made its way into the nation's industry and commerce. Potters began using such simple machinery as foot-pedalled wheels, hand-operated pulverizers, plaster of Paris moulds for casting and glaze sprayers. They also introduced the technique of transfer printing for coloured decorations.

Conspicuous among the features of post-1911 Revolution ceramic production are:

First. Attempting to meet people's needs in social life, potters made complete set of vessels for the market.

Second. Imitating ancient styles was prevalent. Government kilns closed and their craftsmen, skilled in traditional styles, decorative designs and glaze colours, went to work for private porcelain factories where they were doing a familiar job and could display their special knowledge to the full. European and Japanese art dealers vied with each other in buying ancient-style Chinese porcelains, ordering imitations and even joining in designing and setting up small kilns to produce these imitations.

Third. Artists generally used the traditional Chinese painting method of the late Qing Dynasty in painting coloured designs on pottery and porcelain, drawing Chinese

landscapes or depicting stories on the limited surface of porcelain vessels.

It is worthy of note that the Hunan Porcelain Corporation in Liling devised the technique of underglaze polychrome, an outstanding achievement. Such polychrome appeared rich and lively, and was gorgeous in colour. A vitreous glaze covering the pigments rendered the paintings resistant to acid, alkali, corrosion and abrasion.

Potters also improved impressed and stencilled designs, transfer printing, blowing-on of colour glaze and appliqué decorations — all efforts made in times of difficulty in China's semi-colonial and semifeudal society.

Fourth. Utensils of daily use varied little in shape during this period. Porcelain sculpture moved ahead, potters improving their skills by assimilating the essence of Western sculptural art in carving the human figure.

In late Qing, potters began to use drills or diamonds as tools, with sharp and incisive effect in engraved landscapes and portraits on porcelain plaques. In 1915 Yuan Shikai had the portrait of King George V of Britain vividly engraved on a porcelain plaque as a gift. Painted portraits on porcelain plaques and porcelain portrait badges also appeared as new items in late Qing. Shortly after the 1911 Revolution, Yuan Shikai sent Guo Baochang to Jingdezhen to commission a hundred imitation porcelain objects decorated in cloisonné enamel. Known as "porcelain of Hongxian" (the brief "reign" of Yuan Shikai, who styled himself emperor), these had pure white paste and quiet, graceful painted designs. This porcelain made its way into the fashion curio market in China and abroad with great profit.

Compared with early Qing, these later porcelains were of inferior artistry. Isolated from the people's life, they were morbid when viewed from the angle of social production.

In the second decade of the 20th century, certain conditions in Chinese society led to the decadent ideology of the feudal rulers becoming rampant and seriously undermining the traditional style of Chiese pottery and porcelain. Over-elaborateness, superfluous decoration and gaudy colours marked the trend. Even lewd pictures appeared on porcelain. This was a far cry from the traditional Chinese style, which was simple, natural and breathed life's richness, while vessel shapes and decorations suited both refined and popular tastes.

CHAPTER 9

Blossoming of Ceramic Art in New China

Since the founding of the new China, ceramic art has new life. To meet the needs of people's life, and guided by the principle "make the past serve the present" and "weed through the old to bring forth the new", potters have made bold innovations to make a hundred flowers blossom in the pottery and porcelain garden. Now the main producing centres are Jingdezhen in Jiangxi Province, Liling County in Hunan, Tangshan and Handan in Hebei, Shiwan and Chaoan in Guangdong Province, Dehua County in Fujian Province, Yixing County in Jiangsu, Longquan and Wenzhou in Zhejiang Province, and Zibo in Shandong Province.

With a history of over a thousand years, Jingdezhen is China's most famous porcelain centre. "White as jade, thin as paper, bright as a mirror, ringing like a stone chime" are epithets applied to this famous ware. It comes in a great variety of graceful vessel shapes, rich decoration and techniques.

Blue-and-white porcelain is a centuries-old traditional porcelain of Jingdezhen. Potters paint designs on the clay shapes with a cobalt-containing colouring agent, then cover the designs with a transparent glaze and fire them at the high temperature of 1,300°C. Blue-and-white designs are simple, subdued and in good taste. This technique can be used to decorate both ornamental objects and utensils of daily life. The designs in single colour, given the artists'

clever brushwork, appear in darker and lighter shades. Some are done meticulously, others in concise strokes. All are pleasant, varied and colourful to look at. The pigments for painting blue-and-white designs have been imporved in the last few years, making this type of porcelain brighter and more attractive in hue. Jingdezhen's products include dinner, wine, tea and coffee sets, vases, flower pots and other ornamental porcelain objects. Jingdezhen blue-and-white porcelain varieties number 680, more than thirty times that before liberation.

Lustrous and pleasing colour glazes are a gem in Jingdezhen ceramics. The colour of porcelain glaze developed from bluish green in the early period, through white, black and Tang tri-colour glaze with yellow, brown and green as main colours in Sui and Tang times. Glaze colours developed further in the Song, Ming and Qing dynasties. Jingdezhen has revived sacrificial red (said to have been so-named from the use of such red vessels at the Altar of the Sun where red was the ritual colour, though the original meaning may have been simply "blood red"), peacock green, multi-colour glaze and seventy other rare colour glazes. Its craftsmen have also introduced flame red, lilac, mango green and forty other glaze colours. At an exhibition of Jingdezhen porcelain in Beijing in 1978 was a large porcelain vase called Golden Guilin which was decorated in the rare combination of red, yellow, brown

and black glazes to bring out the city of Guilin's beautiful autumn scenery appropriately.

Jingdezhen eggshell porcelain is an art treasure both in China and abroad. As early as in Northern Song, misty blue porcelain ware with a pale blue glaze was popular for its "thin paste and lustrous surface". Records say that the "egg membrane cups" made by Wu Shijiu in the Wanli reign (1573-1619) of the Ming Dynasty were as thin as cicada wings and that the lines and whorls of one's fingers could be seen through them in the light. Jingdezhen's eggshell porcelain today is less than 0.5 millimetre thick. The patterns painted on such transparently thin porcelain paste may be likened to the shadow of the moon in thin clouds, or green mountains in light morning mist, faintly discernible, fascinating.

Jingdezhen eggshell porcelain objects shown in Beijing in 1978 were distinguished for their great number, rich variety and fine quality. The vessel shapes comprise bowls, plates, cups and dishes and all sorts of vases, showy shadow lanterns, desk and wine sets. The thinness, lustre and whiteness of eggshell porcelain have inspired poets. Here is an ancient verse:

Fearful it would be blown away by the wind,
Worried lest it melt in the heat of the sun.

Indeed, a fitting description of eggshell porcelain. Jingdezhen porcelain sculpture is another widely known traditional product which captures the spirit of people and objects and brings them to life.

In decorative art Jingdezhen porcelain has assimilated and skilfully used in ceramic decoration the good features of traditional brushwork, oil painting, water colour, woodcuts and ornamental designs.

Jingdezhen produces good quality porcelain ware in large quantity and variety.

It finds a market in more than eighty countries and regions. Production has risen from 1977, showing a 28 per cent gain over 1976 in output of utensils of daily use. Output in the first half of 1978 stood at 32 per cent over the corresponding period in 1977, the highest until that date.

Liling County in Hunan Province has become China's second porcelain centre. Liling underglaze porcelain is distinguished by designs covered with white glaze resembling a thin film which gives it unusual clearness and transparency. The colours are fast, designs being painted on unglazed biscuit. It is covered with thin glaze and fired at 1,300°C.

Liling porcelain varieties have increased to over a thousand, including both underglaze and overglaze. Items are for daily use and art appreciation. Liling electrical, sanitary and architectural porcelain is also popular on domestic and foreign markets.

Five hundred years ago, in the reign of Yongle (1403-24), Tangshan in Hebei Province was producing ceramics. This city has thirteen factories turning out a wide variety of ceramic products as well as feldspar powder-processing and machinery repair plants, plus an institute of ceramic research, all forming an integrated enterprise.

Varieties, which have reached 5,200, include utensils for daily use — vats, jars, pots, bowls, plates, cups and ewers — and such art porcelain as table lamps, vases, sculptures and paintings on porcelain plaques. Agricultural, building and industrial porcelain is also produced. After the strong earthquake centred in Tangshan in 1976, the Tangshan Ceramic Company staff and workers rapidly resumed production despite the devastation, even turning out "Magnolia" brand porcelain which was fine in texture and pure as white jade. The clinking of two "Magnolia" cups produces a pleasant melodious sound. Tangshan complete dining sets, confectionery jars and ashtrays

are among the many items produced in this famous brand of porcelain.

The art pottery and porcelain of Shiwan in Foshan, Guangdong Province is known for its mottled glaze and graceful shapes. Presenting important themes such as revolutionary stories and historical legends, or clever small ornaments and toys, flowers, birds, insects and fish, they are always vivid and attractive. Like art pottery and porcelain made at Fengxi in Chaoan County in the province, it has the rich local colour of this important ceramic centre in southern China.

Dehua County is the foremost porcelain producer in Fujian Province, its product being known for pure white colour, lustre and fine texture. A table lamp of Dehua porcelain gives a better creamy white light than a glass lampshade of the same colour. Tea sets of Dehua eggshell porcelain are light in weight and translucent. The colour of tea poured into a cup shows through. Formerly represented by Goddess of Mercy statues, Dehua porcelain now appears in dinner and tea sets and other utensils of daily use.

Yixing in Jiangsu Province is China's long-time pottery centre. The legend that pottery-making was introduced by Fan Li, a high-ranking official of Yue State in the Spring and Autumn Period (770-476 B.C.) has been discredited by excavated materials proving that fine pottery vessels were made in the Yixing area 2,000 years before Fan Li. Yixing produced the well-known purplish brown sandy pottery in Song, the only survivals being teapots made at Dingshuzhen of the Yixing area. These teapots are classically elegant in shape and unsophisticated in colour. Tea brewed in the ware is lasting in colour, aroma and taste. "It ranks first among the tea sets," remarked an ancient connoisseur of pottery. Originally made in fifty varieties, there are 600-plus now. Flower pots "breathe", absorb mois-

ture and prevent root rot and are therefore favoured by gardeners both Chinese and foreign. Among other utensils of daily use are the noted earthen *shaguo* pots that bring out the flavour of food simmered in them.

Many fine traditional art wares of diverse varieties have been revived and improved in recent years. The art of Yaozhou celadon of Shaanxi Province, already famous in China and abroad in Song times but lost for centuries, has been restored through joint research and trial production by the Shaanxi Light Industry Research Institute and Chenlu Ceramic Factory of Tongchuan. Yaozhou celadon ranked together with its contemporary wares: Ding, Ru, Guan, Ge and Jun. Quiet and unsophisticated in shape and durable in texture, the glaze was bluish, lustrous and pleasant, with attractive wide-mesh crackles. Objects with incisive, fluent and unrestrained carved patterns were "designed as cleverly as if moulded, as exquisite as fine, carved jade".

It was this art that was lost in the war disasters of the Kin and Yuan dynasties.

Modern craftsmen studied some three hundred formulas and made more than a hundred experiments before they reproduced ancient Yaozhou celadon with authentic glaze colour, carved designs, veiled radiance and wide-mesh crackles. Some twenty types of products are now produced, including art porcelain, dinner, tea, wine and smoking sets.

Among other famous wares that have been revived is the Ru, which was first made in Linru County, Henan Province. Winning great fame in Northern Song, the ware spread to Southeast Asia, Japan and countries of Western Europe. In late Northern Song, Kin troops attacked the dynasty and the art was lost with the destruction of the Ru kilns, as later dynasties failed in attempts to imitate the ware. After liberation the Ru Porcelain Factory finally succeeded in firing the colour glazes of Ru ware after

a thousand experiments carried out over fifteen years. The colour glazes included subdued powder green, pea green resembling jade or sea water, as well as solemn shrimp blue and the tea-dust of ancient simplicity. The revived Ru ware has a thick glaze and soft lustre. Attractive pear-skin mottles appear under the glaze, while on its surface are veiled crisscrossed streaks like crab-claw marks which together with the minute wide-mesh crackles form sesame-flower patterns. These are called "pear peel, crab claws and sesame flowers", unique features of Ru ware. Orders for the ware, exhibited at the Guangzhou Commodities Fair for the first time in the autumn of 1972, were filled at once.

Jun ware was named after Junzhou Prefecture, under whose jurisdiction Yuxian County in Henan Province was placed in ancient times. This porcelain, introduced in Tang and mature in Song, thus has a history of over a thousand years. Today's Jun ware has inherited the tradition of Song Dynasty Jun porcelain in vessel shape, paste texture and glaze colour. One variety with a paste the colour of sheep's liver is durable and compact, its shape possessing classical elegance. This type has a multi-coloured glaze of furnace transmutation resembling rosy clouds at evening. It is claimed that "each individual product of furnace transmutation has its unique features", that is, pieces fired in the same furnace emerge with different colour patterns. The ancients said in describing the charm of Jun porcelain colouring, "In a twinkling a green mountain becomes misty at sunset."

The ancient site of Guan ware was at the foot of Phoenix Hill in Hangzhou. After Southern Song had established its capital in Linan (today's Hangzhou), the government set up two official kilns in the city to manufacture art ware and utensils for daily use,

and these were among famous Song kilns of the time. Guan ware celadon in particular had a kingfisher green tint as lustrous as jade — an art treasure in ancient Chinese porcelain.

To revive the porcelain ware of Southern Song government kilns, ceramic researchers and workers carefully analyzed and assessed the chemical composition of the paste and glaze, the composition of the burning gases and temperature for porcelain firing. Finally, they gained the necessary skill in controlling furnace temperature and degree of firing to achieve ideal glaze colour. Recent products are such art souvenirs as figures of the famous ancient court beauty Wang Zhaojun and of Maitreya Buddha; also vases with double handles, octagonal vases and desk ornaments. These objects have been admired for ingenious shape, vigorous lines, lustrous glaze colour and quiet, elegant taste.

Longquan celadon of Zhejiang Province was also a famous ware of the Song Dynasty. Its verdant glaze colour imparted a feeling of pleasant ease. The ware aroused great interest in Europe in the late 16th century. To revive this ancient famous porcelain, trial manufacture was started in 1956, the Longquan Porcelain Factory being set up two years later. Faculty members and students of the Central Academy of Fine Arts designed over 50 new varieties of products while working in the factory in 1956. These objects retained the elegance of Song porcelain ware, though they were more precise in shape and decoration.

Almost every area in China produces ceramics. Ancient ceramic art flourishes again, ceramic products of different places preserving distinct national style and rich local colour. The pottery and porcelain of the new China contend for beauty as lovely flowers in a garden.

CHAPTER 10

Chinese Pottery and Porcelain in World Culture

Chinese pottery and porcelain play an important role in the economic, cultural and friendly exchange which has long existed between the people of China and other countries. Entering the international market very early, they became known to the world for their beauty and usefulness, and they became symbols of international friendship.

SECTION 1

Export of Chinese Pottery and Porcelain Wares

As early as in the 3rd century B.C., China became world-famous for its silk fabrics, trading silk for products of West Asian countries before the Han Dynasty. In the 2nd century B.C. Zhang Qian of the Western Han Dynasty went twice on diplomatic missions to the Western Regions and established ties between China and a number of countries west of the Pamirs. The first mission was in 138 B.C., the second sixteen years later.

Large quantities of silk fabrics flowed along the road leading to Central Asia, while merchants from the Western Regions frequented it on visits to China. The Han court entertained these merchants with "lakes of wine and forests of meat"; the emperor invited some to accompany him on imperial excursions, indicating the value placed on international trade by the Han Dynasty. This east-west thoroughfare of 7,000 kilometres was the world-famous Silk Road (fig. 38).

The barrier of the Taklimakan Desert in Xinjiang diverted travellers north or south of the desert, the southern route taking them from Changan to Dunhuang, through Kroraina (Qarkilik, east of today's Ruoqiang County), Khotan (today's Hotan) and Yarkant across the Pamirs to Indoscythae (in the central part of today's Amu Darya valley, the main areas of Indoscythae being in today's Afghanistan). From there the southern route led to Parthia (Persia, today's Iran) and then west to Tajiks (today's Iraq or Arabia) and Rome (the Roman Empire,

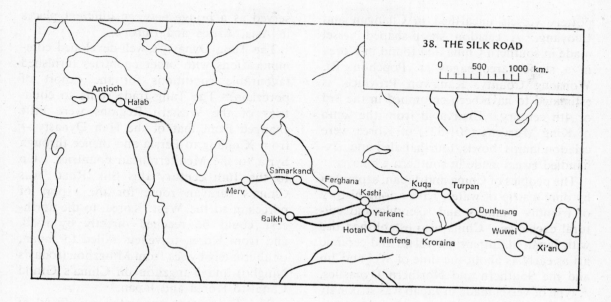

38. THE SILK ROAD

0 500 1000 km.

the eastern part of the Mediterranean). From Changan and Dunhuang the northern route passed through Cheshi Front State (Qoco, today's Turpan, whose capital was Yarkhoto), Qiuci (today's Kuqa in Xinjiang), Kashgar (today's Kashi), across the Pamirs to Dayuan (Farghana, today's Ferghana in the Soviet Union), Sogdiana (today's Samarkand in the Soviet Union), and continued southwest through Parthia to Rome.

This Silk Road of more than 2,000 years ago was the route along which China's pottery and porcelain and silk fabrics were transported west. Vast deserts and perennially snow-capped mountains challenged the camel caravans, these "ships of the desert", throughout the length of the Silk Road. Ancient caravans travelled day and night, braving wind and snow, for friendly trade relations with other countries — a herculean effort!

Chinese sea navigation also goes far back into history. In Qin and Han times Chinese north-south coastal shipping lanes linked China with many countries via the sea. After Emperor Wudi of the Han Dynasty, sea voyages between China and Japan became more frequent, while in the south, sea navigation developed between Chinese and Indian Ocean ports and also points west.

A book, *Ancient Chinese Pottery and Porcelain Exported to Southeast Asia* by Han Huaizhun, reports the discovery of celadon incised with wave patterns and fired at very high temperatures in the Johore River valley at the southern tip of the Malay Peninsula. A blue-green glazed *kui* food vessel of the Han Dynasty with dragon-shaped handle was found in Sambas, West Borneo by personnel of the Djakarta Museum of Indonesia. A Han pottery jar with double handles is part of a collection in Ind-Rugire and one with a cover was discovered in central Java, indicating that as early as 2,000 years ago Chinese pottery reached southeast Asia by sea.

China has had close and friendly economic and cultural exchange since ancient times with neighbouring Korea, and this further developed in the Western Han Dynasty. Glazed pottery vessels with hunting motif discovered in an ancient tomb in Pyongyang, Korea are virtually identical with Han glazed

pottery vessels unearthed in Changan and Luoyang. A celadon sheep-shaped vessel made in southern China and found in Korea in a stone sarcophagus at Popchon Ri, Wonsong County, Kangwon Province, is estimated to have been entombed in the 3rd or 4th century. Excavated from the tomb of King Muryeng (501-523) of Korea were celadon lamps, bowls, four-handled and six-handled ewers made in southern China.

The peoples of China and Japan, separated by only a strip of water, have a long history of friendly contacts and scientific and cultural exchange. China also established ties with Japan in pottery, porcelain and ceramic art as early as about the time of Wei and Jin and the Southern and Northern Dynasties. A type of vessel made in Japan was strikingly similar to Chinese quintuple jars made in the late Eastern Han Dynasty, a result of mutual influence between China and Japan in utensil manufacture. Japanese books also note that Chinese tailors and potters arrived in Japan and helped in developing their respective products for the Japanese people's use. Among the treasures housed in Horyuji Monastery on Nara's outskirts is a celadon four-handled perfume container made in southern China between the 3rd and 6th century.

Only since the early Tang Dynasty, however, around the 7th century, has Chinese pottery and porcelain been exported in large quantities, and in China's feudal period Tang was porcelain's flourishing age. China then, united and with a thriving economy and blossoming culture, was a foremost civilized and prosperous country in the world on which the eyes of many others focused. Envoys, students, merchants and monks from Asian and African countries were attracted to China; Tang Dynasty Chinese also continually visited or traded with other countries. Located in central Asia, China, the "Middle Kingdom", had frequent contacts with other countries and served as a bridge between different places in Asia, Africa and Europe.

The Tang Dynasty's well-developed communications with other countries furnished favourable conditions for the export of porcelain. The Tang trade route to countries of the Western Regions were little changed from that of the Han Dynasty — from Xinjiang to Persia and thence through Syria to the Mediterranean countries. Up to the 16th century this Silk Road was China's caravan route for the export of porcelain to the West. Korea, to the northeast, could be reached directly by road, and from Korea travellers sailed to Japan, or alternately by sea from Mingzhou (today's Ningbo) and Yangzhou on China's Grand Canal to Korea and Japan.

The Tang court appointed an official at Guangzhou to be in charge of sea navigation, shipbuilding and foreign trade, Guangzhou being an important Chinese port for voyagers travelling to countries of Southeast Asia and from there to the Malay Peninsula, Persian Gulf countries and along the Mediterranean coast to Egypt and Syria.

Shipbuilding flourished in Tang Dynasty China, the sea-going vessels measuring about seventy metres long and surpassing Tajik ships in capacity and storm resistance. Tang ships carried six to seven hundred passengers and made frequent voyages between Guangzhou and the Persian Gulf. Dozens of types of foreign vessels also frequented China's ports. These included ships from the South China Sea, Kunlun, the Lion Country (Sri Lanka), Brahmin (India), the Western Regions and Persia. Porcelain was a prime item in the diversified cargo on these ships.

Chinese ceramic art matured in the affluence of the Tang Dynasty. Its celadon was "blue as the sky, clear as a mirror, thin as paper, resonant as a stone chime". The vessels were carved with the patterns of flying white cranes, magical dragons riding

the waves, kingfishers spreading bright-coloured wings and butterflies lingering on flowers. Wonderful craftsmanship indeed! Celadon of Yue ware was also highly valued in international trade. It was exported to Japan in the east and to India, Persia and Egypt in the west.

In 851 (the 5th year of the Dazhong reign in the Tang Dynasty) the Arabian merchant Sulayman wrote in his travel notes: "The Chinese make pottery clay vessels as translucent as glass. Wine poured into them can be seen from outside." Buyers from various countries vied with one another to buy large quantities of such vessels and ship them abroad, many porcelain objects being exported as well to neighbouring Korea, Japan and Southeast Asia. In Korea was discovered a blue-green glazed ewer with brown splashes and appliqué designs made in a Changsha kiln in Hunan Province on which was inscribed in Chinese characters "Made by the Bian family, it has a small mouth and is famous throughout the empire". Tang tri-colour glazed pottery vessels and more than thirty pottery head-rests with twisted glaze were discovered in a layer of burnt clay between Kondo (Great Hall) and the lecture hall in the Daianji Monastery in Nara, Japan. Porcelain ware of the Yue kilns was found in the Riminji Monastery on Koga Road, Tasaifu in Fukuoka. Chinese ocean shipping to Japan increased after the 8th century, ships usually sailing from Mingzhou (Ningbo) and putting in at Fukuoka port.

In 1974, several hundred porcelain objects were discovered on and around a sunken ship at the mouth of the Yuyao River in its Tang Dynasty location, now Zunyi Road in Ningbo. These were appraised to be also celadon of Yue ware and blue-green glazed porcelain with brown splashes of the Changsha kiln. A square brick inscribed in Chinese characters, "5th year of the Qianning reign" (A.D. 898) was found at the

same time, dating it with the porcelain vessels, whose fine quality is attested by their clear, lustrous glaze. It seems likely that the shipwrecked porcelains were part of a consignment packed and ready to be sent to Japan or Korea. The items had apparently been newly fired.

In Southeast Asia, Han Huaizhun, the author of *Ancient Chinese Pottery and Porcelain Exported to Southeast Asia*, picked up a considerable number of celadon shards at the ancient site of Johore valley and collected two *zun* wine vessels with double handles in Brunei, Borneo, one black-glazed and one green-glazed, both of the Tang Dynasty. These ewers were identical to those retrieved from a Tang tomb at Anxi, Fujian Province. On display in the Museum of Chinese History is a photograph of a well-preserved, double-handled, green-glazed jar with brown splashes unearthed in Indonesia. A celadon *zun* wine vessel with four handles was discovered in Pahang, Malay Peninsula.

Frequent discoveries of Tang pottery and porcelain have been made in countries along the much-travelled ancient navigation routes. Late Tang celadon ewers of Yue ware and porcelain bowls of the Changsha kiln were found in Bandhore, a main port on the Indus River (on today's eastern outskirts of Karachi, Pakistan), and other items of late Tang and Five Dynasties Yue ware celadon were found in Arikamedu on India's southwestern coast.

No few Chinese pottery and porcelain shards have been unearthed in Siraf, a major Arabian port on the Persian Gulf. The Tang white porcelain and Yue ware celadon which attracted much attention were precisely the exquisite ware which the local merchant Sulayman saw and praised while in China.

Al Fostat, a city on Cairo's southern outskirts in Egypt, prospered in the 9th century but fell into decay in the early 13th

century. Japanese scholars collected some 600 shards of Yue ware celadon, many of Tang white porcelain and of Tang tri-colour glazed pottery — remains of objects sent to Egypt in the 9th century when the Egyptian city thrived, showing the extent of distribution of Tang pottery in this direction.

Tang pottery and porcelain was also transported along the Silk Road to Central and Western Asia. Historical records of the 9th century say that Al b·Isa, governor of Khorasan in Iran, offered twenty Chinese fine porcelain objects and 2,000 ordinary porcelain vessels as tribute to Hārūn (al-Rashīd) (785-809), king of the fifth generation of the Abbassid Dynasty — all transported by camel caravan along the Silk Road.

The Song Dynasty from its founding highly valued foreign merchants. *Administrative Statutes of the Song Dynasty* (a book treating extensively the dynasty's government and economics) records that in 987 the Song emperor Taizong "sent eight eunuchs with imperial edicts and gold and fabrics of silk out to travel along four route to other countries. . . . Two edicts with blanks to be filled in were carried on each route to be distributed at places of destination". These were invitations for foreign merchants to trade in China. In Southern Song, with territory reduced and finance in trouble, the court relied increasingly on "profit from foreign trade" and spared no efforts to encourage this. At that time more than fifty countries traded with China.

China's porcelain was a major export item during Song. Zhu Yu of the time noted in his *Pingzhou Table Talk* how foreign merchantile ships anchored at Guangzhou. "The ships were several hundred feet long, and wide. Merchants divided space in the ships for stowing goods, each getting several square feet of floor space, while they slept above. Most of the goods were ceramic vessels, one placed within another according to size, with little space between." The extent of porcelain export may be judged from this. To prevent money drain the Southern Song government in 1219 proscribed the use of gold, silver and bronze coins in foreign trade, silk fabrics and porcelain ware being bartered for foreign goods instead. This regulation placed porcelain in a dominant position in foreign trade.

Song porcelain exports in the main followed the routes of the Tang Dynasty — in the north along the Silk Road, and in the south by sea. *Administrative Statutes of the Song Dynasty* lists the following countries as recipients of Chinese porcelain: Tajiks, Kra (on Malay Peninsula), Java, Campa, Brunei, Mait, Sriwidjaja, Pandurainga, Dharmaraja and even Malabar of India and the ancient kingdom south of Somali in eastern Africa which became Zanzibar.

Among Europeans who came to Quanzhou in late Southern Song were Dutch merchants who bought porcelain and sold it in Europe weight for weight at the price of gold. And even so, demand exceeded supply. No little Song porcelain was also transported to Africa. The Egyptian King Saladin presented forty Chinese porcelain objects to King Nur-eddin of Damascus in 1171.

The Yuan Dynasty established well-equipped posts for protection of trade routes, and here couriers changed horses or rested. This facility promoted the export of porcelain ware, and Quanzhou in Yuan became a major world port. Marco Polo (c. 1254-1324), an Italian traveller in East Asia, describes Quanzhou thus in his *Travels of Marco Polo*: "The city is very large. . . . All Indian ships carrying perfume and all other precious goods come to this port." Guangzhou was also important, the Moroccan traveller Ibn Abdullah (1304-77) recording in his travel notes what he saw and heard there: "No big city elsewhere in the world can match this one in

the splendor of its markets. But the biggest of all markets are its ceramic shops. Merchants ship porcelain from the city to different provinces in China as well as to India and Yemen." He also said: "The Chinese ship porcelain ware to India and other countries, and to my homeland Morocco. These ceramics are indeed the best in the world."

During the Yuan Dynasty, the Chinese traveller Wang Dayuan twice sailed to India, the Arabian Peninsula, Persia, countries along the Mediterranean, and the region that is Tanzania today on the east African coast, and recorded his experiences in a book entitled *A Concise Description of Foreign Islanders*. He says: "Karman [in the Persian Gulf of today's eastern Iran] is situated in Western Asia and near Farang.... All putchuk and amber were produced in Farang, and merchants shipped them to the west. We took out such goods as clove and cardamom ... coloured satins and brocades of Suzhou and Hangzhou, blue-and-white porcelain vessels and porcelain vases, and pig-iron, and we brought back pepper on our return journey."

Now, the Philippines, Malaysia, Singapore and Indonesia in Southeast Asia, Iran, Turkey and Iraq in central Asia, and Egypt in Africa have preserved many exquisite celadons including Longquan, underglaze red and blue-and-white porcelain, as well as wares of the Jizhou and Dehua porcelain kilns. Korea and Japan also have a larger number. Longquan celadon, black-glazed porcelain and white porcelain of the Jun and Jizhou kilns were salvaged in 1977 from a sunken Chinese ship of the Yuan Dynasty discovered southwest of South Korea. The cargo was obviously bound for Korea or Japan.

Early in the 15th century, the great Chinese navigator Zheng He with a retinue of over 27,000 people made the first of his seven expeditions to countries of the South Sea, and to India, Persia, Arabia and as far as the east African coast. These passed more than thirty countries and continued through the reigns of Yongle, Hongxi and Xuande for altogether thirty years.

Gong Zhen, who accompanied Zheng He on these voyages, says in the preface to his book *Foreign Countries in the West* that the sea-going ships they sailed on were "so towering and majestic that none can rival" — presumably the world's largest vessels at that time. The countries that Zheng He and his retinue visited often sent envoys back with the ships to China, and so established political, cultural and trade relations, particularly the latter.

China traded porcelain ware, textiles, metal vessels and money for perfume, spices, medicinal herbs, pearls, coral and gems. Silk fabrics, jade objects and porcelain were presented to envoys who visited China from other countries. Since the blue-and-white porcelain of Jingdezhen was fashionable during the reigns of Yongle and Xuande, it was certainly the principal ware sent abroad.

Fei Xin in his *Travel Notes on Wonderlands* and Ma Huan in *Travels on Distant Horizons* both tell how highly Jingdezhen blue-and-white was esteemed abroad. Both wrote first-hand, as they were with Zheng He on his diplomatic missions abroad. Porcelains in Southeast Asian museums likely date from that time. Blue-and-white porcelain shards have been unearthed in various parts of Southeast Asia.

Longquan celadon of Chuzhou was also a big export item in Ming times, its shards having been discovered in Southeast Asia and Japan. In the late 16th century, French buyers were astonished at the lustrous jade-like texture of Longquan celadon when it appeared in French markets. It was they who applied the word "celadon" to the ware, using the name of the hero in *Shepherdess Astrée*, a novel by Honoré d'Urfé. In a stage version, the shepherd Céladon, As-

trée's lover, appears in an attractive costume the colour of Longquan porcelain, and so he gave the ware his name.

The Portuguese in 1498 joined other merchants travelling to the East to obtain the famous Jingdezhen porcelain. Then the Dutch gradually gained influence in the East and established the East Indies Company in India in 1602 which traded in porcelain ware. *Porcelain and the East Indies Company of the Netherlands* tells us that at least 16 million Chinese porcelain vessels were exported by that company alone between 1602 and 1682, and there were others, bringing export volume far above that figure.

It was between the Wangli reign of Ming and the Kangxi reign of Qing that blue-and-white porcelain was the main product of the Jingdezhen kilns, and it must have accounted for a very large proportion of China's exports. Apart from a large European market, the continents of America, Africa and Australia bought Chinese porcelain ware directly or indirectly, and early in the Qing Dynasty Chinese porcelain spread to countries all over the world — Borneo, Java, Sumatra and Malaya receiving large consignments of it. After the Ming Dynasty, Japan and Korea continued to cherish Qing porcelain as they did Ming, and provided good markets.

The development of economic and cultural exchange between China and other countries spurred the spread of exquisite Chinese pottery and porcelain, perfected over millennia, to all corners of the earth. The wares carried the wisdom and friendship of the Chinese people to the people of other countries and added splendour to the civilization of mankind.

SECTION 2

The Art of Chinese Porcelain Goes Abroad

Large-scale export of Chinese porcelain carried its art far and wide, so that potters of other countries learned the techniques.

Korea was the first to emulate the art of Chinese porcelain-making, the technique arriving there in 918 (the fourth year of the Zhenming reign of Later Liang during the Five Dynasties period in China). In the early stage the Koreans imitated the celadon of Yue, Ru and Yaozhou wares with great success. Xu Jing who went on a diplomatic mission to Korea in 1123 (the fifth year of the Xuanhe reign of Northern Song) says of Korean celadon in his book *Descriptions of Korea*: "The Koreans call the pale greyish green of ceramic glaze the colour of green jade. They have attained clever craftsmanship in recent years, especially in colour shades." In the 15th century they used Chinese Mohammedan blue to imitate Chinese blue-and-white porcelain, the objects resembling the blue-and-white of Jingdezhen. They were described as "similar to the products of Jiangxi Province" (where Jingdezhen was and is located).

Japan studied the art of Chinese porcelain-making in Southern Song. In 1223 (the 16th year of the Jiading period in Southern Song) during the reign of the Japanese Emperor Omi Tenno, Kato-Shirozaemon-Koremasa of Yamashiro arrived with Dougen Zenji in Fujian, China, to study the porcelain-making art. They stayed for six years, then after returning to Japan they manufactured black-glazed porcelain in Owari in the city of Seto. The Japanese called the product "Seto ware" and Kato "ancestor of ceramics".

In 1506 (the first year of the Zhengde reign of the Ming Dynasty) Japan sent the envoys

Ryoan and Keigo to China. Goroudayu, who came in their retinue, took the Chinese name Shonyon Zui. During his five-year stay in Jingdezhen, Shonyon Zui concentrated on learning how to make blue-and-white porcelain. He later opened a kiln in Arita, Hizen in Japan to reproduce the ware. Later he also made porcelain vessels on Kaseyama hill near Nara. Subsequent Japanese porcelain kilns modelled after Chinese bluish white, white, black, purple, and polychrome glazes as well as blue-and-white porcelain. Although the vessels were not excellent, every variety was reproduced, according to the Preface to the reprinted edition of *Description of Pottery* written by Kasai Inze of Japan. Shonyon Zui clearly made a great contribution to Japanese porcelain by studying the art of Chinese porcelain-making.

In the West, Egypt first succeeded in imitating Chinese porcelain. A country with a rich tradition of pottery-making, Egypt already had glazed pottery by the time of China's Yin Dynasty (c. 14th-11th century B.C.). In the Fatimid Dynasty of Egypt (A.D. 969-1171, or corresponding to the 2nd year of the Kaibao reign to the 7th year of the Qiandao reign of the Song Dynasty) an artisan named Sa'd imitated Song porcelain and taught the art to many apprentices. In the Mameluke dynasties (when the sultans were drawn from enfranchised slaves) the Egyptians imitated Chinese porcelain ware on a large scale. Relics excavated from the ancient city of Cairo in Egypt show their imitation blue-and-white porcelain vessels in the 14th and 15th centuries to simulate Chinese examples in shape and patterns.

Persia also very early imitated Chinese porcelain. In the 11th century the art of Chinese porcelain-making spread to Rhages in Persia, where craftsmen improved porcelain skills based on the Chinese. Many 13th-century porcelain vessels with decorative designs showing Chinese influence — plates, dishes, ewers, vases and bowls — were discovered in Sultanabad, Iran. Motifs include human figures with Mongolian features, lotus, dragon and phoenix. In the 13th century when the Ilkhans headed by Hulagu Khan (1219-65) ruled Iran, a thousand Chinese craftsmen, technicians and their families were invited to Iran, and the porcelain vessels may be the products of these craftsmen. In the 16th and 17th centuries, Abbas of the Safavid Dynasty endeavoured to develop the porcelain craft and again invited several hundred Chinese porcelain craftsmen and their families to settle in Isfahan, Iran. The Chinese passed on their art of porcelain-making to Iranian craftsmen. Abbas held an exhibition of Chinese porcelain in the Great Hall of Audience in Ardabil for the benefit of the Iranians.

The art of making Chinese porcelain spread from Persia through several other countries to Arabia. The porcelain ware of Raqqah in Iraq retained a distinctive Chinese style in the 11th and 12th centuries. The Arabians in turn passed on their technique of imitating Chinese porcelain to Europeans, spreading it to Italy in 1470. Maestro Antonio, a Venetian alchemist in Italy, learned the art of Chinese porcelain-making and manufactured light, thin and translucent porcelain objects. Craftsmen of Pisa in 1627 made blue-and-white bowls of soft porcelain. Italy soon passed the art on to Delft in the Netherlands. Soft porcelain with traditional Chinese designs of dragon, phoenix, flowers and birds was made in Delft in 1624. Ming Dynasty blue-and-white influence is obvious in this and in the porcelain decoration of other countries.

While porcelain originated in China, the development of ceramic art depended much on mutual promotion. The phoenix-head ewer (fig. 39), a typical Tang shape, was remodelled after a Persian silver vase. The

39. Phoenix-headed ewer of Tang Dynasty.

influence showed especially in the decoration. Besides the phoenix head on the vessel's lid and mouth-rim, the ewer had a curved handle in dragon form from mouth to bottom. However, the entire body was decorated with Persian and Western Regions motifs — grapes, drifting clouds, honeysuckle, scrolls, lotus petals and strong men dancing in boleros with torsos exposed.

Chinese ceramics in the Yuan and Ming dynasties also assimilated techniques from foreign pottery and porcelain. An example is a blue-and-white porcelain vessel shaped like a metal vessel popular in Central Asia that has a straight tube for mouth and neck and a round ball for a belly. This magnificent and solemn bottle-shaped vase was used as an ornamental or sacrificial vessel. Such vases were made at Jingdezhen up to the late Qing Dynasty.

It is now worthwhile for China to learn from ceramic production in many countries of Europe and America, and from Japan, where great advances and innovations have been made in ingredients, shape, glaze colour and painted designs.

Plates

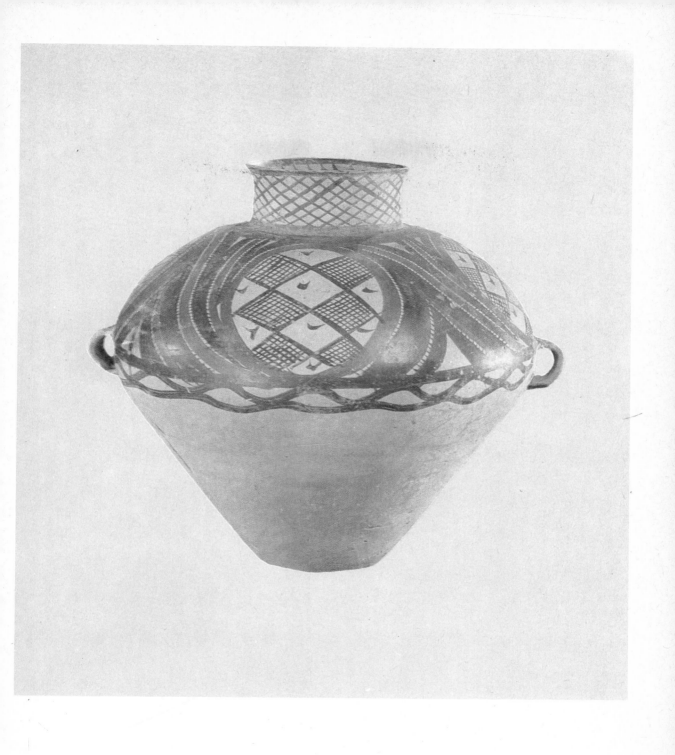

1. Painted pottery twin-eared ewer Majiayao Culture Height: 41.5 cm.

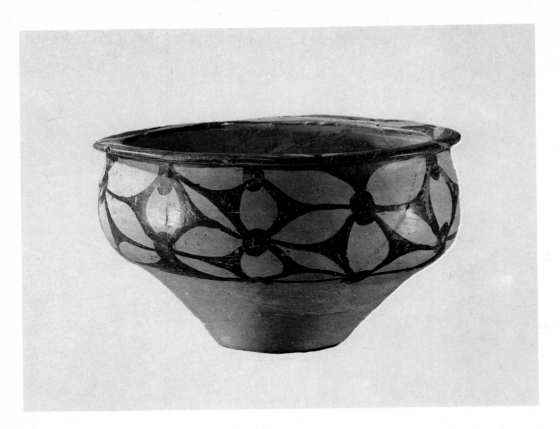

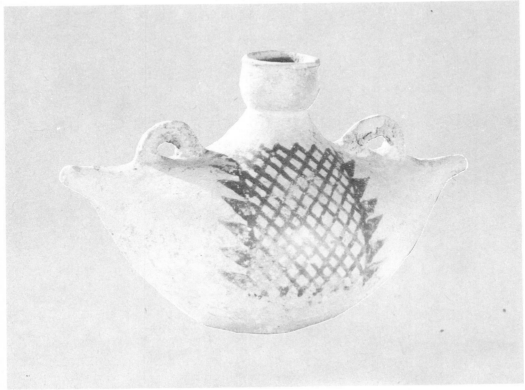

Upper: **2. Painted pottery basin** Yangshao Culture Height: 11.5 cm.

Lower: **3. Painted pottery boat-shaped ewer** Yangshao Culture Height: 16.3 cm.

**4. Painted pottery amphora
with whorl patterns**
Majiayao Culture
Height: about 48 cm.

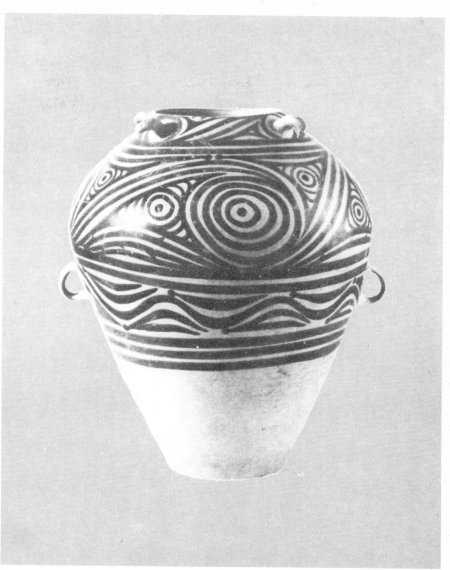

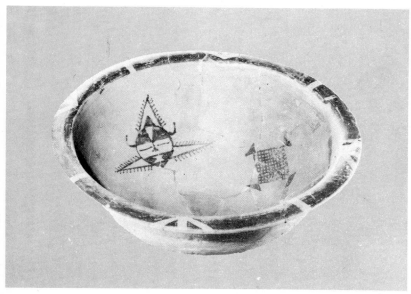

**5. Painted pottery basin with
human face design**
Yangshao Culture
Height: 17 cm.
Diameter: 44.5 cm.

6. **Painted pottery amphora with human face and salamander design**
Yangshao Culture
Height: 38 cm.

7. **Black pottery high-stem cup**
Longshan Culture
Height: 20 cm.

8. Cocoon-shaped ewer with painted designs
Western Han Dynasty (206 B.C.-A.D. 24)

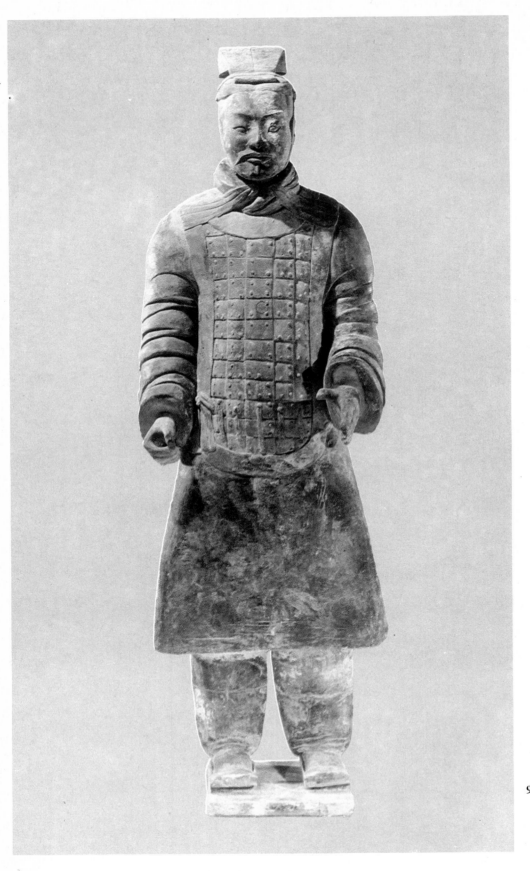

9. **Pottery warrior officer figure**
Qin Dynasty
(221-207 B.C.)
Height: 196 cm.

10. Pottery horse figure Qin Dynasty (221-207 B.C.) Height: 172 cm. Length: 205 cm.

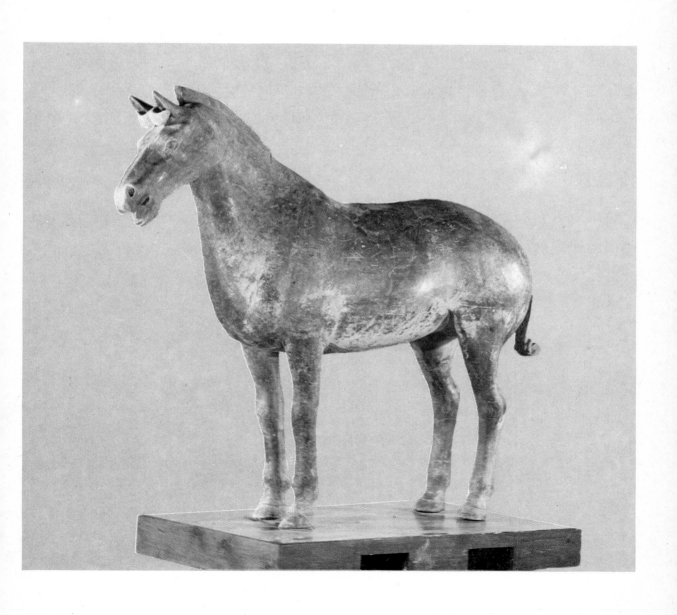

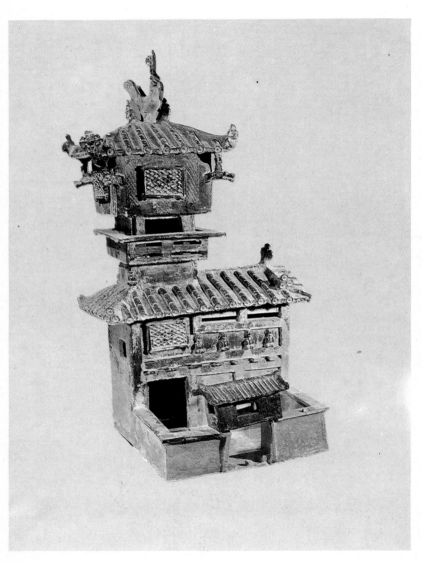

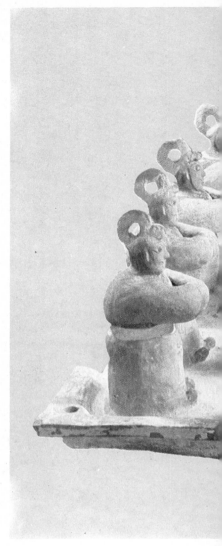

11. Green-glazed pottery multi-storeyed building
Eastern Han Dynasty (A.D. 25-220) Height: 91.5 cm.

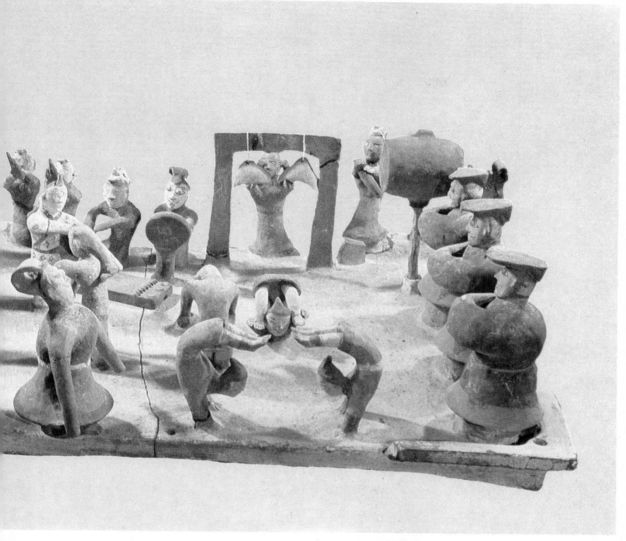

12. Group of painted acrobat figurines
Western Han Dynasty (206 B.C.-A.D. 24)
Height: 22 cm. Length: 67 cm.

13. Pottery ship
Eastern Han Dynasty (A.D. 25-220)
Length: 54 cm.

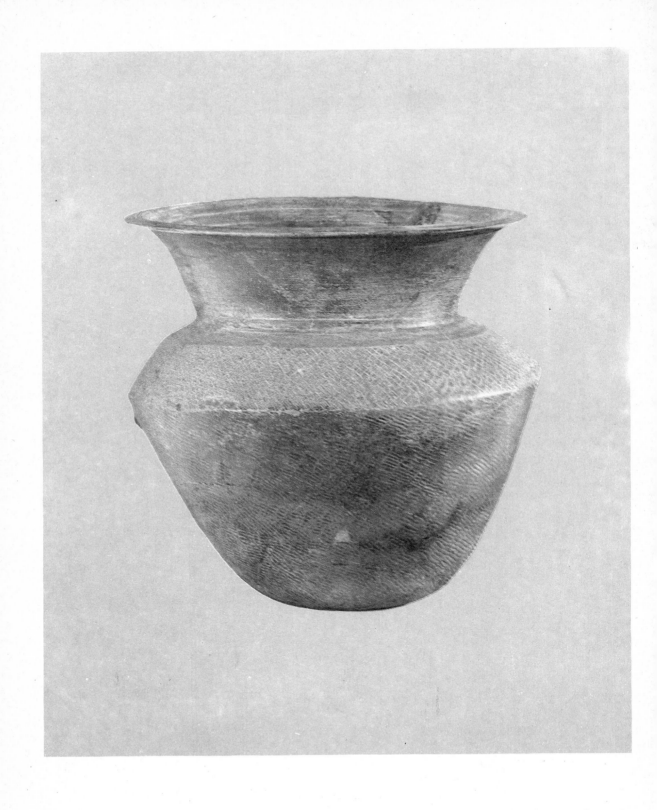

14. Proto-celadon *zun* **wine vessel**
Shang Dynasty (16th-11th century B.C.) Height: 28.2 cm.

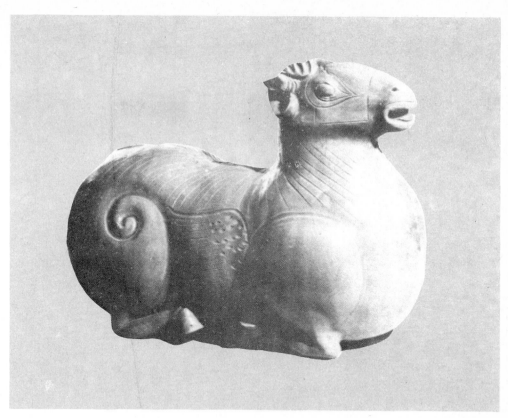

15. Celadon sheep-shaped vessel
Western Jin Dynasty (A.D. 265-316) Height: 19.4 cm.

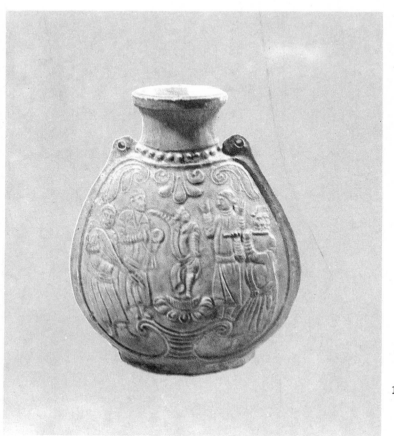

16. Yellow-glazed flat ewer with design of dancers
Northern Qi Dynasty (A.D. 550-577) Height: 20.5 cm.

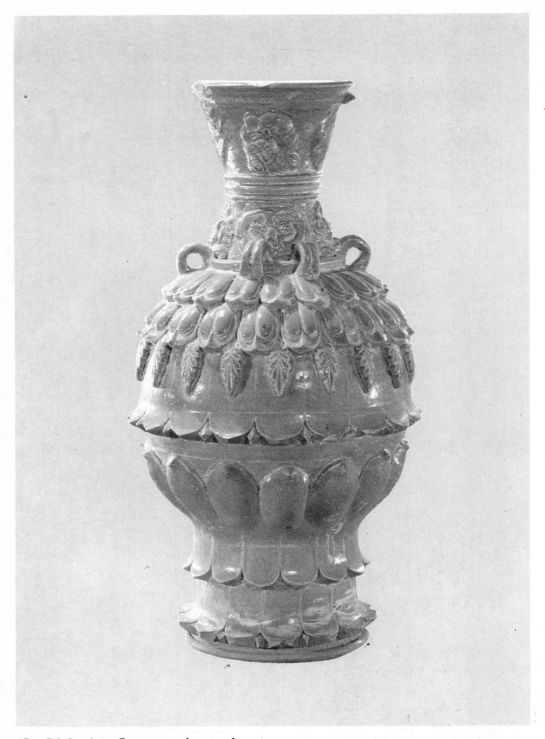

17. Celadon lotus-flower *zun* **wine vessel**
Northern Dynasties (A.D. 386-581) Height: 66.5 cm.

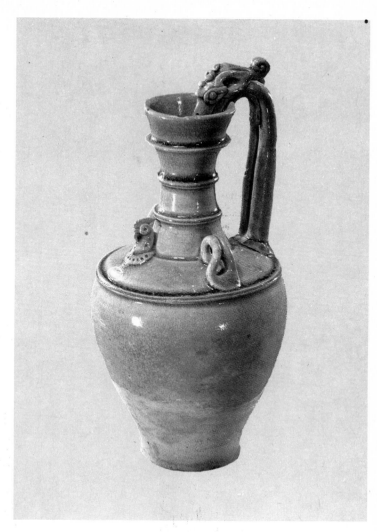

19. Green-glazed chicken-head ewer
Sui Dynasty (A.D. 581-618) Height: 27.2 cm.

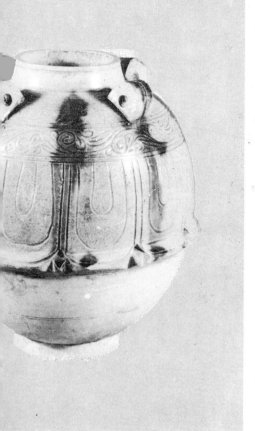

18. Four-looped jar of yellow glaze with green splashes
Northern Qi Dynasty (A.D. 550-577) Height: 18 cm.

20. **White porcelain figurines of attendant officials**
Sui Dynasty (A.D. 581-618) Height: 72 cm.

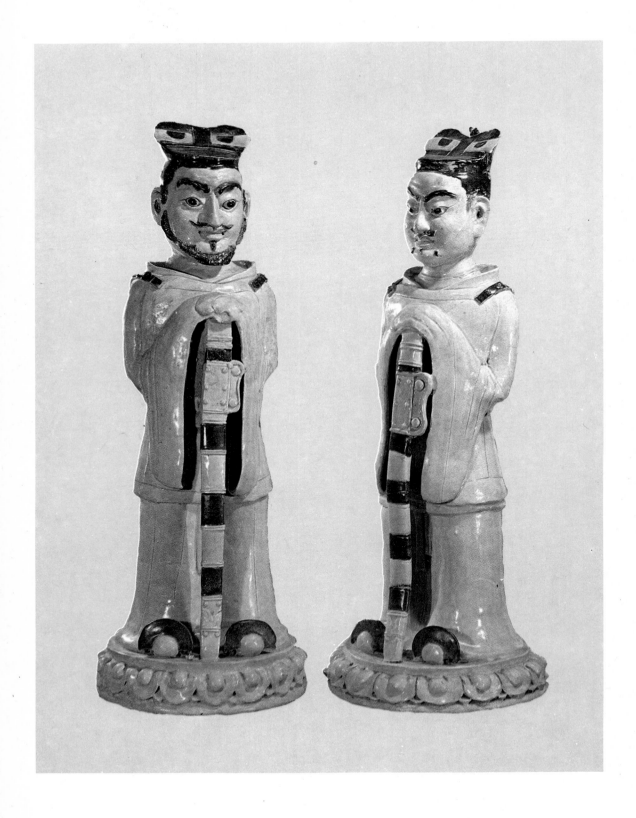

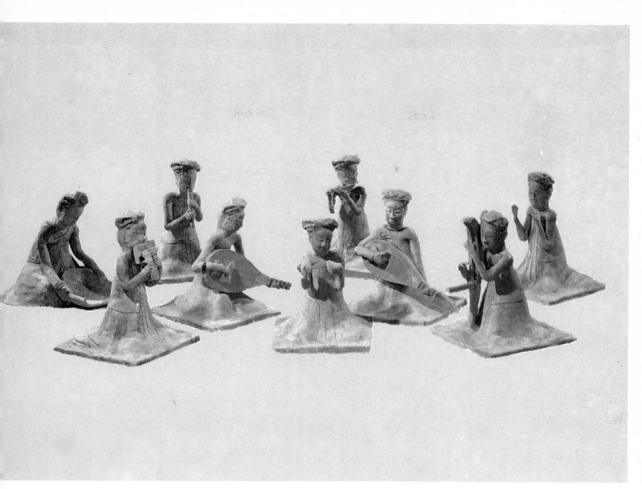

21. Figurines of musicians Sui Dynasty (A.D. 581-618) Height: 17.2-19 cm.

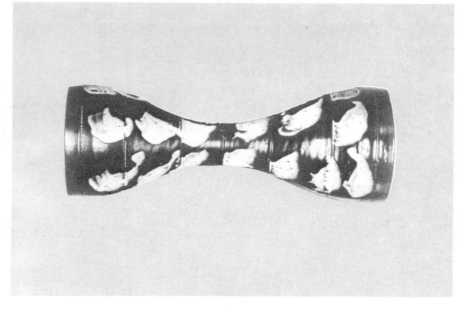

22. Black porcelain waist drum with splashes of contrasting colour
Tang Dynasty (A.D. 618-907)
Length: 59 cm.

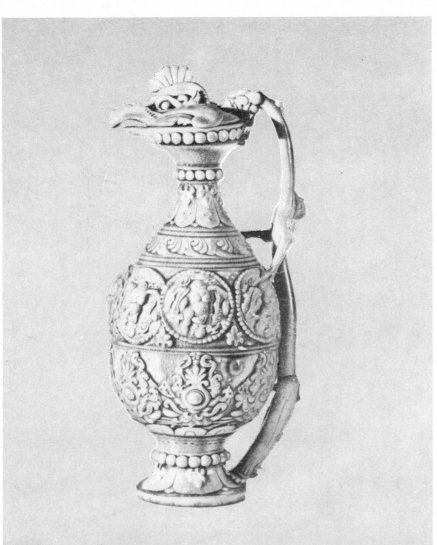

23. **Celadon phoenix-head ewer**
 Tang Dynasty
 (A.D. 618-907)
 Height: 41.2 cm

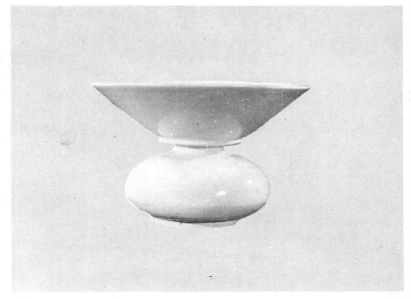

24. **White porcelain cuspidor**
 Tang Dynasty (A.D. 618-907)
 Height: 10.5 cm.

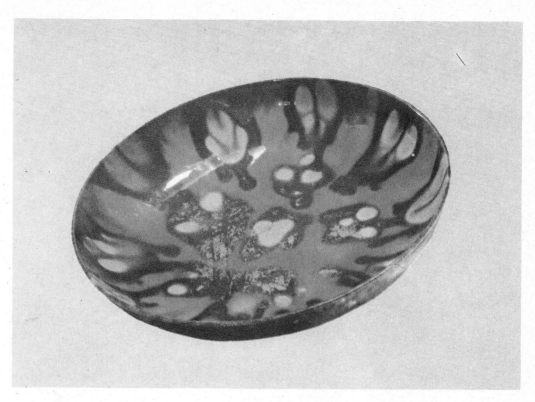

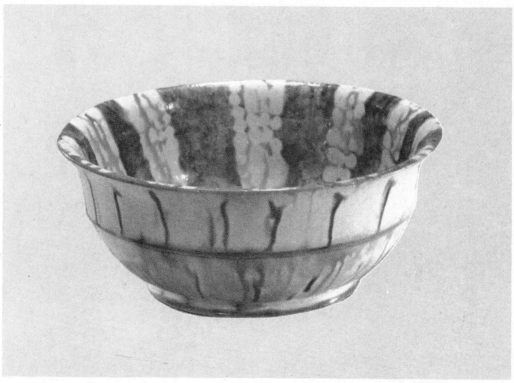

Upper: **25. Tri-colour pottery plate**
Tang Dynasty (A.D. 618-907) Height: 2.7 cm. Diameter: 15 cm.

Lower: **26. Tri-colour pottery bowl with folded waist**
Tang Dynasty (A.D. 618-907) Height: 7.5 cm.

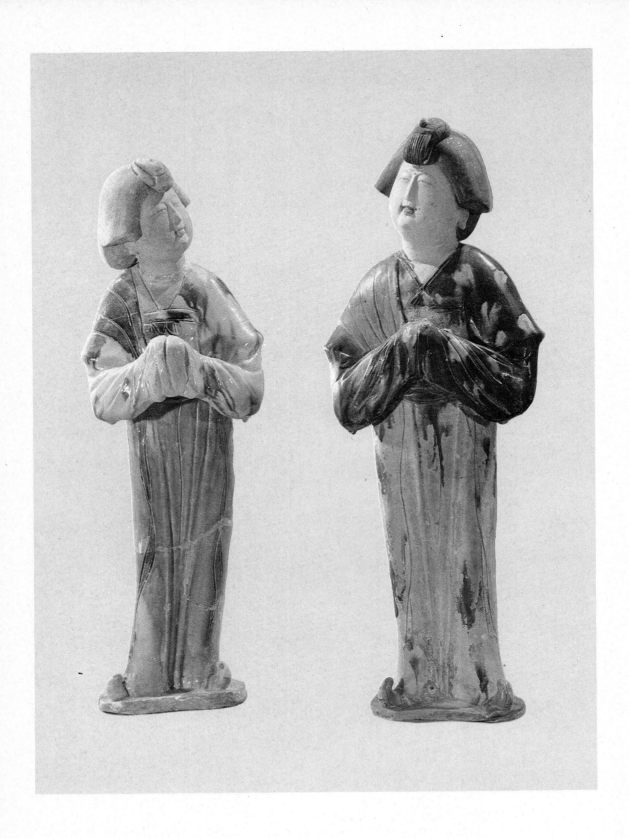

27. Tri-colour pottery woman figurines
 Tang Dynasty (A.D. 618-907) Height: Left 42 cm. Right 45 cm.

28. Yellow-glaze pottery horses Tang Dynasty (A.D. 618-907)
Height of horse with head down: 20.1 cm. Height of horse with head raised: 28 cm.

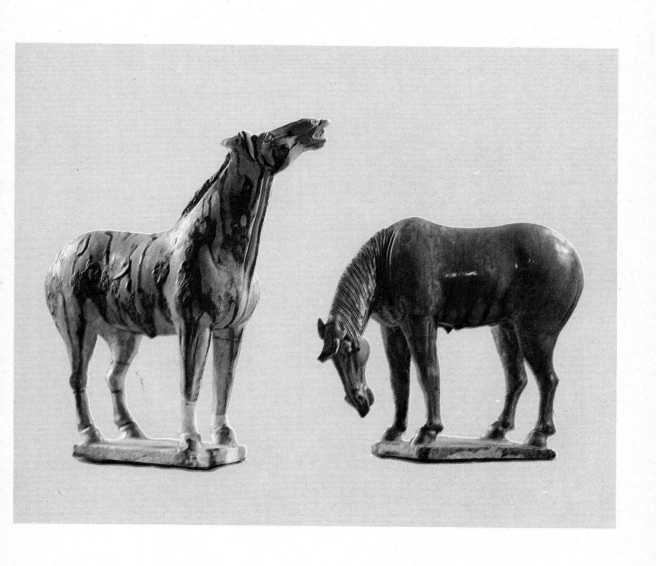

29. Tri-colour pottery camel and groom Tang Dynasty (A.D. 618-907)
 Height of camel: 47.5 cm. Length: 40 cm. Height of groom: 29.7 cm.

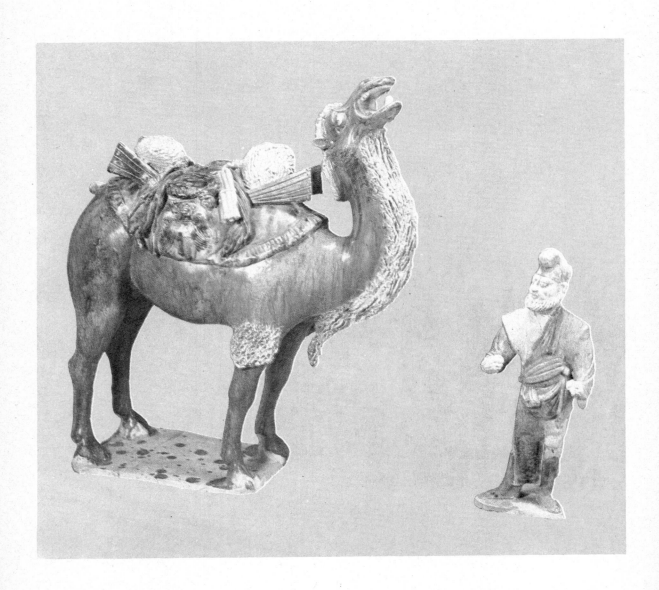

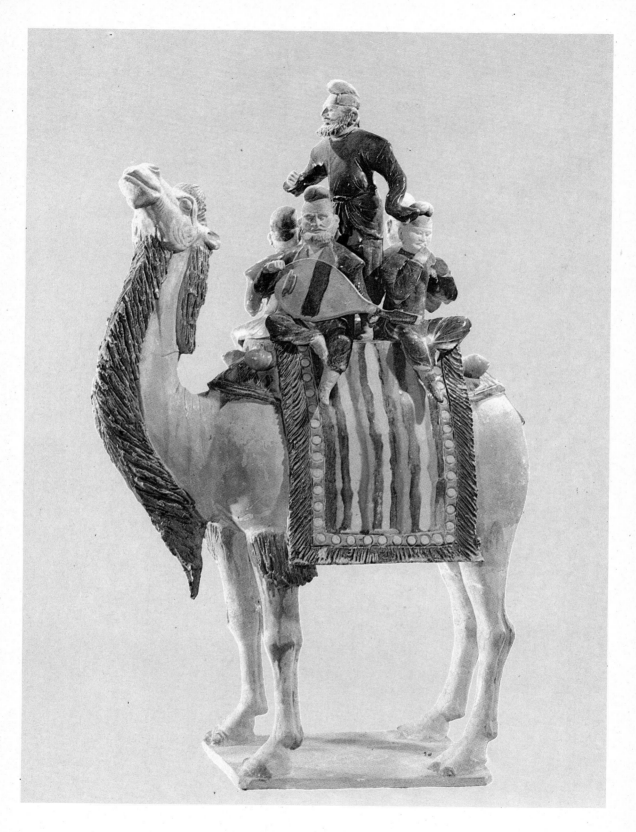

30. Tri-colour glazed pottery camel with performers
Tang Dynasty (A.D. 618-907) Height: 58.4 cm.

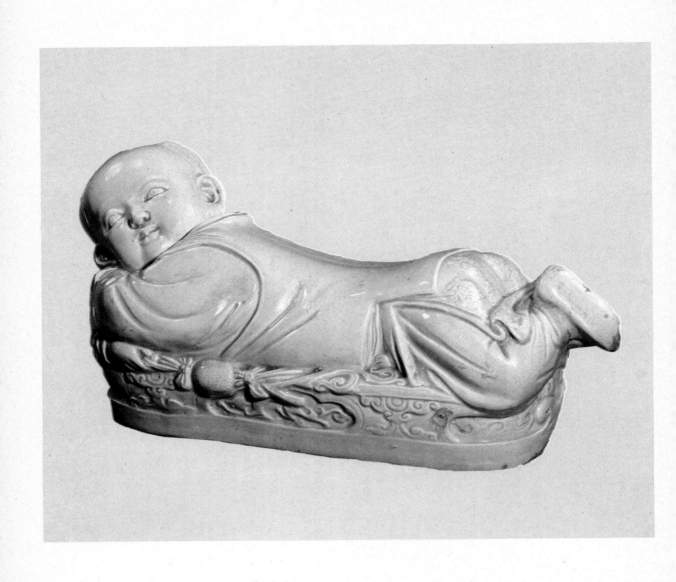

31. Ding ware porcelain child-shaped head-rest
Northern Song Dynasty (960-1127) Height: 18.3 cm.

32. Yaozhou ware celadon vase with carved designs
Song Dynasty (960-1279)
Height: 19.9 cm.

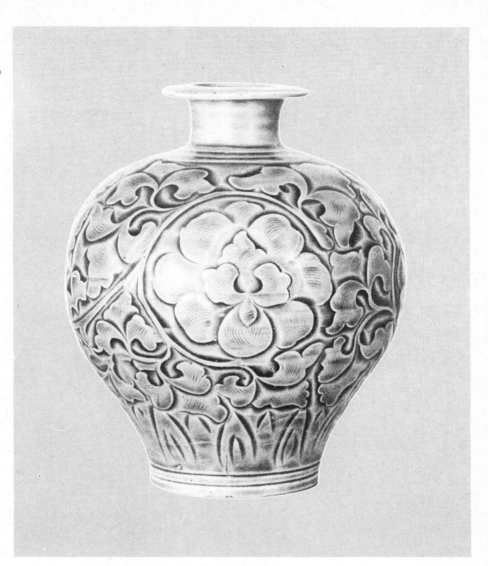

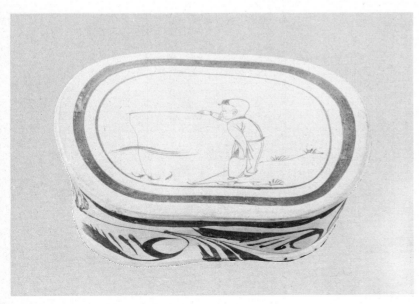

33. Head-rest with design of child fishing, Cizhou ware
Northern Song Dynasty (960-1127)
Length: 28.8 cm.

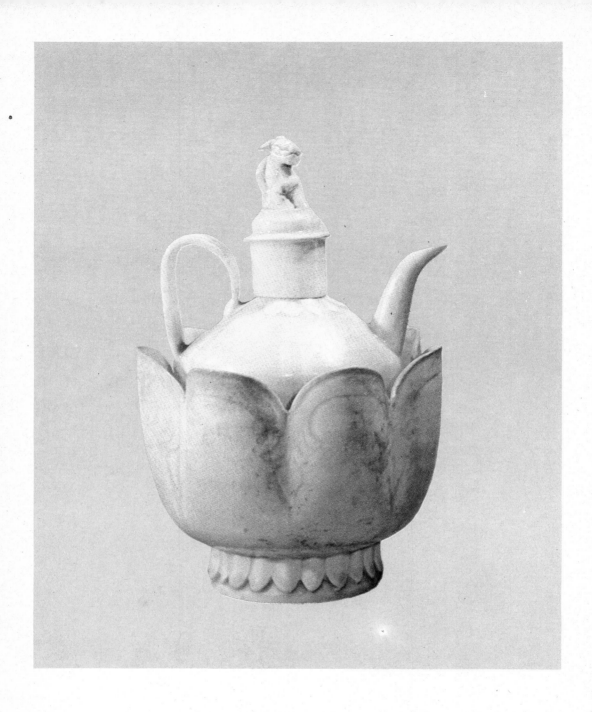

34. Misty blue wine ewer and warmer Song Dynasty (960-1279)
Height of ewer: 25.8 cm. Height of wine warmer: 14 cm.

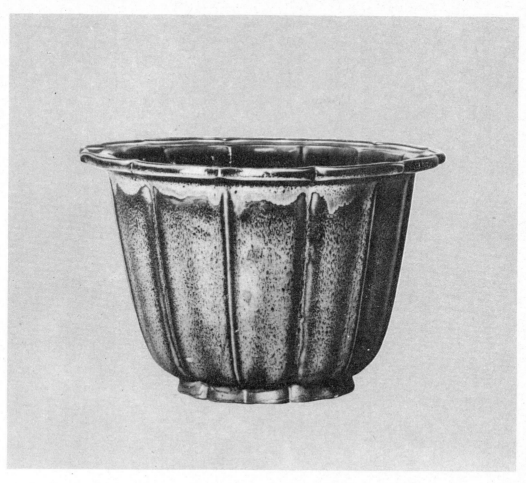

35. **Flower pot of Jun ware**
Northern Song Dynasty (960-1127)
Height: 18.3 cm.

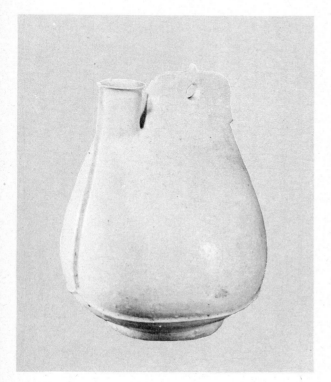

36. **White porcelain ewer in leather-bag shape**
Liao Dynasty (916-1125)　　Height: 23.5 cm.

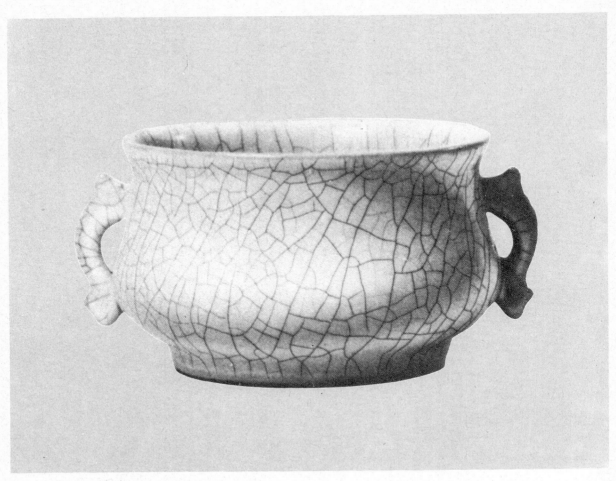

37. **Censer with fish-shaped loops,
 Ge ware** Southern Song
 Dynasty (1127-1279)
 Height: 8.3 cm.

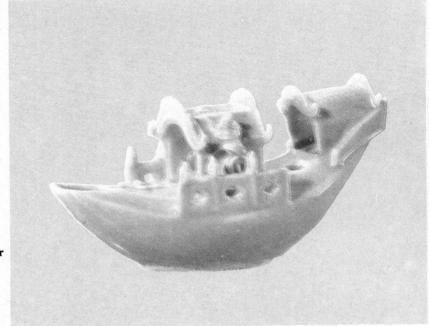

38. **Celadon boat-shaped water
 drop for inkslab,
 Longquan ware**
 Southern Song Dynasty
 (1127-1279)
 Height: 17.3 cm.

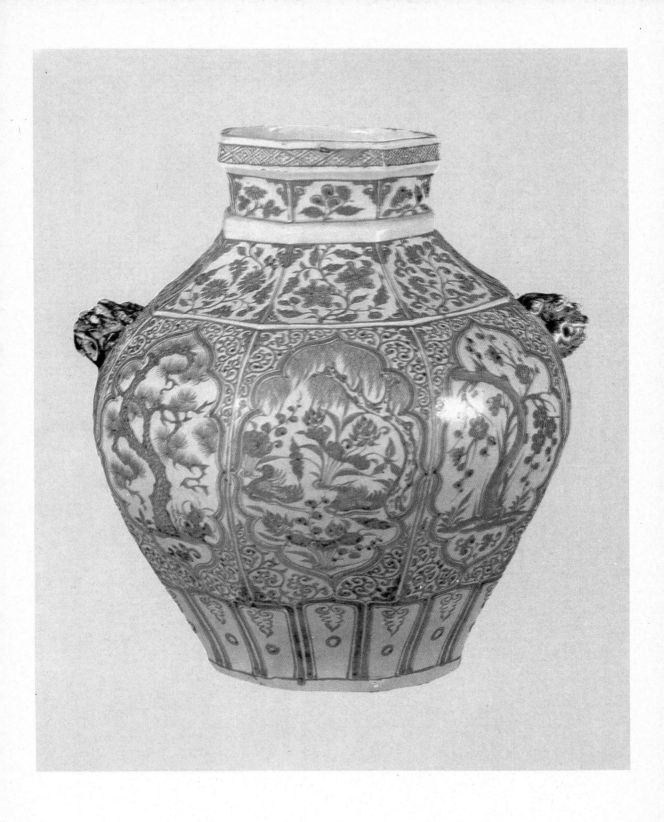

39. Blue-and-white octagonal jar Yuan Dynasty (1271-1368) Height: 39.7 cm.

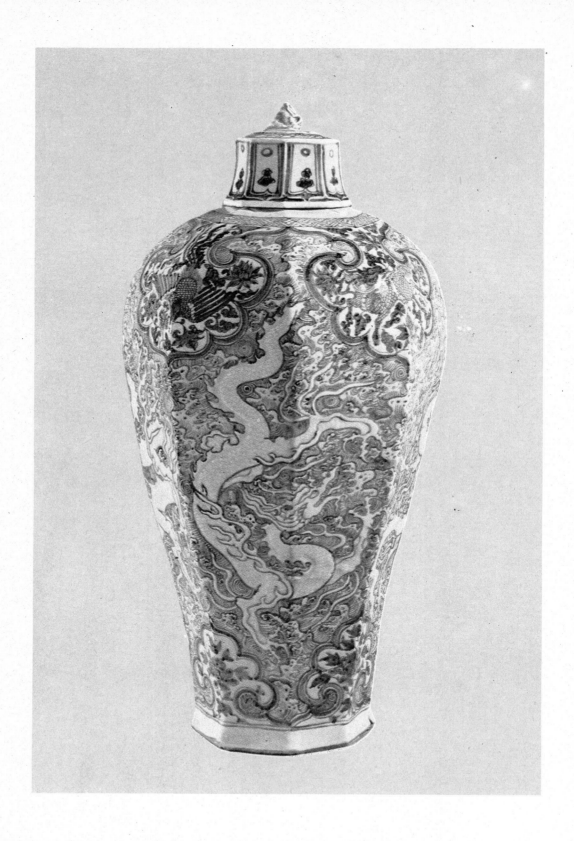

40. **Blue-and-white octagonal vase with sea water and white-dragon design**
Yuan Dynasty (1271-1368) Height: 51.5 cm.

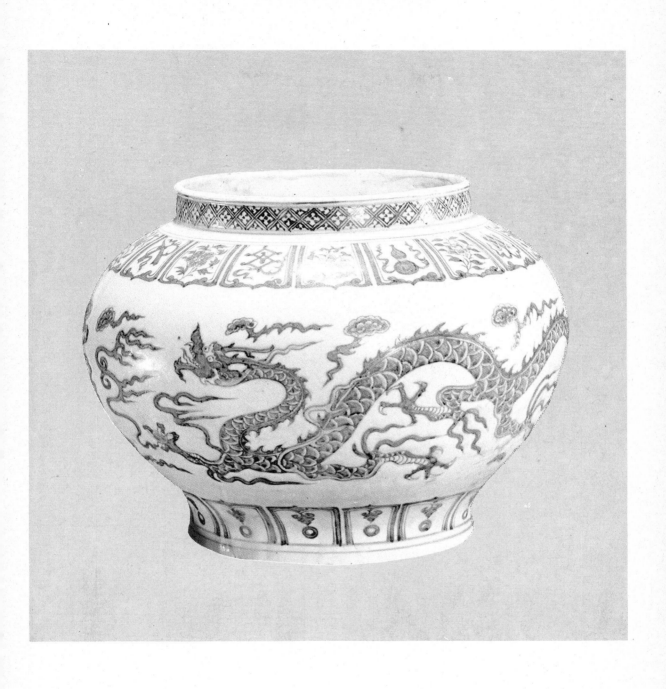

41. Blue-and-white jar with dragon-in-clouds design
Yuan Dynasty (1271-1368) . Height: 26.1 cm.

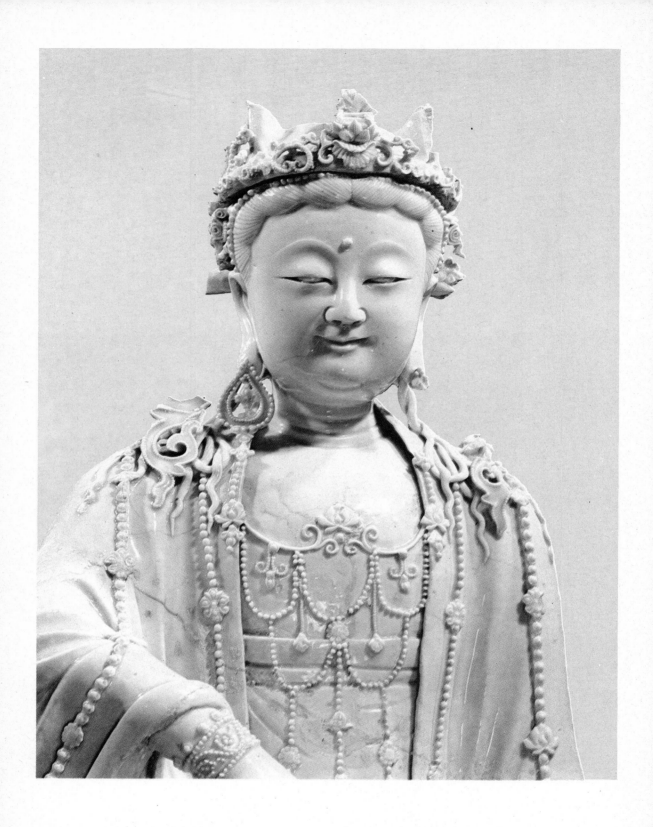

42. Misty blue porcelain statue of the Goddess of Mercy
 Yuan Dynasty (1271-1368) Height: 67 cm.

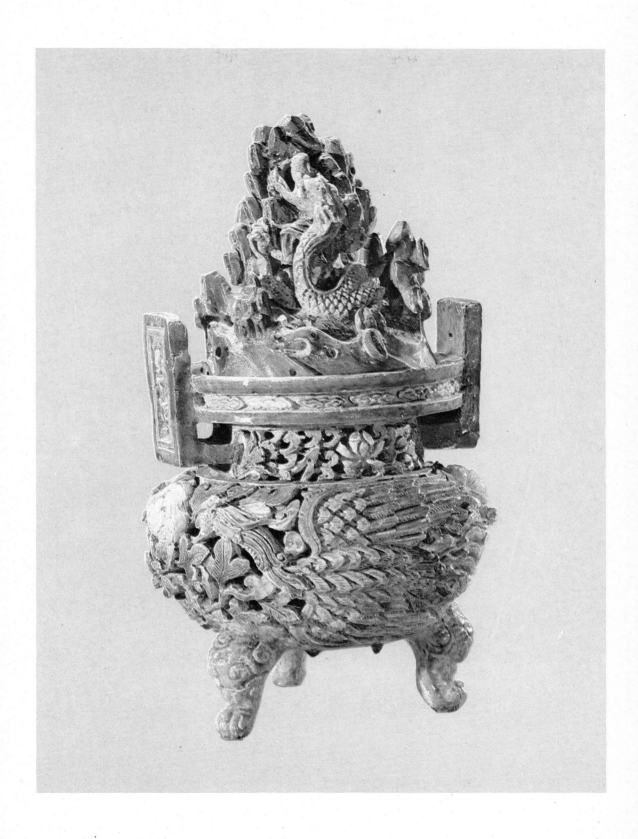

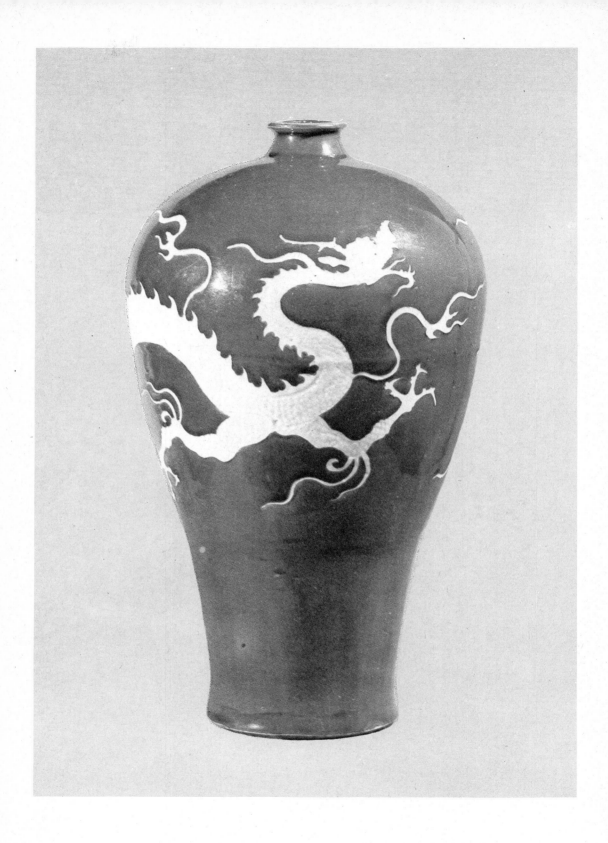

44. Blue-glaze prunus vase with white-dragon design
Yuan Dynasty (1271-1368) Height: 43.3 cm.

45. Twin-phoenix jar, Cizhou ware
Yuan Dynasty (1271-1368) Height: 36 cm.

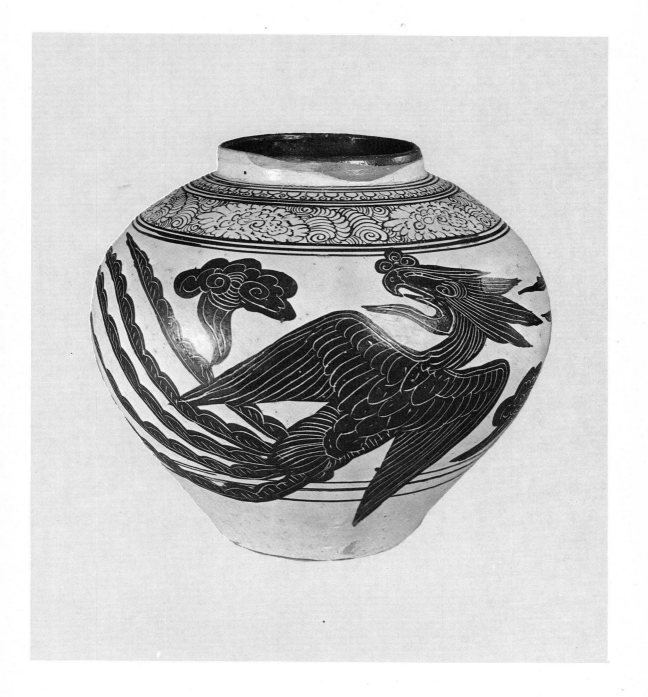

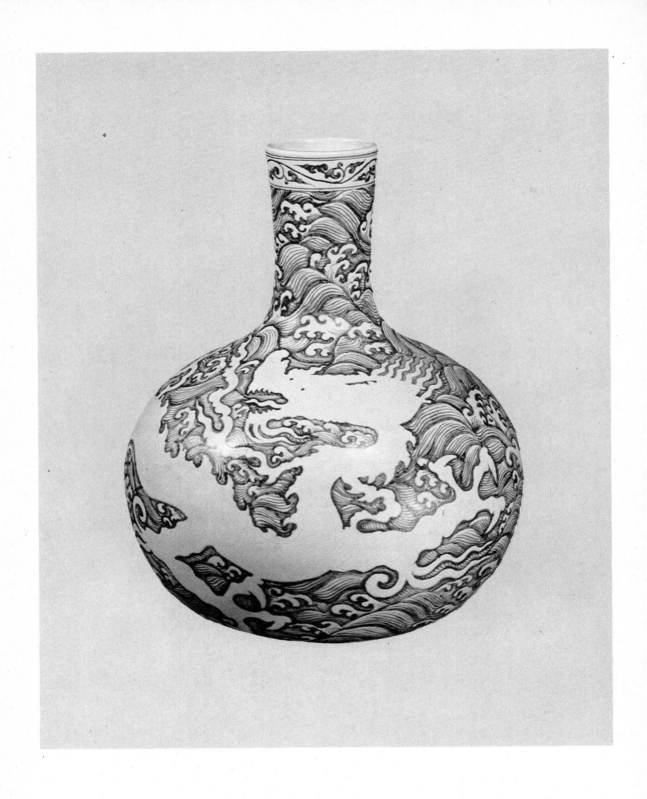

46. Blue-and-white bottle-shaped vase with white dragon-and-wave design
Xuande reign (1426-35) of Ming Dynasty Height: 42.5 cm.

Upper: **47. Red glazed plate**
Yongle reign (1403-24) of Ming Dynasty
Height: 4 cm. Diameter: 20.2 cm.

Lower: **48. Cups with grape design in contending colours**
Chenghua reign (1465-87) of Ming Dynasty
Height: 4.5 cm. Diameter: 7.8 cm.

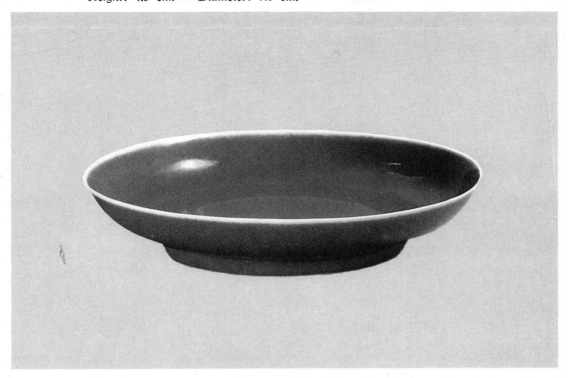

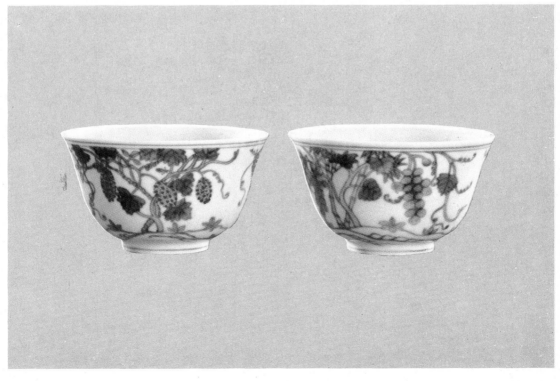

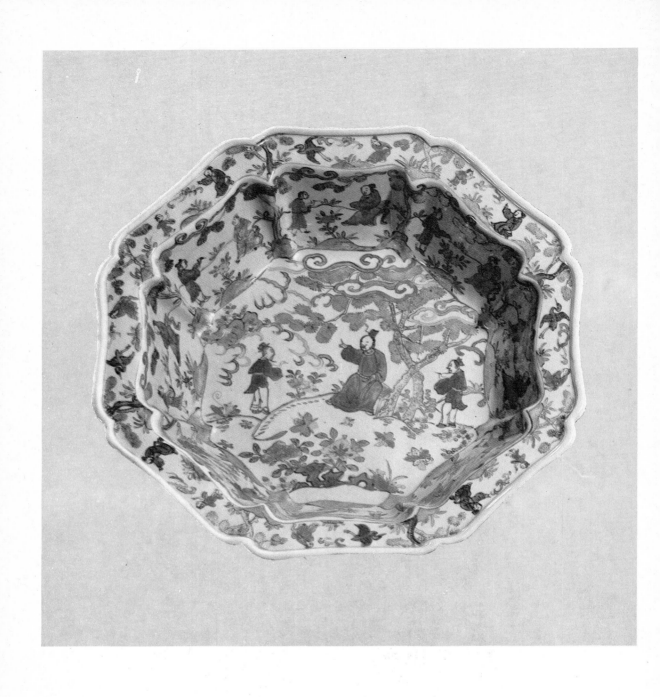

49. Polychrome plate with human figures
Wanli reign (1573-1620) of Ming Dynasty Height: 3 cm. Diameter: 15.5 cm.

50. Blue-and-white lotus-shaped
shallow basin with
Sanskrit inscription
Wanli reign (1573-1620) of
Ming Dynasty
Height: 5.5 cm.
Diameter: 18.5 cm.

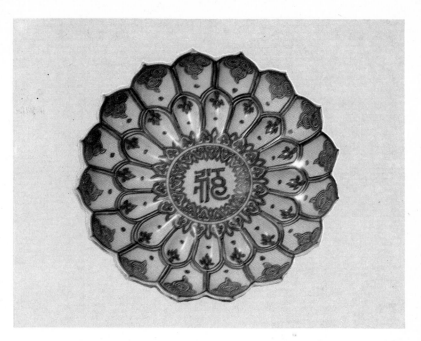

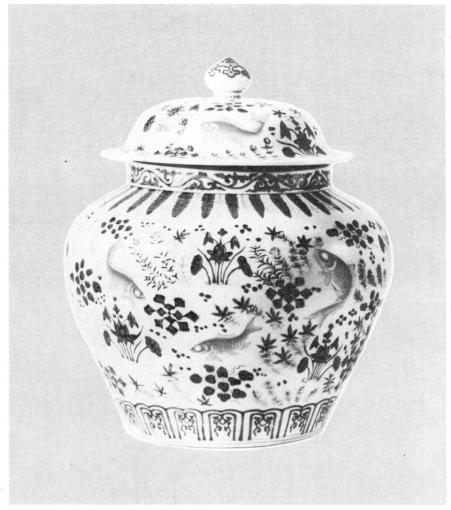

51. Polychrome jar with
design of fish and
aquatic plants
Jiajing reign (1522-66)
of Ming Dynasty
Height: 46 cm.

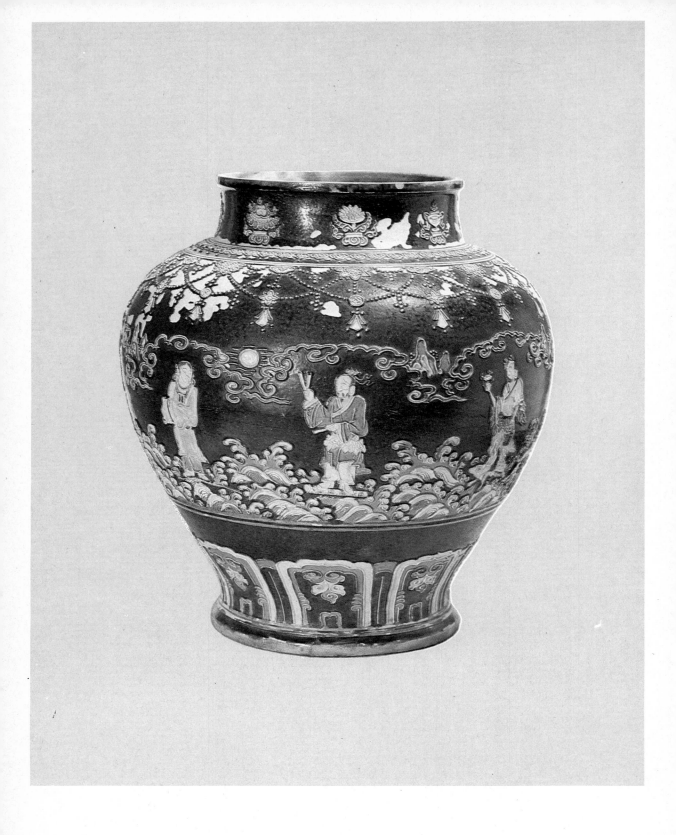

52　Jar with cloisonné enamel decoration of human figures
　Ming Dynasty (1368-1644)　　Height: 43.8 cm.

Left: **53. Polychrome vase with mandarin ducks and lotus-flower design**
 Wanli reign (1573-1620) of Ming Dynasty Height: 53.6 cm.

Right: **54. Blue-and-white *zun* wine vessel with landscape and human figures design**
 Kangxi reign (1662-1722) of Qing Dynasty Height: 46.8 cm.

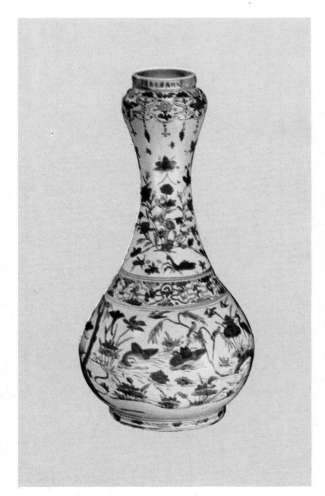
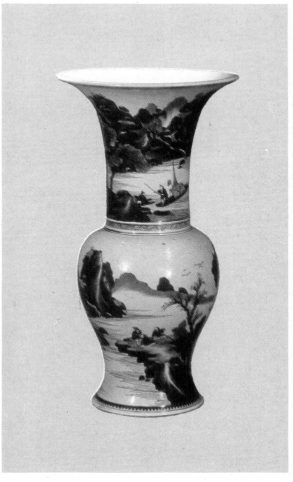

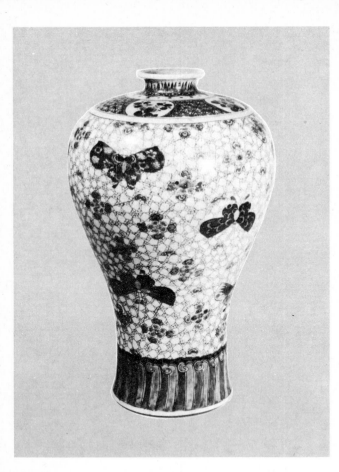

55. Polychrome vase with butterfly design
Kangxi reign (1662-1722) of Qing Dynasty
Height: 36.2 cm.

56. Bowl with yellow ground and peony designs in cloisonné enamel
Kangxi reign (1662-1722) of Qing Dynasty
Height: 17 cm.

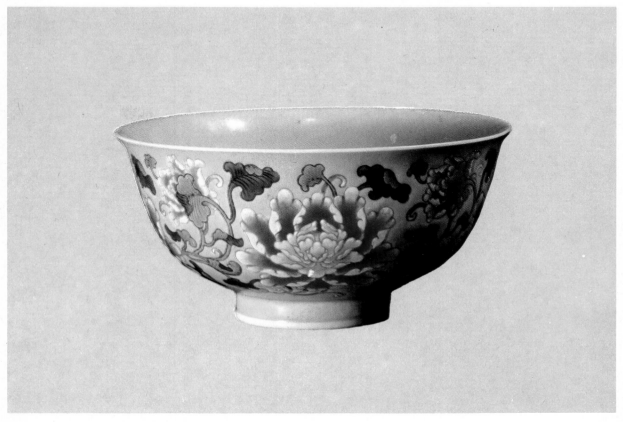

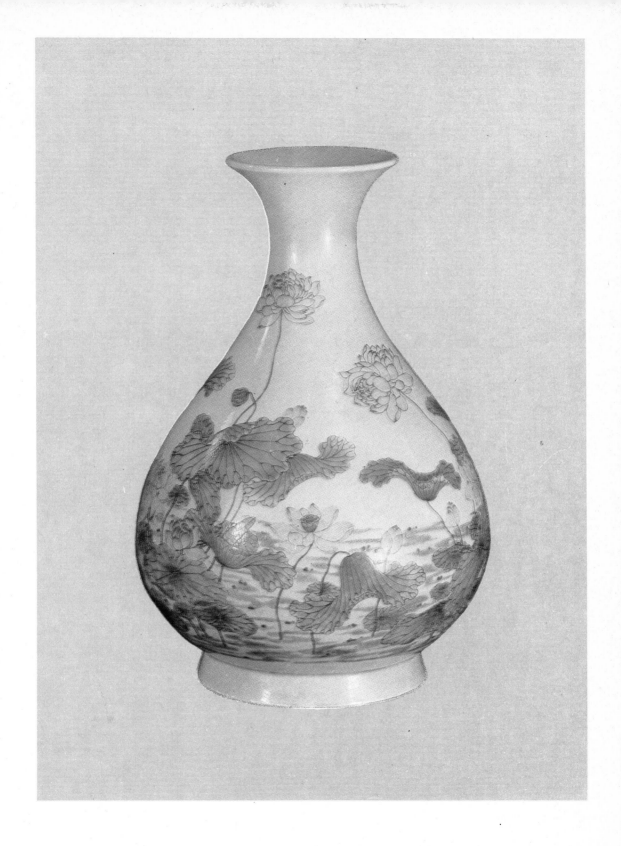

57. *Famille rose* **vase with lotus-flower decoration**
Yongzheng reign (1723-35) of Qing Dynasty Height: 27.5 cm.

58. **Furnace transmutation-glaze vase**
Yongzheng reign (1723-35) of Qing Dynasty Height: 24.2 cm.

59. *Famille rose* **vase with openwork exterior and independently revolving interior**
Qianlong reign (1736-95) of Qing Dynasty Height: 41.5 cm.
Mouth diameter: 19.5 cm.
Foot diameter: 21.2 cm.

60. **Green-glazed** *zun* **wine vessel in fish-basket shape**
Yongzheng reign (1723-35) of Qing Dynasty Height: 35.5 cm.

61. Lotus-flower double vase in cloisonné enamel
Qianlong reign (1736-95) of Qing Dynasty Height: 17 cm.

62. Vase with design symbolizing
surge of good luck

63. Blue-and-white double-eared
vase with flying phoenix pattern

64. Underglaze phoenix vase and gourd-shaped jug

**65. Pottery sculpture of human
figure**

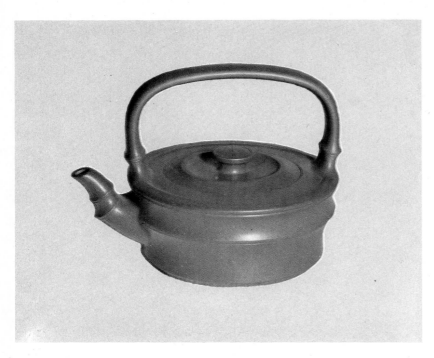

**66. Purplish brown sandy earthen
teapot of Yixing**

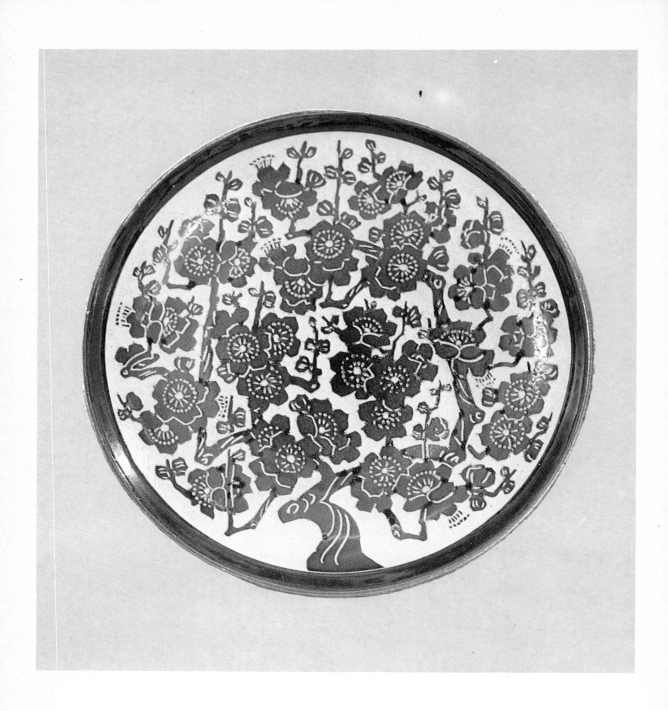

67. Porcelain plaque with plum blossom design

Description of Articles

1. Painted pottery twin-eared ewer

Majiayao Culture
Height: 41.5 cm.

Unearthed from Yongjing County, Gansu Province. Housed in the Gansu Provincial Museum. Straight mouth, round lip, flat shoulders, the upper part of the body round and swelling, the lower part slender. Flat base. Two ears on the body. Handmade. Light yellow paste polished smooth and lustrous. Decorative net, seesaw, wave and curved patterns painted in black and brown on the upper part of the vessel.

2. Painted pottery basin

Yangshao Culture
Height: 11.5 cm.

Unearthed from a Yangshao Culture site at Miaodigou in Sanmenxia city, Henan Province. Now in the Institute of Archaeology of the Chinese Academy of Social Sciences. Slightly contracting mouth, folded rim and round lip. The upper part of the body is plump, widening outward, while the lower part becomes slimmer. Flat base. Light yellow paste; regular in shape. The mouth-rim and upper body have decorative designs of curved triangles and round dots painted in black.

3. Painted pottery boat-shaped ewer

Yangshao Culture
Height: 16.3 cm.

Straight mouth and round lip. Deep cup-shaped mouth. The neck narrows; shoulders extend in opposite directions and the body slightly widens. Flat base. The vessel is shaped like an ancient Chinese wooden boat. Two large sturdy loops on shoulders. Reddish yellow earthen pottery. Net patterns picturing an ancient fishing net are painted on the body. The vessel's shape and decoration point to fishing and hunting as occupying an important position in the economy of the Yangshao Culture.

4. Painted pottery amphora with whorl paterns

Majiayao Culture
Height: about 48 cm.

Unearthed from the Majiayao Culture site at Sanping in Linxia County, Gansu Province. Preserved in the Institute of Archaeology of the Chinese Academy of Social Sciences. Contracting mouth, round lip, broad shoulders, the upper part of the body slightly widens and the lower part becomes slender. Flat base. Three eagle-beak loops at the mouth, two plain loops at the middle part of the body. Yellowish red paste. Hand-made. Whorl and wave patterns and bands painted in black as decorations from the mouth-rim to the middle part of the body. Simple and magnificent in shape, the vessel is known as "king of painted pottery".

5. Painted pottery basin with human face design

Yangshao Culture
Height: 17 cm Diameter: 44.5 cm.

Unearthed from a Yangshao Culture site at Banpo Village in Xian, Shaanxi Province. Preserved in the Museum of Chinese History. Flared mouth, folded rim, round lip, deep body and flat base. Hand-made with polished surface. Orange red paste. The inner surface shows net patterns of fine mesh with triangular net sinkers at the four corners. Opposite is a round human face design with triangular nose and slits for eyes. On top and at both sides of the face are spik-

ed triangle and hook-like decorations. The forehead and lower face are painted black. The designs vividly describe fishing and hunting scenes in clan society life and furnish valuable material for studying the economy of the Yangshao Culture.

6. Painted pottery amphora with human face and salamander design

Yangshao Culture
Height: 38 cm.

Unearthed in 1958 in Wushan County, Gansu Province. Preserved in the Gansu Provincial Museum. Small mouth, round lip, sloping shoulders, slender body, flat base and two loops at the waist. Light yellow paste. Hand-made. The paste surface is polished smooth. The body is decorated with human face and salamander design in black. To combine the human face and salamander as decoration reflects a definite ideology among the people of Yangshao Culture in Gansu Province.

7. Black pottery high-stem cup

Longshan Culture
Height: 20 cm.

Unearthed in 1975 in Jiaoxian County, Shandong Province. Preserved in the Shandong Provincial Museum. Flared mouth, round lip, wide rim, deep body and trumpet-shaped stand. Compact paste. Paste as thin as 0.1 to 0.2 centimetres, the vessel weighing less than 40 grammes. Wheel-made. Paste black and burnished. Its graceful lines and precise dimensions demonstrate superb pottery workmanship more than 4,000 years ago.

8. Cocoon-shaped ewer with painted designs

Western Han Dynasty (206 B.C.-A.D. 24)

Unearthed in Xinxiang, Henan Province. Housed in the Henan Provincial Museum.

Red pottery paste shaped like a fat cocoon. Mouth with folded rim at top, the base mounted on a foot-rim. Its outer wall is coated with white ornamental clay and the design of drifting clouds is painted in white and red as decoration. Representative of Western Han art pottery ewers with painted designs.

9. Pottery warrior officer figure

Qin Dynasty (221-207 B.C.)
Height: 196 cm.

Unearthed in 1979 from No. 1 Vault of Qin Dynasty figures east of Emperor Qin Shi Huang's tomb in Lintong County, Shaanxi Province. Preserved in the Museum of the Vault of Qin Dynasty Figures in Lintong County, Shaanxi Province. The life-size warrior officer stands on a square plank and wears a square headdress, armour and helmet. His bearing, costume, hair, whiskers and expression are vividly depicted. Such figures furnish valuable material for the study of China's history of military affairs and pottery sculptural art of the Qin Dynasty.

10. Pottery horse figure

Qin Dynasty (221-207 B.C.)
Height: 172 cm. Length: 205 cm.

Unearthed in 1979 from No. 1 Vault of terracotta warriors and horse figures east of the tomb of Emperor Qin Shi Huang, founder of the Qin Dynasty and unifier of China, in Lintong County, Shaanxi Province. Housed in the Museum of the Vault of Qin Dynasty Figures in Lintong County, Shaanxi Province. The pottery horse is life-size, standing on four legs, looking intently ahead, the mouth slightly open. It shows well-developed chest muscles and fat buttocks with knotted tail. The courage and alertness of the charger trained for battle are evident. Truly a masterpiece of ancient Chinese pottery sculptural art.

11. Green-glazed pottery multi-storeyed building
Eastern Han Dynasty (A.D. 25-220)
Height: 91.5 cm.

Unearthed in an Eastern Han tomb at Zhangwan in Lingbao, Henan Province. Now in the Henan Provincial Museum. It is a symbolic multi-storeyed farmhouse or granary of a landlord. The courtyard, enclosure walls, window lattices and tile ridges and furrows are authentic. An exotic scarlet bird with head raised and wings spread perches on the main roof ridge. This work furnishes excellent material for studying the architecture, landlord life and pottery sculptural art of the Han Dynasty.

12. Group of painted acrobat figurines
Western Han Dynasty (206 B.C.-A.D. 24)
Height: 22 cm. Length: 67 cm.

Unearthed in 1969 in Wuyingshan on Jinan's outskirts, Shandong Province. The figurines are carved on a pottery plate 67 × 47.5 cm in size. The performers in the centre are backed by musicians, with spectators standing round. The seven persons in the centre perform in two groups. The two performers on the left with rouged cheeks, long hair hanging loose down their back and wearing long costumes with coloured designs are girls waving long sleeves while dancing face to face. Four men on the right perform acrobatics. The two men in front are standing on their hands. A man in the rear bends backward, while the other performs acrobatics. The man in front of the performers in a loose red robe tied at the waist serves possibly as an announcer, or provides comic commentary. A seven-member band (one member is missing) accompanies the performers with music. This sculpture of complicated content and pleasing arrangement presents its chief and minor characters appropriately, while combining movement and tableau. Knowledge of early Western Han music, acrobatics and dancing may be gleaned from this piece.

13. Pottery ship
Eastern Han Dynasty (A.D. 25-220)
Length: 54 cm.

Unearthed from an Eastern Han tomb in Shahe District of Guangzhou. Preserved in the Guangzhou Municipal Commission on Cultural Relics. The ship has forward, midship and stern cabins, all covered with awnings. A watch tower is at the stern. An anchor hangs at the bow, and the stern is equipped with rudder. Since the anchor and rudder appeared only after shipbuilding was comparatively advanced, the situation in shipbuilding in the Eastern Han Dynasty may be assessed from this very early model.

14. Proto-celadon *zun* wine vessel
Shang Dynasty (16th-11th century B.C.)
Height: 28.2 cm.

Unearthed in Zhengzhou, Henan Province. Now in the Henan Provincial Museum. Flared mouth, round lip, broad shoulders, round body and flat base. Greyish brown hard paste. Mat markings and fine cord impressions on shoulders and weaving pattern impressed on the lower part of the body. Coated with thin, yellowish green glaze, which is highly vitreous and not evenly applied. An early celadon.

15. Celadon sheep-shaped vessel
Western Jin Dynasty (A.D. 265-316)
Height: 19.4 cm.

The vessel is moulded into the shape of a reclining sheep with its head raised and mouth open as it gazes ahead. The sheep horns curl around its ears. Things may be put into the vessel through a hole in the centre of the head. The sheep has well-developed muscles; parallel lines are carved on the neck, shoulders and back as if to represent feathers. On both sides of its belly

are carved wings which symbolize the ability to fly. This was a sacrificial vessel to pray for good luck.

16. Yellow-glazed flat ewer with design of dancers.
Northern Qi Dynasty (A.D. 550-577)
Height: 20.5 cm.

Unearthed in Fan Cui's tomb of the sixth year of the Wuping reign (A.D. 575) of Northern Qi in Anyang County, Henan Province. Now in the Henan Provincial Museum. Shallow dish-shaped mouth, slender neck, round, flat body and two perforations on the shoulders. Greyish white paste. Coated with coarse, rough yellow glaze. The vessel is moulded with decorations. Four persons are depicted. In the middle is a dancer with deep-set eyes and a high nose performing the whirling dance of a north China minority nationality on a carpet shaped like a lotus flower.

17. Celadon lotus flower *zun* wine vessel
Northern Dynasties (A.D. 386-581)
Height: 66.5 cm.

Flared mouth, long and fairly large neck, broad shoulders, round body. The stem and foot slightly flared. Thick, hard and solid grey paste. The vessel is decorated outside with appliquéd, carved and incised complicated designs. The mouth-rim and neck are decorated with raised bands, *pushou* (animal heads), cloud patterns and flying celestials. Six strong loops on the shoulders. Along the shoulders are appliquéd two layers of wide, plump, downturned lotus petals. On the lower part of the body and the stem are appliquéd, carved and incised upturned lotus petals. Coated with a bluish green vitreous glaze. The vessel with its unusual shape and lavish decoration is a masterpiece of the Northern Dynasties northern celadon.

18. Four-looped jar of yellow glaze with green splashes
Northern Qi Dynasty (A.D. 550-577)
Height: 18 cm.

Unearthed in 1958 in Li Yun's tomb of the seventh year of the Wuping reign (A.D. 576) of Northern Qi in Puyang County, Henan Province. Preserved in the Palace Museum. Slightly contracting mouth, flat lip, broad shoulders, round and full body, flat base mounted on solid foot. The upper two-thirds of the body is decorated with carved broad lotus petals. Four loops on the shoulders, where carved and incised honeysuckle pattern extends continuously to both sides. White paste. Coated with freely running light yellow glaze with green drippings — a glazing technique that developed into tri-colour glazed pottery in the Tang Dynasty.

19. Green-glazed chicken-head ewer
Sui Dynasty (A.D. 581-618)
Height: 27.2 cm.

Cup-shaped mouth and slightly flared mouth-rim. Long neck decorated with three lines in relief, giving the appearance of bamboo joints. Broad shoulders and upper body round and full, lower body becomes slender. Two loops on shoulders. Chicken-head spout and dragon-head handle in opposite positions on shoulders. The handle extends to the mouth-rim. Greyish white paste which is thick, solid and durable. Coated with glossy vitreous green glaze with yellow tinge but exposing paste from lower part of body to base.

20. White porcelain figurines of attendant officials
Sui Dynasty (A.D. 581-618)
Height: 72 cm.

Unearthed in 1959 from Zhang Sheng's tomb of the 15th year of the Kaihuang reign (A.D. 595) of the Sui Dynasty in Anyang

County, Henan Province. Preserved in the Henan Provincial Museum. Porcelain figurines stand erect on lotus stand. Each wears his hair in a bun and a headdress. Armour on upper body with blue garment beneath. Both wear high-tipped shoes and hold swords in both hands. White paste coated with white glaze. The torsos, garment folds, boot tips and sword sheaths are painted with black pigment.

21. Figurines of musicians
Sui Dynasty (A.D. 581-618)
Height: 17.2-19 cm.

Unearthed from a Sui tomb in Anyang, Henan Province and preserved in the Henan Provincial Museum. The group of nine is performing. They furnish valuable material for studying the composition of Chinese court and aristocratic music ensembles before the last millennium.

22. Black porcelain waist drum with splashes of contrasting colour
Tang Dynasty (A.D. 618-907)
Length: 59 cm.

This Tang Dynasty musical instrument has a fairly slender waist and enlarged, round ends. With leather applied it is a percussion instrument. Preserved in the Palace Museum, the drum has seven ridges — traces of separate sections having been glued over. Greyish brown paste of compact texture. Coated with black glaze with splashes of creamy white clouds. Production centre of this porcelain has been established as the Duandian kilns in Lushan County, Henan Province. The lower Baiyu kilns in Yuxian County, Henan Province also manufactured such articles.

23. Celadon phoenix-head ewer
Tang Dynasty (A.D. 618-907)
Height: 41.2 cm.

A green glazed porcelain vessel made in northern China. The location of its excavation is reportedly the vicinity of Jixian County, Henan Province.

In the Tang Dynasty, China and Central Asia had frequent contacts and influenced each other. This celadon phoenix-head ewer was devised when Tang craftsmen fashioned from a type of Persian ewers with bird head and curved handle. The crown of the phoenix head was decorated with flower petals shaped like a coronet. The curved handle runs from the mouth-rim to the base and assumes a slender dragon shape. The body is covered all over with carved and appliqué designs, the mid-portion appliquéd with six groups of dancing strong men that are symmetrical to the six groups of rosettes in the lower part. These make up the main decorative motif on the body. The ewer's neck and stem are decorated with the designs of lotus petals, scrolls and strung beads. Thick, solid and durable paste that is blue with a slight white tinge. Dignified vessel shape; attractive and elegant decoration. A masterpiece of Tang celadon.

24. White porcelain cuspidor
Tang Dynasty (A.D. 618-907)
Height: 10.5 cm.

Unearthed in 1955 from a Tang tomb on Xian's outskirts in Shaanxi Province. Preserved in the Shaanxi Provincial Museum. Flared mouth, round lip, short and slim neck, flat, round body and flat base. White paste of fine and compact texture. Coated with white, lustrous silver or jade-like glaze. This vessel shows high achievement of white porcelain craftsmanship in mid-Tang.

25. Tri-colour pottery plate
Tang Dynasty (A.D. 618-907)
Height: 2.7 cm. Diameter: 15 cm.

Unearthed from Princess Yongtai's tomb at Qianling Mausoleum in Qianxian County,

Shaanxi Province. Preserved in the Shaanxi Provincial Museum. Curved body and flat base. Fairly thick paste. Coated with free-running lead glaze. The basic colour tone is yellowish brown decorated with designs in white, blue and green along the vessel wall.

26. Tri-colour pottery bowl with folded waist
Tang Dynasty (A.D. 618-907)
Height: 7.5 cm.

Flared mouth, round lip with outwardly curving rim. Deep body folded into a ridge at the waist. Flat base with foot-rim. White paste of compact texture with yellow tinge. Coated with white glaze inside and out. The outer glaze layer shows small, smooth stripes like cotton wisps in green, brown and light yellow. Inside are broad white and green stripes arranged likewise, the dark green tastefully set off against quiet white. The broad white stripes are decorated with wisps of dark brown. The vessel is modelled after gold and silver bowls of the same type used by contemporary nobles.

27. Tri-colour pottery woman figurines
Tang Dynasty (A.D. 618-907)
Height: Left 42 cm. Right 45 cm.

Unearthed in 1959 from a Tang tomb on Xian's outskirts in Shaanxi Province and preserved in the Shaanxi Provincial Museum. Plump of face, their hair is done in wide, low flat bun atop the head. They wear blouses with narrow sleeves and long skirts caught high at the chest, before which their hands are folded. Shoes are boat-shaped. The faces incline slightly, lips are painted red. The figurines are of white clay, unglazed above the neck and coated with a glossy glaze in yellow, white, brown, green, blue and reddish brown below.

28. Yellow-glaze pottery horses
Tang Dynasty (A.D. 618-907)
Height of horse with head down: 20.1 cm.
Height of horse with head raised: 28 cm.

Unearthed in 1962 from a Tang tomb on Xian's outskirts in Shaanxi Province. Now in the Shaanxi Provincial Museum. Both horses stand on rectangular planks. The one with head raised has wide-open eyes and neck outstretched, neighing. The other horse, cropping grass with mane hanging loose, appears contented.

29. Tri-colour pottery camel and groom
Tang Dynasty (A.D. 618-907)
Height of camel: 47.5 cm. Length: 40 cm.
Height of groom: 29.7 cm.

Unearthed in Shaanxi Province and now in the Shaanxi Provincial Museum. The camel's head is lifted in a cry. Thick maroon camel fur. A felt cushion is placed between the humps. On the goods stack is an animal-head silk sack loaded with costly commodities. At either end of the sack are silk fabrics, cotton cloth and bales of silk yarn. Camel groom is a man of minority nationality with deep-set eyes, high nose and whiskers. He wears a long robe open at the neck and fastened with a sash at the waist. Facial expression and glaze texture and colour would date the work as of the 8th century, the height of Tang prosperity.

30. Tri-colour glazed pottery camel with performers
Tang Dynasty (A.D. 618-907)
Height: 58.4 cm.

The camel figurine, head poised skyward, stands on a square plank, its body coated with very light glaze. The brownish yellow hair on its neck is neatly combed and trimmed. The felt cushion between the two humps has over it a rectangular, coloured woolen blanket bordered with green fur. Four performing musicians sit on the camel's back. They surround a standing

turbaned dancer with deep-set eyes, high nose and whiskers. He wears a long robe with rounded neckline and soft, pointed boots. With one hand before his chest and the other hanging at his side, he dances to the music. This superb tri-colour glazed pottery sculpture appeared at the height of Tang and illustrates the art of music and dancing at that time.

31. Ding ware porcelain child-shaped head-rest

Northern Song Dynasty (960-1127)
Height: 18.3 cm.

The porcelain head-rest, or pillow, is modelled in the shape of a child lying prone on a couch, its head on crossed arm. An embroidered silk ball is in its right hand. The curve of the child's back forms the head-rest. All four sides of the couch are decorated with impressed designs of coiled dragon and clouds in exquisite carving. Fine porcelain of white glaze with slight yellow tinge, soft and lustrous. A valuable art work of utility in Northern Song.

32. Yaozhou ware celadon vase with carved designs

Song Dynasty (960-1279)
Height: 19.9 cm.

Preserved in the Palace Museum. Straight mouth, folded rim, round lip and straight neck. The upper part of the body is round and swelling, the lower part somewhat slim. Flat base. Brownish grey paste. Coated with olive-green glaze. The outer wall of the vessel is decorated with incised designs of twining sprays of peony flowers and a row of pointed lotus petals. Its regular composition and fluent lines are important characteristics of Song Dynasty private porcelain kilns.

33. Head-rest with design of child fishing, Cizhou ware

Northern Song Dynasty (960-1127)
Length: 28.8 cm.

Unearthed in 1955 in Xingtai, Hebei Province. Somewhat coarse porcelain coated with white glaze. The head-rest, or pillow, has floral sprays painted on all sides and child motif on the top surface. This is a popular northern porcelain vessel for daily use which furnishes good material for studying Northern Song folk customs.

34. Misty blue wine ewer and warmer

Song Dynasty (960-1279)
Height of ewer: 25.8 cm.
Height of wine warmer: 14 cm.

Unearthed in Susong County, Anhui Province. Preserved in the Anhui Provincial Museum. The wine warmer has a deep lotus flower shaped body. Flat base with foot-rim around which are carved lotus petals. The wine ewer has a straight mouth, cylindrical neck, sloping shoulders, round body and flat base. A spout and curved handle are opposite on the shoulders. The ewer is fitted with a lid on which a lion squats. White, compact and durable paste coated with *yingqing* (misty blue) glaze. Hot water placed in the warmer heats the wine in the ewer.

35. Flower pot of Jun ware

Northern Song Dynasty (960-1127)
Height: 18.3 cm.

Housed in the Palace Museum. Mouth shaped like a water chestnut blossom. Flat folded rim. Flower petal-shaped body and flat base with foot-rim. Fairly thick, solid, greyish brown paste. Coated with a thick layer of purple red glaze. The body of the vessel is decorated with coiled, wriggling small streaks, or "earthworm marks".

36. White porcelain ewer in leather-bag shape

Liao Dynasty (916-1125)
Height: 23.5 cm.

Unearthed in 1953 from the tomb of the husband of a Liao Dynasty princess in Chifeng, Liaoning Province. Preserved in the Liaoning Provincial Museum. Made in the form of a leather bag, it was a utensil of daily use for a minority national living on the northern grassland. With a flat, straight back, its spout is cylindrical with upturned mouth. This prevents water from escaping when it is tied to the saddle on horseback. A representative work of the Liao Dynasty.

37. Censer with fish-shaped loops, Ge ware
Southern Song Dynasty (1127-1279)
Height: 8.3 cm.

Historical records say that in the Song Dynasty two brothers of the Zhang family had porcelain kilns at Longquan. Porcelain vessels fired by Zhang the Elder were called Ge (Elder Brother) ware. These were covered all over with large and small interspersed crackles. Most of the big crackles were black.

38. Celadon boat-shaped water drop for inkslab, Longquan ware
Southern Song Dynasty (1127-1279)
Height: 17.3 cm.

A stationery item for holding water for scholars' use in grinding inkstick. The shape is a wooden boat with arched awning along whose sides are protective planks. A boatman is in position as though the boat were in motion. Greyish white paste. Coated with thick lustrous glaze giving the impression of green jade.

39. Blue-and-white octagonal jar
Yuan Dynasty (1271-1368)
Height: 39.7 cm.

The main part of the body of this eight-sided jar is decorated with brocade design in curved panels, each with a painting of pond, flowers or landscape. This product of Jingdezhen, Jiangxi Province, was unearthed in distant Anshan, Liaoning Province. Now in the Anshan Cultural Relics Office, this fine blue-and-white porcelain vessel of the Yuan Dynasty had a wide domestic market.

40. Blue-and-white octagonal vase with sea water and white-dragon design
Yuan Dynasty (1271-1368)
Height: 51.5 cm.

Unearthed in 1964 in Baoding, Hebei Province. Small mouth, short neck, polygonal body; thick and solid paste. The vessel wall is painted all over with blue-and-white sea water design set off by four white dragons. The shoulders and lower part of the body are decorated with a dragon amidst clouds, flowers, phoenix and rare animals. Vigorous strokes and dense pigments forming mottles achieve a surprisingly artistic effect.

41. Blue-and-white jar with dragon-in-clouds design
Yuan Dynasty (1271-1368)
Height: 26.1 cm.

Unearthed in 1966 in the hoard of Taoxi Commune in Jintan County, Jiangsu Province. Product of Jingdezhen. Slightly contracting, straight mouth and flat lip. Wide and round shoulders and body. The lower part of the body is very short. Flat base. White paste coated with bluish white glaze. Underglaze blue-and-white design. The decorative motif is a lively three-clawed dragon amidst clouds. On the mouth-rim, shoulders and foot are painted rhomboid brocade patterns, lotus petals, flames, bouquets and miscellaneous Taoist emblems.

42. Misty blue porcelain statue of the Goddess of Mercy
Yuan Dynasty (1271-1368)
Height: 67 cm.

Unearthed at Dadu, Great Capital of the Yuan Dynasty, in Beijing. Now in the Beijing Cultural Relics Office. The statue depicts a plump, calm and tranquil smiling face with curved eyebrows and half-closed eyes. Regular features. The headdress, garment folds and jewel necklaces and strings of ornaments are exquisitely made. The porcelain object has a fine, pure, white and hard texture and lustrous glaze. Representative of misty blue porcelain made at Jingdezhen in the Yuan Dynasty.

43. Tri-colour glazed pottery censer
Yuan Dynasty (1271-1368)
Height: 37 cm.

Unearthed in Beijing and now in the Beijing Cultural Relics Office. In shape it imitates ancient bronzes. Round and full body mounted on three animal feet. The cover is shaped like the legendary Taoist mountain of immortals with entwined magic dragon. The neck and body of the censer have the appliqué design of peony flowers with phoenixes flying in their midst. Coated with white, blue, yellow and green glaze. Tri-colour glazed pottery was rather rare in the Yuan Dynasty.

44. Blue-glaze prunus vase with white-dragon design
Yuan Dynasty (1271-1368)
Height: 43.3 cm.

Housed in Yangzhou Antiques Store, Jiangsu Province. Small mouth and neck, broad shoulders, round and full body. Slender vessel shape. The fullest part of the body is incised with a three-clawed dragon coated all around with magnificent, lustrous blue glaze. Vivacious white dragon shows superb craftsmanship.

45. Twin-phoenix jar, Cizhou ware
Yuan Dynasty (1271-1368)
Height: 36 cm.

Straight mouth, flat lip and broad shoulders. Round, swelling body, the lower part somewhat slim and short. Flat base. Greyish brown paste coated with fine, pure, white ornamental clay. The surface is decorated with designs in black. The shoulders have decorative patterns of lotus petals and large medallion patterns. Two flying phoenixes set off by clouds decorate the body. Cizhou was a centre of private porcelain kilns in north China, this being representative of its products, which catered to popular needs. Its vessel shapes and decorations were forthright and lively.

46. Blue-and-white bottle-shaped vase with white dragon-and-wave design
Xuande reign (1426-35) of Ming Dynasty
Height: 42.5 cm.

Straight mouth, round lip and body, long neck. Solid in shape. White compact and durable paste. Coated with white glaze. Cobalt blue is used in underglaze blue-and-white decorations. Twining floral sprays extend continuously to opposite sides on the mouth-rim. Neck and body feature towering wave patterns and a sturdy three-clawed white dragon battling the waves. The blue pigment of the blue-and-white design is so dense as to coagulate into deep-coloured mottles which enhance the artistic effect.

47. Red glazed plate
Yongle reign (1403-24) of Ming Dynasty
Height: 4 cm. Diameter: 20.2 cm.

Preserved in the Palace Museum. Flared mouth and round lip, the wall of the body slightly curved. Flat base with foot-rim. White paste coated with red glaze. Thick, bright and lustrous glaze layer, with the exception of the mouth-rim and foot-rim, which remain white.

48. Cups with grape design in contending colours

Chenghua reign (1465-87) of Ming Dynasty
Height: 4.5 cm. Diameter: 7.8 cm.

Unearthed in Beijing and housed in the Beijing Cultural Relics Office. Flared mouth, round lip, deep body and small flat base with foot-rim. Fine, pure paste. Coated with lustrous white glaze on which grape design is painted. Potters effected attractive contending colours by first outlining the designs under the glaze and then colouring the twigs, leaves and fruit in purple red, green and brownish yellow, producing precious pieces.

49. Polychrome plate with human figures
Wanli reign (1573-1620) of Ming Dynasty
Height: 3 cm. Diameter: 15.5 cm.

Unearthed in 1962 in Haidian District, Beijing, and now in the Beijing Cultural Relics Office. Octagonal plate with folded rim and round lip. White paste coated with white glaze. Genre paintings in red, blue, green, yellow and purple are drawn in the centre, wall and rim of the plate. Represents the unique style of polychrome porcelain made at Jingdezhen in the 16th and early 17th century.

50. Blue-and-white lotus-shaped shallow basin with Sanskrit inscription
Wanli reign (1573-1620) of Ming Dynasty
Height: 5.5 cm. Diameter: 18.5 cm.

The vessel, patterned after a multi-petal lotus blossom, is of pure, white, fine paste coated with white glaze. The lotus petals are outlined in deep, bright blue and white. In the centre is a Sanskrit inscription. The characters "Made during the Wanli Reign of Ming Dynasty" are inscribed inside the foot-rim.

51. Polychrome jar with design of fish and aquatic plants
Jiajing reign (1522-66) of Ming Dynasty
Height: 46 cm.

Straight mouth, round lip, somewhat short neck and broad shoulders, short, round, swelling body. Flat base. Pure, white, solid and durable paste coated with white glaze. Aquatic plants and flowers painted underglaze in cobalt blue. After firing at high temperature the design of lotus petals, strings of ornaments and bands are painted in red, brown, yellow and green. The knob of the cover is shaped like a lotus bud. On the widest and flattest portion of the vessel are portrayed fish jumping after food and swimming among waterweed and lotus. Composition is original and life-like. A representative work of Jingdezhen porcelain craftsmanship in the Jiajing period of the Ming Dynasty.

52. Jar with cloisonné enamel decoration of human figures
Ming Dynasty (1368-1644)
Height: 43.8 cm.

Unearthed in 1972 on Beijing's outskirts and now in the Beijing Cultural Relics Office. Straight mouth, round lip and broad shoulders, the lower part of the body slender. Coated with blue lustrous glaze, fairly thick. The vessel wall is decorated with cloud, jewel necklace and strung ornaments, sea wave, lotus petal, and the human figure designs of the Eight Immortals. This pottery with cloisonné enamel decoration was a product of Shanxi. Artistically, it ranks fairly high.

53. Polychrome vase with mandarin ducks and lotus-flower design
Wanli reign (1573-1620) of Ming Dynasty
Height: 53.6 cm.

Preserved in the Palace Museum. Straight mouth and flat lip. The top of the vase is garlic-shaped, with long neck, gradually enlarging towards bottom. The lower part of the body round and swelling. White paste, coated with white glaze. One side of

the mouth-rim is inscribed in blue-and-white characters "Made in the Wanli reign of the Ming Dynasty". The decorative motif of mandarin ducks sporting among lotus flowers painted on the body is a popular one among Chinese people.

54. Blue-and-white *zun* wine vessel with landscape and human figures design
Kangxi reign (1662-1722) of Qing Dynasty
Height: 46.8 cm.

Flared mouth, round lip and long neck. Slightly swelling body somewhat shorter than the neck. White, compact and durable paste. Stately in shape. Coated with white glaze. Decorative designs of large landscapes and genre paintings in pure and bright cobalt blue glaze on neck and body, the pictures showing good perspective and gradations. Representative of 17th and early 18th century blue-and-white porcelain.

55. Polychrome vase with butterfly design
Kangxi reign (1662-1722) of Qing Dynasty
Height: 36.2 cm.

Curved rim, round lip, thin short neck. The shoulders and the upper part of the body are round and swelling, the lower part slim and graceful. Flat base. White paste. Coated with white glaze. The neck is painted with a fine banana-leaf design and the shoulders with drifting clouds, bands and dots in red and green. The widest part of the shoulders has bands and brocade patterns in red, green and blue, panels on the brocade ground are painted with red and green flowers, while the body is covered with red brocade designs on which are drawn butterflies and flowers in red, blue, black, yellow and brown. A product of the Jingdezhen kiln.

56. Bowl with yellow ground and peony designs in cloisonné enamel
Kangxi reign (1662-1722) of Qing Dynasty
Height: 17 cm.

Flared mouth, round lip, deep body and flat base with foot-rim. Fine, compact and durable paste. Coated with pure, white sparkling glaze. Full-blown peonies are painted overglaze in cloisonné enamel. Cloisonné enamel was introduced during the Kangxi reign, this bowl being highly prized as an early product.

57. *Famille rose* vase with lotus-flower decoration
Yongzheng reign (1723-35) of Qing Dynasty
Height: 27.5 cm.

Preserved in the Palace Museum. Flared mouth, round lip, thin neck, round and swelling body. White paste. Coated with white glaze. A painting of a pond with blooming lotus flowers in soft watercolour hues.

58. Furnace transmutation-glaze vase
Yongzheng reign (1723-35) of Qing Dynasty
Height: 24.2 cm.

Preserved in the Palace Museum. Straight neck, flat and round body. Fairly thick paste. The neck is decorated with four raised bands. Coated with furnace transmutation glaze, freely running and thick in deep blue, light blue, brown, purple, white and yellow. The vessel is ingeniously designed with specially graceful lines. This was a representative work of the Yongzheng reign, showing the high development of ceramic craftsmanship.

59. *Famille rose* vase with openwork exterior and independently revolving interior
Qianlong reign (1736-95) of Qing Dynasty
Height: 41.5 cm. Mouth diameter: 19.5 cm.
Foot diameter: 21.2 cm.

Preserved in the Palace Museum. The vase consists of upper and lower parts, the main part being below the shoulders. Round and swelling body with foot-rim.

Openwork round panel in the middle of the body with balustrades, Taihu Lake rockery and plum blossoms carved in the panel through which the inside is visible. The mouth and neck are made separately and fitted to the body forming an integral whole, though the upper part of the vase revolves. As the neck turns, the ten Heavenly Stems and twelve Earthly Branches above and below the neck designate dates. Exquisite decorative patterns are painted in *famille rose* on the upper and lower parts of the vase. A rare piece of art made at Jingdezhen especially for the imperial court during the Qianlong reign.

60. Green-glazed *zun* wine vessel in fish-basket shape
Yongzheng reign (1723-35) of Qing Dynasty
Height: 35.5 cm.

Preserved in the Palace Museum. The vessel is patterned after a split bamboo fish basket with the weaving pattern carved on the vessel surface. Porcelain craftsmanship matured considerably in the Qing Dynasty; potters devised diverse types of vessels which cleverly imitated the original objects in both shape and texture. This *zun* wine vessel represents such maturity.

61. Lotus-flower double vase in cloisonné enamel
Qianlong reign (1736-95) of Qing Dynasty
Height: 17 cm.

Two vases are joined to form one. Broad shoulders and body, the lower part of the body fairly slim, foot slightly flared. Pure, white, fine paste, coated with white glaze. Overglaze cloisonné enamel decoration. Light blue predominates on one side of the vase and brownish red on the other. The cover of the vase has twin gold knobs. The ground is needled into fine brocade patterns on which are carved twining floral sprays. Worked in exquisite detail, it is typical of cloisonné enamel vessels of the Qianlong reign.

62. Vase with design symbolizing surge of good luck

A product of Jingdezhen. Gem-like glaze in red, black and blue is applied on the surface to represent the upsurge of *yang* spirit in spring. Of excellent workmanship, it is one of the modern art porcelain varieties made at Jingdezhen.

63. Blue-and-white double-eared vase with flying phoenix pattern

Made at Jingdezhen, Jiangxi Province. It has a shallow, dish-shaped mouth, straight neck, flat body, and trumpet-shaped high stem. There are crackles in the ceramic glaze at the neck and the lower part of the body. Phoenixes in pairs are painted in bright colours in the middle of the neck and on the body. This is one of Jingdezhen's traditional works. Since the Qianlong reign of the Qing Dynasty, this complex decoration has been widely used on large artistic porcelain vessels.

64. Underglaze phoenix vase and gourd-shaped jug

Made at Jingdezhen, Jiangxi Province, the vase is a large artistic porcelain vessel for ornamental use. Flared mouth, round lip, long neck, broad shoulders, spherical body with foot-rim. The jug is gourd-shaped. The decorative designs are done in blue-and-white and red pigments before glazing. The pleasant pastels, protected by a layer of white glaze, remain unfaded. This decoration has been fashionable since the Tang Dynasty.

65. Pottery sculpture of human figure

A product of the Shiwan Ceramics Factory in Guangdong Province, it inherits the tradi-

tion of fine craftsmanship of pottery sculpture of Shiwan kiln. It depicts an ancient, robust peasant with long flowing beard. One arm is akimbo, while in the other hand is a hoe. The paste colour of skin and glaze colour of garments are convincing.

66. Purplish brown sandy earthen teapot of Yixing

The purplish brown earthen teapot of Yixing, Jiangsu Province, is a good vessel for drinking tea, famous far and near. This modern version has a classical elegant shape and glossy colour. Tea infused in an earthen teapot preserves aroma and flavour.

67. Porcelain plaque with plum blossom design

A work of the Handan Ceramics Company in Hebei Province. A hardy old twig of plum blossoms painted in black, surrounded by the border design of a wide black band. Quiet and graceful, it has the appearance of a woodcut.

Appendixes

Important Ancient Kiln Sites
Discovered in China

Name of Kiln	Location	Dates by Dynasty	Varieties of Products	Literature
Ding	**Hebei Province:** Quyang County	Sui, Tang, Five Dynasties, Song, Kin, Yuan	Celadon of Sui; white porcelain of Tang and the Five Dynasties; white, black, brown, yellow, and green glazes; white glazed porcelain with incised, carved or impressed designs or mouldings and carvings of Song, Yuan and Kin.	Hebei Provincial Cultural Bureau Archaeological Team: "Investigation and Initial Excavation at Jiancicun Kiln Site in Quyang County, Hebei Province" (*Archaeology*, August 1965).
Cizhou	Handan	Song, Kin, Yuan	White glaze with black designs, carved, incised or impressed designs, mouldings and carvings; green glaze with black designs; white; black, brown glaze.	Hebei Provincial Cultural Bureau Archaeological Team: "Excavation Report on Guantai Kiln Site" (*Cultural Relics*, June 1959). Li Huibing: "An Investigation on Cizhou Kiln Site" (*Cultural Relics*, August 1964).
North Jiabi	Cixian County	Sui	Celadon.	Feng Xianming: "First Investigation on Sui Celadon Site at Jiabi Village in Cixian County, Hebei Province" (*Archaeology*, October 1959).
West Jiabi	Cixian County	Yuan	Jun ware.	

Name of Kiln	Location	Dates by Dynasty	Varieties of Products	Literature
Qingwan	Cixian County	Yuan	Jun ware.	Chen Wanli *et al*: "Investigations of Ancient Kiln Sites by the Palace Museum in the Past Ten Years" (*Journal of the Palace Museum* No. 2, p. 104).
Yuci	**Shanxi Province:** Taiyuan, Mengjiajing	Song	White, black, and green glazes.	Yang Zhirong: "Porcelain Kiln Site at Mengjiajing" (*Cultural Relics*, September 1964).
Jiexiu	Hongshanzhen, Jiexiu County	Song	White, black, and brown glazes; white glaze with incised designs.	Wu Liancheng: "Introduction to a Song Kiln Site at Hongshanzhen in Jiexiu County, Shanxi Province" (*Cultural Relics*, October 1958).
Gaoping	Gaoping County	Song, Yuan	White glaze; white glaze with red and green patterns.	
Pingding	Yangquan County	Song, Yuan	White glaze.	
Huoxian	Huoxian County	Song, Yuan	White porcelain; green glaze with black designs.	
Hunyuan	Hunyuan County	Tang	White porcelain.	
Anyang	**Henan Province:** Anyang	Sui, Tang	Celadon; white porcelain.	Henan Provincial Museum and others: "Initial Excavation of a Sui Porcelain Kiln at Anyang, Henan Province" (*Cultural Relics*, February 1977).

Name of Kiln	Location	Dates by Dynasty	Varieties of Products	Literature
West Shan-ying	Anyang	Tang, Song, Yuan	Black porcelain of Tang; Jun glaze of Song and Yuan.	Chen Wanli: "Investigation Report on Ancient Kiln Sites in Pingyuan and Hebei Provinces" (*Reference Data on Cultural Relics*, January 1952).
North Shan-ying	Anyang	Yuan	Jun glaze.	Chen Wanli: "Investigation Report on Ancient Kiln Sites in Pingyuan and Hebei Provinces" (*Reference Data on Cultural Relics*, January 1952).
Tianxi-zhen	Anyang	Tang, Song	Black glaze; white glaze with black designs.	Chen Wanli: "Investigation Report on Ancient Kiln Sites in Pingyuan and Hebei Provinces" (*Reference Data on Cultural Relics*, January 1952).
Hebiji	Hebiji	Tang, Song, Yuan	White, black, and yellow porcelain of Tang; white, black, brown, and yellow porcelain and tri-colour glazed pottery of Song; Jun-glaze porcelain of Yuan.	Yang Baoshun: "Ancient Porcelain Kiln Sites at Hebiji in Tangyang County" (*Reference Data on Cultural Relics*, July 1956). Chen Wanli: "Impressions on Hebiji" (*Ibid.*, October 1957). Henan Provincial Cultural Bureau Archaeological Team: "A Brief Report on Excavations of Porcelain Kiln Sites at Hebiji, Henan Province" (*Cultural Relics*, August 1964).

Name of Kiln	Location	Dates by Dynasty	Varieties of Products	Literature
Huixian	Huixian County	Tang, Song	White, yellow porcelain.	Henan Provincial Cultural Bureau Archaeological Team: "A Brief Report on Investigations of Kiln Sites in Huixian County, Henan Province" (*Cultural Relics*, November 1966).
Dang-yangyu	Xiuwu County	Song	White, brown or black glazed porcelain, white glazed porcelain with incised designs.	Chen Wali: "Investigation Report on Ancient Kiln Sites in Pingyuan and Hebei Provinces" (*Reference Data on Cultural Relics*, January 1952). Chen Wanli: "A Talk on Dangyangyu Kiln" (*Ibid.*, April 1954).
Xiguan	Mixian County	Tang, Song	White porcelain of Tang; porcelain with black or yellow glazes, white glaze with pearl ground and incised designs, white glaze, black glaze, white ground with black designs, all of Song.	Henan Provincial Cultural Bureau Archaeological Team: "A Brief Report on Investigations of Tang and Song Kiln Sites in Mixian and Dengfeng Counties, Henan Province" (*Cultural Relics*, February 1964). Feng Xianming: "Investigations on Tang and Song Kiln Sites in Mixian and Dengfeng Counties, Henan Province" (*Cultural Relics*, March 1964).
Yaogou	Mixian County	Song		Henan Provincial Cultural Bureau Archaeological Team: "A Brief Report on Investigations of Tang and Song Kiln Sites in Mixian and Dengfeng Counties, Henan Province" (*Cultural Relics*, February 1964).

Name of Kiln	Location	Dates by Dynasty	Varieties of Products	Literature
Gong-xian	Gongxian County	Sui, Tang	Green glaze of Sui; white porcelain, black porcelain and tri-colour glazed pottery of Tang.	Feng Xianming: "A Summary of Investigations of Ancient Kiln Sites in Gongxian County, Henan Province" (*Ibid.*, March 1959).
Quhe	Dengfeng County	Song	White porcelain; pearl ground with incised or carved designs; tri-colour glazed pottery.	Henan Provincial Archaeological Team: "A Brief Report on Investigations of Tang and Song Kiln Sites in Mixian and Dengfeng Counties, Henan Province" (*Ibid.*, February 1964). Feng Xianming: "Investigations on Tang and Song Kiln Sites in Mixian and Dengfeng Counties, Henan Province" (*Ibid.*, March 1964).
Jun	Bagua Cave in Yuxian County	Song	Jun and Cizhou wares.	Zhao Qingyun: "Excavation on Juntai Kiln Site in Yuxian County, Henan Province" (*Ibid.*, June 1975).
A Shen-hou group	Yuxian County	Tang, Song, Yuan	Huaci (one-colour glazed porcelain decorated with splashes of contrasting colour) and black porcelain of Tang; Jun ware and white porcelain with black designs of Song; Jun ware of Yuan.	Chen Wanli: "Travel in Yuzhou" (*Reference Data on Cultural Relics*, February 1951).
A Fang-shan District group	Yuxian County	Song, Yuan	Jun ware.	Ye Zhemin: "A Summary of Investigations on Ancient Kiln Sites in Yuxian County, Henan Province" (*Cultural Relics*, August 1964).

Name of Kiln	Location	Dates by Dynasty	Varieties of Products	Literature
A Hua-shi group	Yuxian County	Yuan	Jun ware.	Ye Zhemin: "A Summary of Investigations on Ancient Kiln Sites in Yuxian County, Henan Province" (*Cultural Relics*, August 1964).
Pacun	Yuxian County	Song, Yuan	White glaze with black designs, tri-colour glazed pottery, white glaze with carved designs, black glaze, green glaze with black designs.	Ye Zhemin: "A Summary of Investigations on Ancient Kiln Sites in Yuxian County, Henan Province" (*Cultural Relics*, August 1964).
Yang-jiazhai	Yuxian County	Song, Yuan	Jun ware.	Ye Zhemin: "A Summary of Investigations on Ancient Kiln Sites in Yuxian County, Henan Province" (*Cultural Relics*, August 1964).
Shigeda (Miaojia-yu, Zhang-zhuang, etc.)	Yuxian County	Song, Yuan	Jun ware.	Ye Zhemin: "A Summary of Investigations on Ancient Kiln Sites in Yuxian County, Henan Province" (*Cultural Relics*, August 1964).
Lower Baiyu	Yuxian County	Tang, Yuan	Black porcelain and Huaci (one-colour glazed porcelain decorated with splashes of contrasting colour) of Tang.	Ye Zhemin: "A Summary of Investigations on Ancient Kiln Sites in Yuxian County, Henan Province" (*Cultural Relics*, August 1964).
Liujia-men	Yuxian County	Song	Jun ware.	Ye Zhemin: "A Summary of Investigations on Ancient Kiln Sites in Yuxian County, Henan Province" (*Cultural Relics*, August 1964).

Name of Kiln	Location	Dates by Dynasty	Varieties of Products	Literature
Laozhai	Yuxian County	Song	Jun ware.	Ye Zhemin: "A Summary of Investigations on Ancient Kiln Sites in Yuxian County, Henan Province" (*Cultural Relics*, August 1964).
Bianjia-fen	Yuxian County	Song	Jun ware.	Ye Zhemin: "A Summary of Investigations on Ancient Kiln Sites in Yuxian County, Henan Province" (*Cultural Relics*, August 1964).
Wang-jiafen	Yuxian County	Song	Jun ware.	Ye Zhemin: "A Summary of Investigations on Ancient Kiln Sites in Yuxian County, Henan Province" (*Cultural Relics*, August 1964).
Lower Baiyu	Yuxian County	Song	Jun ware.	Ye Zhemin: "A Summary of Investigations on Ancient Kiln Sites in Yuxian County, Henan Province" (*Cultural Relics*, August 1964).
Wayao-gou	Yuxian County	Song	Jun ware.	Ye Zhemin: "A Summary of Investigations on Ancient Kiln Sites in Yuxian County, Henan Province" (*Cultural Relics*, August 1964).
Maoer-duo	Yuxian County	Song	Jun ware.	Ye Zhemin: "A Summary of Investigations on Ancient Kiln Sites in Yuxian County, Henan Province" (*Cultural Relics*, August 1964).

Name of Kiln	Location	Dates by Dynasty	Varieties of Products	Literature
Huang-dao	Jiaxian County	Tang, Song	Huaci of Tang; white glazed porcelain with black designs of Song.	
Hong-yaogou	Jiaxian County	Tang, Song	Huaci of Tang; white glazed porcelain with black designs of Song.	
Yezhu-gou (Ai-zhugou)	Jiaxian County	Song	Jun ware.	
Qing-longsi	Baofeng County	Song	Celadon; black porcelain.	Chen Wanli: "What I Think of Ru Ware" (*Reference Data on Cultural Relics*, February 1951).
Duan-dian	Lushan County	Tang, Song, Kin, Yuan	Huaci and black porcelain of Tang; black porcelain, white porcelain, Jun ware, brown glazed porcelain, white porcelain with black designs, white porcelain with red splashes, tri-colour glazed pottery of Song, Kin and Yuan.	Li Huibing and Li Zhiyang: "Duandian Kiln in Lushan County, Henan Province" (Not yet published). Chen Wanli *et al*: "Investigations of Ancient Kiln Sites by the Palace Museum in the Past Ten Years" (*Journal of the Palace Museum*, No. 2).
Zhaigou	Xingyang County	Sui, Tang	Celadon.	
Yun-mengshan	Xinan County	Yuan	Jun ware.	Chen Wanli *et al*: "Investigations of Ancient Kiln Sites by the Palace Museum in the Past Ten Years" (*Journal of the Palace Museum*, No. 2).

Name of Kiln	Location	Dates by Dynasty	Varieties of Products	Literature
Beiye	Xinan County	Song, Yuan	Celadon with impressed designs, sky-blue, light bluish green and ivory white glaze Linru ware of Song; Jun ware and blue-and-white porcelain of Yuan.	Henan Provincial Museum: "Investigations of Ancient Kiln Sites in Xinan County, Henan Province" (*Cultural Relics*, December 1974).
Tanzi-gou	Xinan County	Song, Yuan	Light sky-blue with green tinge, sky-blue, light bluish green, greyish green, rose purple, crab-apple red Pacun type ware of Song; Jun ware of Yuan.	Henan Provincial Museum: "Investigations of Ancient Kiln Sites in Xinan County, Henan Province" (*Cultural Relics*, December 1974).
Shishu-ling	Xinan County	Song, Yuan	Light sky-blue with green tinge, sky-blue, light bluish green, moon white, rose purple, crab-apple red, black glazed Jun ware of Song and Yuan.	Henan Provincial Museum: "Investigations of Ancient Kiln Sites in Xinan County, Henan Province" (*Cultural Relics*, December 1974).
Maxing-gou	Xinan County	Yuan	Light sky-blue with green tinge, sky-blue, light bluish green, rose purple, crab-appel red and other Jun ware.	Henan Provincial Museum: "Investigations of Ancient Kiln Sites in Xinan County, Henan Province" (*Cultural Relics*, December 1974).
Wang-guduo	Xinan County	Yuan	Light sky-blue with green tinge, sky-blue, aubergine and other Jun ware.	Henan Provincial Museum: "Investigations of Ancient Kiln Sites in Xinan County, Henan Province" (*Cultural Relics*, December 1974).
Shisi	Xinan County	Yuan	Light sky-blue with green tinge, sky-blue, light bluish green, moon white, and other Jun ware of Yuan.	Henan Provincial Museum: "Investigations of Ancient Kiln Sites in Xinan County, Henan Province" (*Cultural Relics*, December 1974).
Jiagou	Xinan County	Yuan	Light sky-blue with green tinge, sky-blue, light bluish green, moon white, creamy white and other Jun ware of Yuan.	Henan Provincial Museum: "Investigations of Ancient Kiln Sites in Xinan County, Henan Province" (*Cultural Relics*, December 1974).

Name of Kiln	Location	Dates by Dynasty	Varieties of Products	Literature
Xiquli	Xinan County	Yuan	Jun ware.	Henan Provincial Museum: "Investigations of Ancient Kiln Sites in Xinan County, Henan Province" (*Cultural Relics*, December 1974).
Upper Gudeng	Xinan County	Yuan	Jun aware.	Henan Provincial Museum: "Investigations of Ancient Kiln Sites in Xinan County, Henan Province" (*Cultural Relics*, December 1974).
Baizui	Xinan County	Yuan	Jun ware.	Henan Provincial Museum: "Investigations of Ancient Kiln Sites in Xinan County, Henan Province" (*Cultural Relics*, December 1974).
Jinpingshan	Yiyang County	Song	Green glazed porcelain with impressed designs.	Henan Provincial Museum: "Jinpingshan porcelain Kiln Site in Yiyang, Henan Province" (Not yet published).
Yaozhou	**Shaanxi Province:** Tongchuan	Tang, Song, Kin, Yuan	Black porcelain and white porcelain of Tang; celadon of Song; celadon and brown glazed porcelain of Kin and Yuan.	Wang Jiaguang: "Analysis and Studies of Yaozhou Kiln" (*Archaeology*, June 1962). Shaanxi Provincial Institute of Archaeology: *Yaozhou Kiln in Tongchuan, Shaanxi Province* (Science Press, 1963).
Yuhuagong	Tongchuan	Five Dynasties, Song		Wang Jiaguang: "Analysis and Studies of Yaozhou Kiln" (*Archaeology*, June 1962). Shaanxi Provincial Institute of Archaeology: *Yaozhou Kiln in Tongchuan, Shaanxi Province* (Science Press, 1963).

Name of Kiln	Location	Dates by Dynasty	Varieties of Products	Literature
Agan-zhen	**Gansu Province:** Lanzhou	Yuan	Black glazed and brown glazed porcelain.	
Ankou	Jingchuan County	Song, Yuan	Black glaze, iron-rust designs.	
Yixing	**Jiangsu Province:** Yixing County	Jin, Tang	Celadon.	Jiangsu Provincial Commission on Cultural Relics: "Discovery of Celadon Kiln Site of the Six Dynasties in Yixing" (*Cultural Relics*, July 1959). Liu Ruli: "Discovery of Ancient Celadon Site at Junshan in Yixing" (*Cultural Relics*, February 1960).
Yue	Zhejiang Province: Yuyao County	**Tang, Five Dynasties, Song**	Green glazed porcelain.	"Xing and Yue Kilns and Ding Kiln" (*Reference Data on Cultural Relics*, September 1953). "More on Yue Ware" (*Ibid.*, May 1954). *A Brief History of Chinese Celadon*, Shanghai People's Publishing House, February 1956. Wang Shilun: "Studies of Porcelain Ware of Yuyao Kiln" (*Reference Data on Cultural Relics*, August 1958).
Yinxian	Yinxian County	Eastern Jin, Southern Dynasties, Five Dynasties, Northern Song	Green glazed porcelain.	Zhejiang Provincial Commission on Cultural Relics: "A Summary of Investigations of Ancient Kiln Sites in Yinxian County, Zhejiang Province" (*Archaeology*, April 1964). Li Huibing: "Gains from Investigations of Yinxian County Kiln in Zhejiang Province" (*Cultural Relics*, May 1973).

Name of Kiln	Location	Dates by Dynasty	Varieties of Products	Literature
Zhuji	Zhuji County	Song	Celadon.	Zhu Boqian: *A Short History of the Development of Longquan Celadon* (Not yet published).
Sheng-xian	Shengxian County	Five Dynasties, Song	Celadon.	Zhu Boqian: *A Short History of the Development of Longquan Celadon* (Not yet published).
Xiang-tang	Dongyang County	Tang, Five Dynasties, Northern Song	Celadon.	Zhu Boqian: *A Short History of the Development of Longquan Celadon* (Not yet published).
Wuzhu-tang	Jinhua County	Eastern Jin, Tang, Song	Celadon.	Zhang Xiang: "Investigations of Celadon Kiln Sites in Jinhua, Zhejiang Province" (*Archaeology*, May 1965).
Gufang-zhen	Jinhua County	Song	Celadon, black porcelain.	
Wuyi	Wuyi County	Song, Yuan	Celadon, black porcelain.	
Xianju	Xianju County	Song	Celadon.	Zhu Boqian: *A Short History of the Development of Longquan Celadon* (Not yet published).
Wukong-ao	Linhai County	Southern Dynasties, Tang	Celadon.	
Xiang-shan	Xiangshan County	Tang	Celadon.	
Huang-yan	Huangyan County	Five Dynasties, Northern Song	Celadon.	Zhejiang Provincial Commission on Cultural Relics: "Investigations of Ancient Celadon Kiln Sites in Huangyan, Zhejiang Province" (*Archaeological Correspondence*, August 1958).

Name of Kiln	Location	Dates by Dynasty	Varieties of Products	Literature
Lower Siqian	Ruian County	Five Dynasties, Song	Celadon.	Zhejiang Provincial Commission on Cultural Relics: "A Summary of Investigations of Ancient Kiln Sites in Wenzhou Prefecture" (*Cultural Relics*, November 1965).
Upper Siqian	Ruian County	Tang	Celadon.	Zhejiang Provincial Commission on Cultural Relics: "A Summary of Investigations of Ancient Kiln Sites in Wenzhou Prefecture" (*Cultural Relics*, November 1965).
Liyu-shan	Ruian County	Tang	Celadon.	Zhejiang Provincial Commission on Cultural Relics: "A Summary of Investigations of Ancient Kiln Sites in Wenzhou Prefecture" (*Cultural Relics*, November 1965).
Shitou-mian-shan	Ruian County	Five Dynasties	Celadon.	Zhejiang Provincial Commission on Cultural Relics: "A Summary of Investigations of Ancient Kiln Sites in Wenzhou Prefecture" (*Cultural Relics*, November 1965).
Lingbei	Ruian County	Five Dynasties	Celadon.	Zhejiang Provincial Commission on Cultural Relics: "A Summary of Investigations of Ancient Kiln Sites in Wenzhou Prefecture" (*Cultural Relics*, November 1965).
Mao-tian	Ruian County	Five Dynasties	Celadon.	Zhejiang Provincial Commission on Cultural Relics: "A Summary of Investigations of Ancient Kiln Sites in Wenzhou Prefecture" (*Cultural Relics*, November 1965).

Name of Kiln	Location	Dates by Dynasty	Varieties of Products	Literature
Chang-pudi	Ruian County	Five Dynasties	Celadon.	Zhejiang Provincial Commission on Cultural Relics: "A Summary of Investigations of Ancient Kiln Sites in Wenzhou Prefecture" (*Cultural Relics*, November 1965).
Shan-luozi	Ruian County	Five Dynasties	Celadon.	Zhejiang Provincial Commission on Cultural Relics: "A Summary of Investigations of Ancient Kiln Sites in Wenzhou Prefecture" (*Cultural Relics*, November 1965).
Taishun	Ruian County	Five Dynasties, Song	Celadon, misty blue porcelain, white porcelain.	Zhejiang Provincial Commission on Cultural Relics: "A Summary of Investigations of Ancient Kiln Sites in Wenzhou Prefecture" (*Cultural Relics*, November 1965).
Lübu-keng	Lishui County	Southern Dynasties, Tang	Celadon.	Zhu Boqian and Wang Shilun: "Chief Gains from Investigations and Excavations at Kiln Sites of Longquan Celadon in Zhejiang Province" (*Cultural Relics*, January 1963).
Shiniu	Lishui County	Five Dynasties	Celadon.	"
Huang-shan	Lishui County	Five Dynasties	Celadon.	"
Bao-ding	Lishui County	Yuan	Celadon.	"
Guixi	Lishui County	Yuan	Celadon.	"
Gaoxi	Lishui County	Yuan	Celadon.	"

Name of Kiln	Location	Dates by Dynasty	Varieties of Products	Literature
Chishi-bu	Yunhe County	Song, Yuan	Celadon.	Zhu Boqian and Wang Shilun: "Chief Gains from Investigations and Excavations at Kiln Sites of Longquan Celadon in Zhejiang Province" (*Cultural Relics*, January 1963).
Hushan	Suichang County	Song, Yuan	Celadon.	Zhu Boqian and Wang Shilun: "Chief Gains from Investigations and Excavations at Kiln Sites of Longquan Celadon in Zhejiang Province" (*Cultural Relics*, January 1963).
Long-quan	Longquan County	Five Dynasties, Song, Yuan, Ming	Celadon.	Zhu Boqian and Wang Shilun: "Chief Gains from Investigations and Excavations at Kiln Sites of Longquan Celadon in Zhejiang Province" (*Cultural Relics*, January 1963). Zhu Boqian: *A Short History of the Development of Longquan Celadon* (Not yet published). Jin Zuming: "A Summary of Investigations of Celadon Kiln Sites at Xikou, Longquan" (*Archaeology*, October 1962).
Xishan	Wenzhou	Tang, Five Dynasties, Song	Celadon.	Zhang Xiang: "Period of Xishan Kiln in Wenzhou and Its Relations with Dongou Kiln" (*Archaeology*, October 1962). Deng Bai: "The True Story of Light Bluish Grey Porcelain in Dongou" (*Reference Data on Cultural Relics*, November 1956).

Name of Kiln	Location	Dates by Dynasty	Varieties of Products	Literature
Chaqiao	Wenzhou	Eastern Han	Celadon, hard pottery with impressed designs.	"
Xiabi-shan	Yongjia County	Eastern Jin, Tang, Song	Celadon.	Chen Wanli: "What I Saw During Recent Investigations on Ancient Kiln Sites" (*Reference Data on Cultural Relics*, August 1955).
Tantou	Yongjia County	Eastern Jin, Tang, Song	Celadon.	"
Nanao	Yongjia County	Yuan	Celadon.	"
Meiao	Yongjia County	Yuan	Celadon.	"
Zhutu	Yongjia County	Yuan	Celadon.	"
Fen-shan-jiao	Yongjia County	Eastern Han	Celadon, hard pottery with impressed designs.	Zhejiang Provincial Commission on Cultural Relics: "A Summary of Ancient Kiln Sites in Wenzhou Prefecture" (*Cultural Relics*, November 1965).
Dian-ling-shan	Yongjia County	Eastern Han	Celadon, hard pottery with impressed designs.	Zhejiang Provincial Commission on Cultural Relics: "A Summary of Ancient Kiln Sites in Wenzhou Prefecture" (*Cultural Relics*, November 1965).
Shui-jing-w a n	Yongjia County	Eastern Han	Celadon, hard pottery with impressed designs.	Zhejiang Provincial Commission on Cultural Relics: "A Summary of Ancient Kiln Sites in Wenzhou Prefecture" (*Cultural Relics*, November 1965).

Name of Kiln	Location	Dates by Dynasty	Varieties of Products	Literature
Chitou-shan	Yongjia County	Eastern Han	Celadon, hard pottery with impressed designs.	Zhejiang Provincial Commission on Cultural Relics: "A Summary of Ancient Kiln Sites in Wenzhou Prefecture" (*Cultural Relics*, November 1965.)
Datan-cun	Yongjia County	Tang	Celadon, hard pottery with impressed designs.	Zhejiang Provincial Commission on Cultural Relics: "A Summary of Ancient Kiln Sites in Wenzhou Prefecture" (*Cultural Relics*, November 1965).
Houbei-shan	Yongjia County	Tang	Celadon, hard pottery with impressed designs.	Zhejiang Provincial Commission on Cultural Relics: "A Summary of Ancient Kiln Sites in Wenzhou Prefecture" (*Cultural Relics*, November 1965).
Men-qian-shan	Yongjia County	Tang	Celadon, hard pottery with impressed designs.	Zhejiang Provincial Commission on Cultural Relics: "A Summary of Ancient Kiln Sites in Wenzhou Prefecture" (*Cultural Relics*, November 1965).
Ruoao-cun	Yongjia County	Tang	Celadon, hard pottery with impressed designs.	Zhejiang Provincial Commission on Cultural Relics: "A Summary of Ancient Kiln Sites in Wenzhou Prefecture" (*Cultural Relics*, November 1965.)
Qiling-shan	Yongjia County	Tang	Celadon, hard pottery with impressed designs.	Zhejiang Provincial Commission on Cultural Relics: "A Summary of Ancient Kiln Sites in Wenzhou Prefecture" (*Cultural Relics*, November 1965).

Name of Kiln	Location	Dates by Dynasty	Varieties of Products	Literature
Datan-fenshan	Yongjia County	Tang	Celadon, hard pottery with impressed designs.	Zhejiang Provincial Commission on Cultural Relics: "A Summary of Ancient Kiln Sites in Wenzhou Prefecture" (*Cultural Relics*, November 1965).
Wayao-shan	Yongjia County	Tang	Celadon, hard pottery with impressed designs.	Zhejiang Provincial Commission on Cultural Relics: "A Summary of Ancient Kiln Sites in Wenzhou Prefecture" (*Cultural Relics*, November 1965).
Hou-shan	Yongjia County	Tang	Celadon, hard pottery with impressed designs.	Zhejiang Provincial Commission on Cultural Relics: "A Summary of Ancient Kiln Sites in Wenzhou Prefecture" (*Cultural Relics*, November 1965.)
Qishen-miao	Yongjia County	Tang	Celadon, hard pottery with impressed designs.	Zhejiang Provincial Commission on Cultural Relics: "A Summary of Ancient Kiln Sites in Wenzhou Prefecture" (*Cultural Relics*, November 1965).
Meiao	Yongjia County	Southern Song	Celadon.	Zhejiang Provincial Commission on Cultural Relics: "A Summary of Ancient Kiln Sites in Wenzhou Prefecture" (*Cultural Relics*, November 1965).
Dong-shan	Yongjia County	Southern Song	Celadon.	Zhejiang Provincial Commission on Cultural Relics: "A Summary of Ancient Kiln Sites in Wenzhou Prefecture" (*Cultural Relics*, November 1965).

Name of Kiln	Location	Dates by Dynasty	Varieties of Products	Literature
Laofen-shan	Yongjia County	Southern Song	Celadon.	Zhejiang Provincial Commission on Cultural Relics: "A Summary of Ancient Kiln Sites in Wenzhou Prefecture" (*Cultural Relics*, November 1965.)
Ping-shansi	Yongjia County	Yuan, Ming	Celadon.	Zhejiang Provincial Commission on Cultural Relics: "A Summary of Ancient Kiln Sites in Wenzhou Prefecture" (*Cultural Relics*, November 1965).
Upper Fenshan	Yongjia County	Ming	Celadon.	Zhejiang Provincial Commission on Cultural Relics: "A Summary of Ancient Kiln Sites in Wenzhou Prefecture" (*Cultural Relics*, November 1965).
Qiaojiao	Yongjia County	Ming	Celadon.	Zhejiang Provincial Commission on Cultural Relics: "A Summary of Ancient Kiln Sites in Wenzhou Prefecture" (*Cultural Relics*, November 1965).
Dashan	Yongjia County	Ming	Celadon.	Zhejiang Provincial Commission on Cultural Relics: "A Summary of Ancient Kiln Sites in Wenzhou Prefecture" (*Cultural Relics*, November 1965.)
Nanao-cun	Yongjia County	Ming	Celadon.	Zhejiang Provincial Commission on Cultural Relics: "A Summary of Ancient Kiln Sites in Wenzhou Prefecture" (*Cultural Relics*, November 1965).

Name of Kiln	Location	Dates by Dynasty	Varieties of Products	Literature
Man-toushan	Leqing County	Southern Dynasties	Celadon.	
Yuhou-cun	Leqing County	Song	Brown glazed porcelain with painted designs.	
Baitu	**Anhui Province:** Xiaoxian County	Tang, Song, Kin	Yellow glazed porcelain and white porcelain of Tang; white porcelain and white glazed porcelain with black designs of Song and Kin.	Song Boyin: "A Summary of Investigations of Xiao Kiln" (*Archaeology*, March 1962). Hu Yueqian: "Baitu Kiln in Xiaoxian County, Anhui Province" (*Ibid.*, December 1963).
Shou-zhou	Huainan	Sui, Tang	Celadon.	Hu Yueqian: "A Summary of Investigations of Shouzhou Kiln Sites" (*Cultural Relics*, December 1961).
Fan-chang	Fanchang County	Song	Misty blue porcelain.	Zhang Daohong: "Initial Excavation of Fanchang Porcelain Kiln Site" (*Reference Data on Cultural Relics*, June 1958).
Tong-guan	**Hunan Province:** Changsha	Tang, Five Dynasties	Green glazed porcelain, green glazed porcelain with brown splashes.	Hunan Provincial Museum: "An Investigation of Tang Dynasty Kiln Sites at Wazhaping in Changsha" (*Cultural Relics*, March 1960). Feng Xianming: "Gains from Two Investigations of Tongguan Kiln in Changsha" (*Ibid.*, March 1960).
Yue-zhou	Xiangyin County	Southern Dynasties, Tang, Five Dynasties	Green glazed vessels.	Hunan Provincial Commission on Cultural Relics: "Investigation Report of Yuezhou Kiln Sites" (*Reference Data on Cultural Relics*, September 1953).

Name of Kiln	Location	Dates by Dynasty	Varieties of Products	Literature
Wu-longzui	Xiangyin County	Song, Yuan, Ming	Green glazed porcelain with brown splashes.	Hunan Provincial Commission on Cultural Relics: "An Investigation on Ming Kiln Sites at Wulongzui in Xiangyin County, Hunan Province" (*Archaeological Correspondence*, March 1957).
Leiyang	Leiyang County	Five Dynasties, Song	Green glazed vessels.	Hunan Provincial Museum: "Ancient Kiln Sites Discovered in Leiyang and Yongxing, Hunan Province" (*Archaeology*, October 1960).
Yong-xing	Yongxing County	Five Dynasties, Song	Green glazed vessels.	Hunan Provincial Museum: "Ancient Kiln Sites Discovered in Leiyang and Yongxing, Hunan Province" (*Archaeology*, October 1960).
Yang-meiting	Jiangxi Province: Jingdezhen	Tang, Five Dynasties, Northern Song	Celadon, white porcelain, misty blue porcelain.	Chen Wanli: "Investigations on Several Ancient Kiln Sites at Jingdezhen" (*Reference Data on Cultural Relics*, September 1953).
Shihu-wan	Jingdezhen	Tang, Five Dynasties, Northern Song	Celadon, white porcelain, misty blue porcelain.	"
Hutian	Jingdezhen	Song, Yuan	Misty blue porcelain, black porcelain, blue-and-white porcelain.	"
Xiang-hu	Jingdezhen	Song	Misty blue porcelain.	"

Name of Kiln	Location	Dates by Dynasty	Varieties of Products	Literature
Dong-jiawu	Jingdezhen	Yuan, Ming	Blue-and-white porcelain.	"
Jizhou	Jian	Song, Yuan, Ming	Misty blue porcelain, black porcelain, brown glazed porcelain, celadon, white porcelain with black designs, blue-and-white porcelain.	He Guowei: "A General Survey of Jizhou Kiln Sites" (*Reference Data on Cultural Relics*, September 1953). Jiang Xuanyi: *Jizhou Kiln*, Cultural Relics Publishing House, 1958.
Baihu	Linchuan County	Tang	Celadon.	Chen Boquan: "Investigations of Kiln Sites in Linchuan and Nanfeng, Jiangxi Province" (*Archaeology*, December 1963).
Baishe	Nanfeng County	Song	Misty blue porcelain.	Chen Boquan: "Investigations of Kiln Sites in Linchuan and Nanfeng, Jiangxi Province" (*Archaeology*, December 1963).
Ganzhou	Ganzhou	Yuan	Celadon, black porcelain.	Wang Zichen: "Song Kiln Sites Discovered at Qilizhen in Ganzhou" (*Reference Data on Cultural Relics*, August 1956).
Jiujiang	Jiujiang	Song	Celadon.	
Leping	Leping County	Tang, Song, Yuan, Ming	Celadon of Tang; celadon and misty blue porcelain of Yuan; blue-and-white porcelain of Ming.	Wang Houqian: "A Brief Account of Investigations on Ancient Kiln Sites in Leping County" (Not yet published). Chen Boquan: "An Investigation on Ming Blue-and-white Porcelain Kiln Sites in Leping, Jiangxi Province" (*Cultural Relics*, March 1973).
Xingan	Xingan County	Tang	Celadon.	

Name of Kiln	Location	Dates by Dynasty	Varieties of Products	Literature
Pu-cheng	Fujian Province: Pucheng County	Song, Ming	Celadon of Song; blue-and-white porcelain of Ming.	Lin Dengxiang: "Song Kiln Sites in Pucheng" (*Cultural Relics*, June 1959).
Chong-an	Chongan County	Song, Ming	Black porcelain, celadon, misty blue porcelain.	Gan Jingfu *et al*: "Song Kiln Sites in Chongan" (*Ibid.*, June 1959). Xu Qingquan *et al*: "Song Black Porcelain Kilns at Xingcun Village in Chongan" (*Ibid.*, June 1959). Xu Qingquan *et al*: "Ming Kiln Sites in Chongan" (*Ibid.*, June 1959).
Qihui-chang	Songqi County	Song	Celadon, black porcelain.	Xiao Mingjun *et al*: "Song Kiln Sites in Songqi County" (*Ibid.*, June 1959).
Zhenghe	Zhenghe County	Yuan, Ming	Misty blue porcelain, blue-and-white porcelain.	Fujian Provincial Commission on Cultural Relics: "An Investigation on Ming Porcelain Kilns in Zhenghe County" (Not yet published).
Guang-ze	Guangze County	Song	Misty blue porcelain, black porcelain.	Zheng Fan: "Song Kiln Sites at Maodian in Guangze County" (*Reference Data on Cultural Relics*, February 1958).

Name of Kiln	Location	Dates by Dynasty	Varieties of Products	Literature
Jian	Jianyang County	Song	Black porcelain.	Song Boyin: "An Investigation on the Jian Kiln" (*Reference Data on Cultural Relics*, March 1955). The Anthropological Museum of Shamen University: "A Brief Account of Excavation on the Song Dynasty Jian Kiln at Shuiji in Jianyang County, Fujian Province" *Archaeology*, April 1964). Fujian Provincial Commission on Cultural Relics: "An Account of Investigations on Ancient Kiln Sites in Jianyang County" (Not yet published).
Yuan-touzai	Jianyang County	Song	Black porcelain.	"
Wan-yao-xiang	Jianyang County	Ming	Black porcelain.	"
Jianou	Jianou County	Song, Ming, Qing	Misty blue porcelain, celadon, black porcelain.	
Taining	Taining County	Song	Black porcelain.	
Jianning	Jianning County	Song	Black porcelain.	Fujian Provincial Commission on Cultural Relics: "An Investigation on Song Kiln Sites at Wangjiapu in Jianning County" (Not yet published).
Jiangle	Jiangle County	Tang	Celadon.	Shao Liangrong: "Tang Kiln Sites Discovered in Jiangle County, Fujian Province" (*Cultural Relics*, September 1959).

Name of Kiln	Location	Dates by Dynasty	Varieties of Products	Literature
Ping-nan	Pingnan County	Ming, Qing	Blue-and-white porcelain.	Fujian Provincial Commission on Cultural Relics: "An Account of Investigations on Porcelain Kilns at Qianyuan in Pingnan County" (Not yet published).
Ningde	Ningde County	Song	Black porcelain.	Fujian Provincial Commission on Cultural Relics: "An Ancient Kiln Site at Feiluanzhen in the Fifth District of Ningde County" (Not yet published).
Minqing	Minqing	Song, Yuan	Misty blue porcelain.	Qiu Jiabing: "Song Kiln Sites in Minqing County" (Cultural Relics, June 1959).
Maling	Tianshan, Fuzhou	Southern Dynasties	Celadon.	Wang Tiefan: "Fuzhou Discovers the Province's Earliest Kiln Site" (Ibid., September 1962).
Lian-jiang	Lianjiang County	Song	Celadon, misty blue porcelain.	Song Boyin: "Two Ancient Porcelain Kiln Sites in Lianjiang County" (Reference Data on Cultural Relics, February 1958).
Aiyou	Minhou County	Song	Celadon, misty blue porcelain.	Lin Dengxiang: "An Investigation on Song Kiln Sites at Aiyou in Minhou County, Fujian Province" (Archaeology, January 1963).
Ting-shan	Xiping, Min-hou County	Song	Celadon, misty blue porcelain.	Fujian Provincial Commission on Cultural Relics: "Ancient Kiln Sites Discovered at Tingshan, Xiping in Minhou County" (Not yet published).

Name of Kiln	Location	Dates by Dynasty	Varieties of Products	Literature
Fuqing	Fuqing County	Song	Celadon, black porcelain.	Fujian Provincial Commission on Cultural Relics: "A Brief Account of Investigations on Ancient Kiln Sites at Dongmen Reservior in Fuqing County" (*Reference Data on Cultural Relics*, February 1958).
Qudou-gong	Dehua County	Song, Yuan	White porcelain, misty blue porcelain.	Song Boyin: "A Talk on the Dehua Kiln" (*Reference Data on Cultural Relics*, April 1955).
Zulong-gong	Dehua County	Song	White porcelain, misty blue porcelain.	Chen Wanli: "A Short Account of Investigations on Ancient Kiln Sites in Southern Fujian Province" (*Ibid.*, September 1957).
Xin-chang	Dehua County	Song	White porcelain, misty blue porcelain.	"
Shipaige	Dehua County	Ming, Qing	White porcelain of Ming; white porcelain and blue-and-white porcelain of Qing.	Chen Wanli: "A Short Account of Investigations on Ancient Kiln Sites in Southern Fujian Province" (*Ibid.*, September 1957).
Shitao-ling	Dehua County	Qing	White porcelain, blue-and-white porcelain.	Chen Wanli: "A Short Account of Investigations on Ancient Kiln Sites in Southern Fujian Province" (*Ibid.*, September 1957).
Housuo	Dehua County	Ming	White porcelain.	Chen Wanli: "A Short Account of Investigations on Ancient Kiln Sites in Southern Fujian Province" (*Ibid.*, September 1957).

Name of Kiln	Location	Dates by Dynasty	Varieties of Products	Literature
Xian-you	Xianyou County	Song	Celadon, misty blue porcelain, black porcelain.	Fujian Provincial Commission on Cultural Relics: "A Brief Account of Investigations on Ancient Porcelain Kilns in Xianyou County" (Not yet published).
Shibi	Nanan County	Song	Celadon, misty blue porcelain, black porcelain.	Huang Bingyuan: "Initial Excavation of Ancient Kiln Sites at Shibi Reservoir in Nanan County, Fujian Province" (*Reference Data on Cultural Relics*, December 1957).
Wan-yao-xiang	Quanzhou	Song, Yuan	Misty blue porcelain, celadon.	Chen Wanli: "A Short Account of Investigations on Ancient Kiln Sites in Southern Fujian Province" (*Ibid.*, September 1957).
Cizao	Quanzhou	Song, Yuan	Celadon, black porcelain.	"
Tongan	Tongan County	Song, Yuan	Celadon, misty blue porcelain.	Chen Wanli: "A Short Account of Investigations on Ancient Kiln Sites in Southern Fujian Province" (*Ibid.*, September 1957). Fujian Provincial Commission on Cultural Relics: "An Investigation of Ancient Porcelain Kiln Sites at Dingxi Reservoir in Tongan County" (*Ibid.*, February 1958). Huang Hanjie: "Song Kiln Sites in Tongan County" (*Cultural Relics.* June 1959). Li Huibing: "A Summary of Investigations on the Tongan Kiln in Fujian Province" (*Ibid.*, November 1974).

Name of Kiln	Location	Dates by Dynasty	Varieties of Products	Literature
Xukeng	Tongan County	Song, Yuan	Celadon, misty blue porcelain.	"
Xinmin-xiang	Tongan County	Song, Yuan	Celadon, misty blue porcelain.	"
Zhang-pu	Zhangpu County	Song	Celadon, misty blue porcelain.	Fujian Provincial Commission on Cultural Relics: "An Investigation of Ancient Kiln Sites at Zumalin Reservoir in Zhangpu County" (Not yet published).
Nan-xiong	**Guangdong Province:** Nanxiong County	Song	Celadon.	
Chao-zhou	Chaoan County	Song	Misty blue porcelain, black porcelain.	Chen Wanli: "A Talk on the Chaozhou Kiln, Inspired by Several Porcelain Statues" (*Reference Data on Cultural Relics*, March 1957). Zeng Guangyi: "Tang Kiln Sites in Northern Chaoan County, Guangdong Province" (*Archaeology*, April 1964).
Zhugan-shan	Chaoan County	Song	Misty blue porcelain, black porcelain.	"
Huiyang	Huiyang County	Yuan	Celadon, misty blue porcelain.	Guangdong Provincial Commission on Cultural Relics *et al*: "A Brief Account of Excavation of Ancient Porcelain at Xinan No. 3 Village in Huiyang County, Guangdong Province" (*Archaeology*, April 1964).
Xicun	Guangzhou	Tang, Five Dynasties, Song	White porcelain, misty blue porcelain, black porcelain, misty blue porcelain with painted designs.	Guangzhou Commission on Cultural Relics: *Ancient Kiln Sites at Xicun, Guangzhou*, Cultural Relics Publishing House, 1958.

Name of Kiln	Location	Dates by Dynasty	Varieties of Products	Literature
Nanhai Guan (Official) Kiln	Nanhai County	Song	Celadon, green glazed porcelain with black designs.	Guangdong Provincial Commission on Cultural Relics: "A Brief Account of Investigations on Several Ancient Kiln Sites in Foshan Prefecture" (*Cultural Relics*, December 1959).
Shiwan	Foshan	Song	Black porcelain, celadon.	Guangdong Provincial Commission on Cultural Relics: "A Brief Account of Investigations on Several Ancient Kiln Sites in Foshan Prefecture" (*Cultural Relics*, December 1959).
Dong-kou	Sanshui County	Tang	Celadon.	Guangdong Provincial Commission on Cultural Relics: "A Brief Account of Investigations on Several Ancient Kiln Sites in Foshan Prefecture" (*Cultural Relics*, December 1959).
Da-gang-shan	Gaohe County	Tang	Celadon.	Guangdong Provincial Commission on Cultural Relics: "A Brief Account of Investigations on Several Ancient Kiln Sites in Foshan Prefecture" (*Cultural Relics*, December 1959).
Guan-chong of Yamen	Xinhui County	Tang	Greenish yellow glazed porcelain, blackish brown glazed porcelain.	Guangdong Provincial Commission on Cultural Relics: "A Brief Account of Investigations on Several Ancient Kiln Sites in Foshan Prefecture" (*Cultural Relics*, December 1959).

Name of Kiln	Location	Dates by Dynasty	Varieties of Products	Literature
Panyu	Panyu County	Song	Celadon.	Guangdong Provincial Commission on Cultural Relics: "A Brief Account of Investigations on Several Ancient Kiln Sites in Foshan Prefecture" (*Cultural Relics*, December 1959).
Wan-yaojing	Zhongshan County	Yuan, Ming	Celadon, misty blue porcelain.	Guangdong Provincial Commission on Cultural Relics: "A Brief Account of Investigations on Several Ancient Kiln Sites in Foshan Prefecture" (*Cultural Relics*, December 1959).
Shiwan Village	Yangjiang County	Tang, Song	Celadon.	Ou Jiafa: "Ancient Kiln Sites Discovered at Shiwan Village in Yangjiang County, Guangdong Province" (*Reference Data on Cultural Relics*, March 1955).
Hepu	Hepu County	Tang	Celadon.	
Dong-xing	Dongxing County	Ming	Green glazed porcelain, blue-and-white porcelain.	
Cheng-mai	Chengmai County	Song, Yuan	Celadon, white porcelain.	Zeng Guangyi: "An Investigation on Ancient Kiln Sites in Boluo and Chengmai Counties, Guangdong Province" (*Cultural Relics*, February 1965).
Fengkai	Fengkai County	Song	Celadon.	He Jisheng and Zhao Quanshun: "An Investigation on Song Porcelain Kilns at Dumiao in Fengkai County, Guangdong Province" (*Ibid.*, July 1975).

Name of Kiln	Location	Dates by Dynasty	Varieties of Products	Literature
Yan-guan	**Guangxi Zhuang Autonomous Region: Xingan County**	Song	Celadon, black porcelain.	Li Hongqing: "Ancient Kiln Sites Discovered in Xingan County" (*Ibid.*, September 1962).
Guang-yuan	**Sichuan Province:** Guangyuan County	Song	Black porcelain, white porcelain, white glazed porcelain decorated with green splashes.	Wang Jiahu: "Preliminary Investigation on a Black Glazed Porcelain Kiln in Guangyuan County, Sichuan Province" (*Ibid.*, March 1955).
Qing-yang-gong	Chengdu	Southern Dynasties, Sui, Tang	Celadon.	Jiang Xuechu *et al*: "A Brief Account of Initial Excavation of Ancient Kiln Sites at Qingyang-gong" (*Reference Data on Cultural Relics*, June 1956).
Peng-xian	Pengxian County	Song	White porcelain.	
Guyi	Qionglai County	Southern Dynasties, Sui	Celadon.	Xu Pengzhang: "An Investigation of Ancient Porcelain Kilns in Western Sichuan" (*Ibid.*, February 1958).
Shi-fang-tang	Qionglai County	Tang	Green glazed porcelain with brown and green splashes.	
Jian-shanzi	Qionglai County	Tang	Green glazed porcelain with brown and green splashes.	
Wayao-shan	Qionglai County	Tang	Green glazed porcelain with brown and green splashes.	
Yu-huang-guan	Xinjin County	Southern Dynasties	Celadon.	Luo Yongzuo: "Two Ancient Kiln Sites Discovered at Dengshuang Township in Xinjin County" (*Ibid.*, January 1957).
Shi-chang-wan	Xinjin County	Tang	Celandon	"

Name of Kiln	Location	Dates by Dynasty	Varieties of Products	Literature
Liuli-chang	Huayang County	Five Dynasties, Song	Green glazed porcelain with painted designs.	Lin Kunxue: "An Investigation of the Liuli-chang Kiln Site in Huayang County, Sichuan Province" (*Reference Data on Cultural Relics*, September 1956).
Tie-zuan-shan	Chongning, Pixian County	Song, Ming	Celadon.	
Gang-wa	**Liaoning Province:** Chifeng County	Liao	White porcelain, tri-colour glazed porcelain.	Zhoujie: "An Investigation of Liao Dynasty Porcelain Kilns at Gang-wayao Village in Chifeng County" (*Archaeology*, July 1973).
Huitu	**Yunnan Province:** Kunming	Ming, Qing	Blue glazed porcelain, green glazed porcelain.	Duan Yongyuan: "In formation on Local Customs"; Ge Jifang: "Hui-tu Kiln in Kunming" (*Cultural Relics*, November 1956).

Chronology of Chinese Dynasties

Primitive Society	c. 600,000 years ago- 21th century B.C.	Jin	265-420
		Western Jin	265-316
Slave Society	c. 21st century-476 B.C.	Eastern Jin	317-420
Xia	c. 21st-16th century B.C.	Southern and Northern Dynasties	420-589
Shang	c. 16th-11th century B.C.	Southern Dynasties	420-589
Zhou	c. 11th century-221 B.C.	Song	420-479
		Qi	479-502
Western Zhou	c. 11th century-770 B.C.	Liang	502-557
		Chen	557-589
Eastern Zhou Spring and Autumn Period	770-221 B.C. 770-476 B.C.	Northern Dynasties	386-581
		Northern Wei	386-534
		Eastern Wei	534-550
Feudal Society Warring States Period	475 B.C.-A.D. 1840 475-221 B.C.	Western Wei	535-557
		Northern Qi	550-577
		Northern Zhou	557-581
Qin	221-207 B.C.	Sui	581-618
Han	206 B.C.-A.D. 220	Tang	618-907
Western Han	206 B.C.-A.D. 24		
Eastern Han	25-220	Five Dynasties and Ten Kingdoms	907-979
Three Kingdoms	220-280	Song	960-1279
Wei	220-265		
Shu	221-263	Northern Song	960-1127
Wu	222-280	Southern Song	1127-1279

Liao	916-1125
Western Xia	1038-1227
Kin	1115-1234
Yuan	1271-1368

| Ming | 1368-1644 |
| Qing* | 1644-1911 |

*After 1840 China was reduced to a semi-colonial and semi-feudal society.

Reigning Periods of the Ming and Qing Dynasties

Ming Dynasty	**(1368-1644)**	Wanli	1573-1620
Hongwu	1368-1398	Taichang	1620
Jianwen	1399-1402	Tianqi	1621-1627
Yongle	1403-1424	Chongzhen	1628-1644
Hongxi	1425	**Qing Dynasty**	**(1644-1911)**
Xuande	1426-1435	Shunzhi	1644-1661
Zhengtong	1436-1449	Kangxi	1662-1722
Jingtai	1450-1456	Yongzheng	1723-1735
Tianshun	1457-1464	Qianlong	1736-1795
Chenghua	1465-1487	Jiaqing	1796-1820
Hongzhi	1488-1505	Daoguang	1821-1850
Zhengde	1506-1521	Xianfeng	1851-1861
Jiajing	1522-1566	Tongzhi	1862-1874
Longqing	1567-1572	Guangxu	1875-1908
		Xuantong	**1909-1911**

中国陶瓷

李知宴　程雯著

*

外文出版社出版

（中国北京百万庄路24号）

邮政编码100037

文联印刷厂印刷

中国国际图书贸易总公司发行

（中国北京车公庄西路21号）

北京邮政信箱第399号　　邮政编码100044

1984年（16开）第一版

1989年第二次印刷

（英）

ＩＳＢＮ　7-119-01167-7/G・66（外）

0 2055

7—E—1714 P